THE **DIGITAL SLR** EXPERT

LANDSCAPES

essential advice from top pros

TOM MACKIE • WILLIAM NEILL • DAVID NOTON • DARWIN WIGGETT • TONY WOROBIEC

Edited by Cathy Joseph

David and Charles

A DAVID & CHARLES BOOK
Copyright © David & Charles Limited 2008, 2009

David & Charles is an F+W Media Inc. company
4700 East Galbraith Road
Cincinnati, OH 45236

First published in the UK in 2008
This paperback edition first published in the UK in 2009

Text and photographs copyright © Tom Mackie, William Neill, David Noton,
Darwin Wiggett and Tony Worobiec 2008, 2009

A catalogue record for this book is available from the British Library.

ISBN-13: 978-0-7153-2940-5 paperback
ISBN-10: 0-7153-2940-5 paperback

Printed in China by RR Donnelley
for David & Charles
Brunel House Newton Abbot Devon

Commissioning Editor: Neil Baber
Desk Editor: Emily Rae
Project Editor: Cathy Joseph
Copy Editor: Nicola Hodgson
Designer: Joanna Ley
Production Controller: Beverley Richardson

Visit our website at www.davidandcharles.co.uk

David & Charles books are available from all good bookshops; alternatively you
can contact our Orderline on 0870 9908222 or write to us at FREEPOST EX2 110,
D&C Direct, Newton Abbot, TQ12 4ZZ (no stamp required UK only); US customers
call 800-289-0963 and Canadian customers call 800-840-5220.

CONTENTS

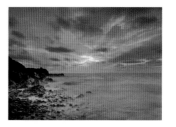

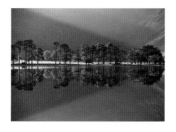

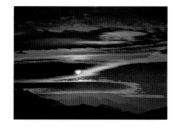

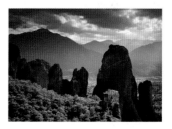

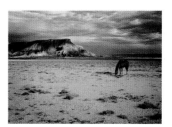

INTRODUCTION

TOM MACKIE

Digital SLR cameras have opened up newly found interests in landscape photography. Digital makes photography easier. There's no need to think about focusing, metering or what film to use. It's all done for you and your masterpieces will fly on to your memory cards. Don't believe it! You still need a good understanding of the basics. When I started shooting with a DSLR I had to learn a lot about this new technology, and it is a continuous education. A few years ago I couldn't tell you what a histogram was, let alone how to read one.

Digital can very easily create lazy photographers, and I find myself slipping into this realm on occasion. I have to consciously evaluate what I am doing all the time. When I'm shooting with my large-format camera, I naturally work slowly and methodically, as this is the nature of the camera system. But when I have a DSLR in my hands, my first instinct is to snap away. Look at all these strange new features that I've never had the pleasure of using, such as autofocus, auto metering and zoom lenses! But snapping away without thought only creates snapshots.

It's also very easy to shoot handheld, but this is not always a good approach to achieving the best quality. Having the camera on a tripod allows you to take your hands away from the camera and concentrate on what's going on within the viewfinder. Check the edges of the frame to make sure unwanted elements such as wires or branches are not slipping into view. Don't have the attitude that these can be taken out later in Photoshop; try to get the image right at the point of capture.

Just a word about processing and editing your files in Photoshop (actually some advice from my assistant, Lisa, who works her magic on all of my images): when working with multiple images it's easy to run an action in Photoshop to carry out several tasks at once. However, when it comes to getting the best out of each individual image, you can't action perfection. Treat each image on its own merits.

Digital has definitely opened up my photography, particularly the way I shoot. I now find photographic situations where previously I wouldn't even have taken the camera out of the bag because of technical constraints. I wouldn't say that digital capture is better than film, but it's certainly different.

I still use film, and I enjoy shooting with my 4x5 Ebony view camera, because there is nothing like viewing a large-format transparency on a light table. But shooting with large format comes at a price. I'm not just talking about film and processing – more importantly, my back! Working with large-format gear is slow, heavy and cumbersome. I now take the camera system to suit the location.

Digital has enhanced the output of my work, allowing me to achieve images that I wouldn't obtain with larger film formats, but I consider it an addition to the camera formats that I use. It is not the end-all camera system that will satisfy all of my clients' needs. But digital is here to stay, so embrace it to whatever degree you choose.

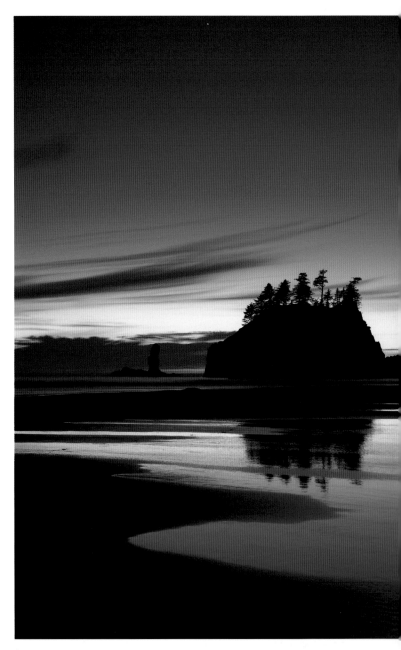

⋀ **La Push Beach at Twilight, Olympic National Park, Washington. One of the great advantages of the DSLR is the wider exposure range compared to film. This allows me to continue shooting in low light levels long past when I would have to put the film camera in the bag. It increases my productivity, allowing me more time to work a scene.**
Canon EOS 5D, 24mm–105mm lens, 1/10 sec at f/18, ISO 100

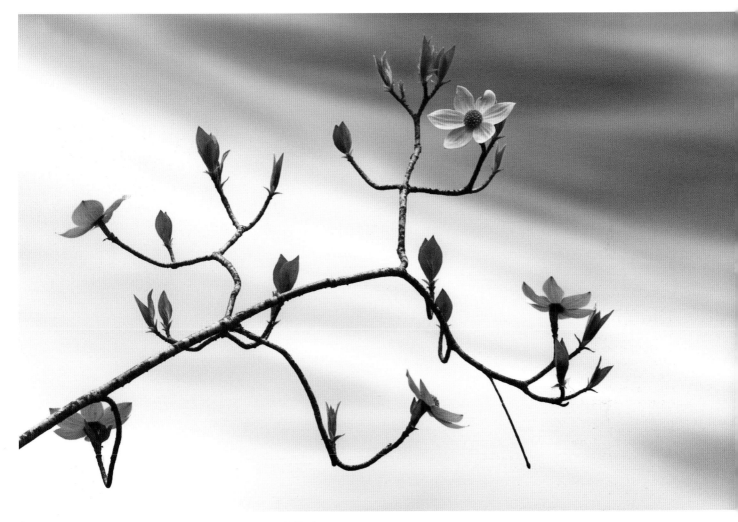

⚹ **Dogwood blooming over the Merced River, Yosemite National Park, California.**
Canon EOS-1Ds Mark II, 70–200mm lens, 1/5 sec at f/13, ISO 100

WILLIAM NEILL
I have used a 4x5 camera for most of my career, mostly for the outstanding quality. In 2004, I started using Canon's high-megapixel cameras and found many advantages. These include wider choice of focal lengths, immediate feedback on composition and exposure via the LCD, no more need for scanning film and the convenience of reviewing and editing the results.

Additionally, Canon's top model has progressed from my original 12MP 1Ds, to the 16.7MP 1Ds Mark II, to my current 21.9MP 1Ds Mark III. These advancements have made it easier to stick with the DSLR option due to the great improvements in resolution and noise reduction. Weight is another factor. As heavy as the Canon DSLRs are, they are still lighter than the 4x5 option, and I am not getting any younger!

Many photographers can benefit from the convenience and quality control afforded by modern DSLRs. Combined with the post-processing features of image-editing software, the speed of review to check exposure quality, sharpness, and so on is greatly streamlined. Simply learning to control your histogram while in the field is a revolution. But, to fully maximize your images, you must learn at least the basics of Photoshop, especially to make local adjustments within an image.

Learning is greatly aided by the freedom to experiment and take creative chances that the use of reusable memory cards offers us. I have found it liberating to use my DSLRs. My reasons are simple: excellent quality that will continue to improve, convenience in terms of seeing results quickly and easily, and the economic advantage of no longer buying film or paying for high-resolution drum scans.

Introduction

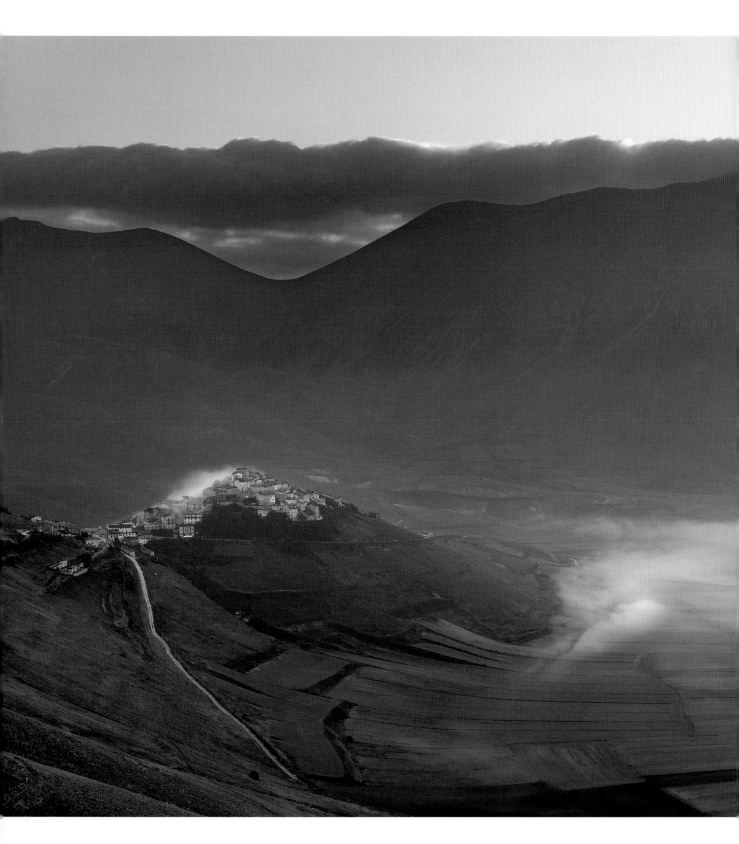

∨ This image shows the village of Castellucio in Umbria, Italy, perched high above the Piano Grande with the mountains of Monti Sibillini National Park beyond. I'm bowled over by the crispness and detail of images shot on the Canon EOS-1Ds Mark II. I now preach the benefits of digital capture with all the fervour of a convert.
Canon EOS-1Ds Mark II, 100–400mm lens, 1/50 sec at f/8, ISO 100

DAVID NOTON

In March 2005, I had a mid-life crisis. I terminated a long-term relationship with my Nikons, switched to digital, and ran off with a younger camera system. Like all such momentous changes it was traumatic and expensive, but it had to be done. Now, several years later, I'm ruminating over the changes, weighing up the pros and cons. What do I love about my new life? Freedom, flexibility and quality. What do I hate? The fact that I now feel wedded to a computer. Still, in all honesty, I have no regrets: the timing was right.

I'm looking back at an article I wrote in 2003, when the 'Big Debate' was in full flow. The digital revolution was perhaps the biggest seismic shift in photography since the evolution of the negative. Pixels were replacing light-sensitive emulsion, and photographers were wondering if and when to make the change, and how it would affect them.

Back then I decided to stick with film because of issues such as power, quality and compatibility with my existing system. 'If it works, don't fix it', was my ethos. But things moved on quickly and just a year later I couldn't ignore the fact that the latest generation of digital SLRs were producing images of superior quality than my 35mm film cameras. A jump in available quality was enticing, not to mention all the other advantages of working digitally.

There was, however, a big problem for me and many other Nikon users, which delayed my decision: sensor size. Nikon's DSLRs use a half-frame sensor – suitable for press work maybe, but not for my game. For a full-frame sensor I'd have to switch to Canon, and change my entire system. As I had a shed full of Nikons worth the price of a small house, this was a tough call, but I bit the bullet.

I think the debate has now moved on; shooting digitally is the norm and most photographers have a foot at least partially in the pixel camp. I have to admit that I'm a convert. The digital revolution has sounded the death knell of 35mm film; the quality and versatility available from most DSLRs is far superior. As for medium format, it's a tougher call. I've done comparisons between my Canon and a Mamiya RZ67 and in my view, not only is the DSLR far more flexible and portable, it delivers superior image quality. Surprised? So was I; but whichever way you cut it, the EOS-1Ds Mark II produces a crisper image. And the ability to vary the sensitivity, or ISO setting, to suit the conditions is very useful, not to mention a digital camera's flexibility when dealing with mixed lighting.

Still, many will disagree with me, and let's never lose sight of the fact that it's the pictures that matter. Ultimately in this debate, intangibles creep in. A photographer friend of mine insists that he prefers the feel of film; he doesn't like 'metallic' digital images. I know what I think, though: using those two crucial tools, the Curves and Levels controls, wisely at the RAW conversion and Photoshop stages, I have far more control over all aspects of my images than I ever have done before. I think the flexibility offered by a DSLR system is a priceless asset that can translate into better pictures when the chips are down.

Conversely, shooting digitally can foster a looser approach, a more laissez-faire attitude that you can just blast away and sort it out later; that if you shoot enough one is bound to work. Well, garbage in, garbage out, as they say. In fact, I think that to extract the best from my DSLR I need to be even more meticulous behind the camera. However, the flexibility of digital capture undoubtedly allows me to explore more options and to extract more from any photographic opportunity. To avoid that condemning me to endless computer hours, I have to hone in on the best. I'd rather produce one great picture than 50 average ones.

The great challenge of the switch to digital has been first to ensure a tight, disciplined approach to shooting, and second to learn a whole new way of editing to avoid spending the rest of my life in Photoshop.

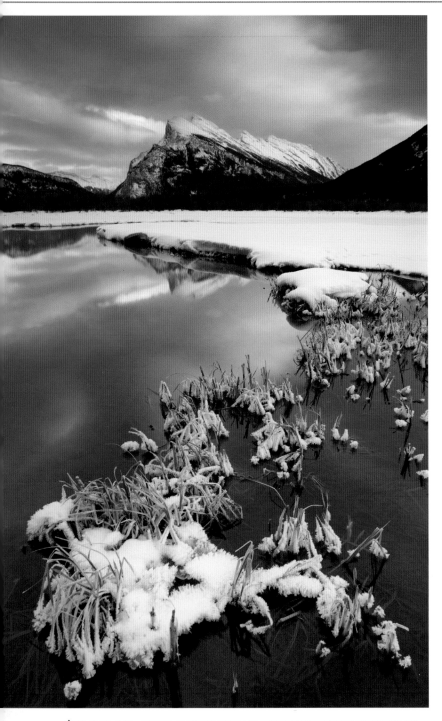

⌃ This photo of Mount Rundle and the Vermilion Lakes in Banff National Park was taken with my Canon EOS-1Ds Mark III and a 24mm TSE lens. I used the tilt feature on the lens to get depth of field beyond that possible with a regular lens. The foreground snow was only inches away from the front of my lens, yet the whole image is sharp, even at my middle aperture setting of f/11.
Canon EOS-1Ds Mark III, 24mm lens, 10 sec at f/11, ISO 100

DARWIN WIGGETT

For me, the greatest single advantage of digital capture is the ability to see whether you captured the shot in the field. You can make adjustments on the fly to obtain the image as you want it. Because of the power of instant feedback, I have seen new photographers progress at a much faster rate than they would with film.

Creative control is another big plus. Digital post-production is the chemical darkroom on performance-enhancing drugs. So much more can be done in the computer to manipulate images than was even imagined in the wet darkroom. The creative possibilities are endless. Of course, this advantage can be applied to film shooters who scan their negatives or slides, but capturing digital images and massaging them in the computer has opened up more people to personal expression than has the craft of wet darkroom work.

There is no longer the question of whether digital can match film in terms of quality. The detail, resolution and colour fidelity of digital capture easily matches or even surpasses 35mm and even medium-format film. Almost every stock photo agency in the world no longer accepts film, for both workflow and quality issues. Film and digital capture have different 'looks', and photographers generally prefer the look of one medium over the other, but in terms of quality of information captured, the nod now goes to digital.

There are some disadvantages to digital, too, though. My expenses for photography have tripled since my switch to digital, and I was a prolific film consumer! Most digital shooters upgrade their camera every 18 months to three years, and digital cameras are much more expensive than film cameras, which tend to be used for much longer periods. Also, digital users need computers, and these are upgraded on average every three years. Then there is the software, printers, monitors, calibration hardware, paper, ink, accessories and so on. The costs for professional digital capture are much higher than film. If you switched from film to save money, you're in for a surprise!

Digital imaging also sucks up my time like nothing else. In my film days, a two-week trip was followed by three days of work to get the film processed at the lab, to caption, label and file my slides, and to send submissions to my stock agency. Digital workflow after a two-week trip means I will spend two weeks behind the computer editing and processing the RAW captures, adding keywords, archiving and backing up multiple copies and preparing digital submissions to my stock agency. This is despite the fact that I am ruthless at editing – keeping only about 10 per cent of what I shoot – and am considered a 'power user' at Photoshop.

Digital photographers are notorious for having the attitude of 'fix it later in Photoshop'. With film, you had to get the shot perfect in-camera, so photographers were more careful about lighting, contrast control and composition. Many digital photographers are lazy with capture in the field, often preferring to correct their mistakes later in the computer, which eats up more time and money in the end.

Having said that, I use digital capture mainly because the advantages outweigh the disadvantages: I will give up time and money in return for instant feedback and greater creative control and quality.

TONY WOROBIEC

As the overwhelming majority of my work is landscape, where quality really is an issue, I have been a devotee of medium-format photography for more than 20 years and initially doubted that I would ever return to using an SLR. However, in recent years I noticed that the quality of digital SLRs had improved so much that I felt sufficiently curious to buy one. In those years, I had forgotten just how flexible an SLR can be; coupled with an astonishing improvement in quality, I quickly appreciated that this new generation of cameras has a great deal to offer.

The range of lenses available to a medium-format worker is limited, particularly the availability of zooms. Good landscape photography often requires trekking, and the heavier the equipment, the more reluctant I am to carry it. By contrast, digital SLR equipment is lighter and infinitely more flexible. I have restricted myself to just two zoom lenses, but their coverage is easily a match for all the medium-format equipment I used.

I particularly value using zooms again, partly because I do not constantly have to change lenses, but more importantly because I find that using a zoom greatly benefits my composition. It is easy to set off with a predetermined image in your mind, but being able to experiment with a range of focal lengths is truly invaluable.

Another important feature of digital is being able to set the ISO rating image by image. While the vast majority of my photographs are set for ISO 100, being able to shoot 800 or even 1600 at the drop of a hat certainly appeals.

I always shoot RAW and while I have been doing more colour work in recent years, my first love is monochrome. This is another feature of digital SLRs that I greatly appreciate. When shooting film, I needed to make a conscious decision to take a camera loaded with black and white or colour film. In the past I have jettisoned the occasional roll of film in order to change from one to the other.

Unquestionably the biggest advantage I find when shooting digitally is being able to immediately review what I have just taken. If I have any doubts about an exposure, particularly after an arduous trek, being able to bring up the histogram can prove immensely reassuring. Finally, when you return home, being able to download all your images onto your computer really is a boon.

This scene in Weston-super-Mare, England, is a location I have visited on various ⩔ occasions in recent years. I am fascinated by this fabulously ornate Victorian structure, which appears somewhat surreal when set against this featureless seascape. Taken on a winter's evening, the mackerel sky and the overall tonality of this image makes it a particularly suitable subject for monochrome.
Canon EOS 40D, 17–85mm lens, 42 sec at f/16, ISO 100

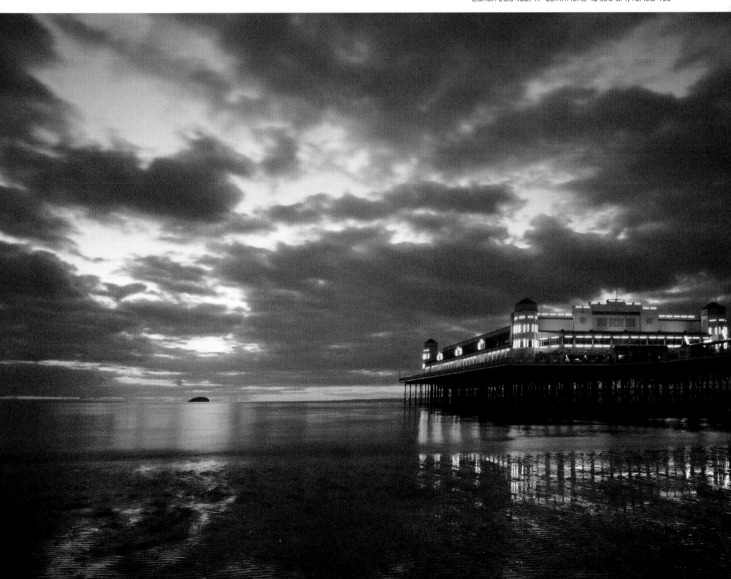

EQUIPMENT

TOM MACKIE

Camera:	Canon EOS 5D
Lenses:	EF 17–40mm; TS-E 24mm 3.5L; EF 24–105mm; 100mm macro; EF 70–200mm f4; Extender EF 1.4x
Tripod:	Manfrotto Neotec
Bag:	Lowepro Orion AW belt pack
Accessories:	Assorted filters from Lee Filters; Canon cable release; FlightLogistics.com sunrise/sunset calculator

My advice would always be to start by investing in a good tripod to mount your camera on. People often put most of their money into the best camera and lenses they can afford, and rightly so, but then they buy a cheap, poor-quality tripod almost as an afterthought. They end up spending more time messing around with the tripod than making pictures, or their tripod and camera are whisked away with the first gust of wind because it's not sturdy enough. I use a Manfrotto Neotec with my DSLR because of the quickness of the self-locking legs. I can set up and start shooting within seconds.

With the ever-increasing travel restrictions on luggage, it's a joy to carry just a small Lowepro Orion AW belt pack with everything I need for my digital system.

One important aspect of digital that was not as much of an issue with medium- and large-format camera systems is the quality of lenses. There seems to be a huge lack of quality control with 35mm lenses to the extent that three identical lenses can return different test results, especially with regards to edge sharpness.

The glass that you place on your camera is one of the most important components in producing high-quality images. If you can, test several lenses when buying and choose the best one.

WILLIAM NEILL

Camera:	Canon EOS-1Ds Mark III
Lenses:	TS-E 24mm 3.5L; EF 50mm 2.5 macro; TS-E 90mm 2.8L; EF 16–35mm 2.8L II; EF 28–135mm 3.5–5.6 IS; EF 70–200mm 2.8L; EF 300mm f/4L; Extender EF 2x; Extension Tube EF25 (2)
Tripod:	Gitzo Series 3 Studex Carbon with Arca-Swiss B1 Monoball head
Bags:	Lowepro Rolling CompuTrekker Plus AW; Super Trekker AW II; Commercial AW
Accessories:	Singh-Ray Vari-ND; LB warming polarizer filters; SanDisk Extreme IV 8GB memory cards

For landscape photography, I use my 70–200mm lenses most often. I love to extract and simplify the key elements, and this lens works very well for that purpose. I also use my tilt and shift lenses a great deal, especially the 90mm one. These lenses give me great control over depth of field and perspective. Sometimes I use my 90mm TS lens with a 2X extender so that I have a focal length of 180mm with great depth-of-field control.

I often use extension tubes on my 50mm macro lens for greater magnification. I have also added extension tubes to my 70–200mm and 90mm TS lens to give me closer focusing distances. Another combination I use is the 70–200mm with the 2X extender so that I have a range of 140–400mm, which is very useful for wildlife photography.

Regarding filters, I use my Vari-ND filter extensively for my 'Impressions of Light' series, where I 'paint with light' by moving the camera during a single exposure.

DAVID NOTON

Camera:	Canon EOS-1Ds Mark II; Canon EOS-1Ds Mark III
Lenses:	Canon EF 16–35mm 2.8; EF 24–70mm 2.8; EF 70–200mm 2.8; TS-E24mm; EF 15mm f/2.8 fisheye; EF 85mm f/1.2; 100–400mm f/4.5–5.6
Tripod:	Manfrotto MF055 plus head
Bags:	Lowepro backpacks
Accessories:	Assorted filters from Lee Filters; Sekonic L-408 meter; Lee Filters lens hood; SanDisk Extreme 1V 4GB memory cards

I believe that the importance of equipment in photography is often overestimated. Many people are more interested in the gear and technology than the actual images. However, the tools are important.

I've used and owned many cameras of all formats over the years. I still use my big 6x17cm panoramic film camera; as yet there's no digital alternative for that, apart from image stitching, which is fine if nothing is moving in the frame along the join (which there often is). However, the 35mm Nikons I used for years have been replaced with digital Canons.

I defected from Nikon to Canon because of the issue of full-frame sensor size, which is especially important with wide-angle lenses and my much-loved 15mm fisheye. Now I have an extensive system built around Canon EOS-1Ds Mark II and Mark III bodies, with lenses ranging from 15mm to 400mm.

The resolution of the camera sensor is so good that it demands great attention to detail. Camera shake, inaccurate focusing and poor technique will all be exposed mercilessly. This also means that I have to use the very best optics that Canon produces. I used to use prime lenses, but now find that fast zooms give me more flexibility and I don't have to spend so much time changing lenses.

Glastonbury Tor appearing above the mist lying on the Somerset Wetlands ≫
at dawn, Somerset, England.
Canon EOS-1Ds Mark II, 24-70mm lens, 1/6sec at f/16, ISO 100

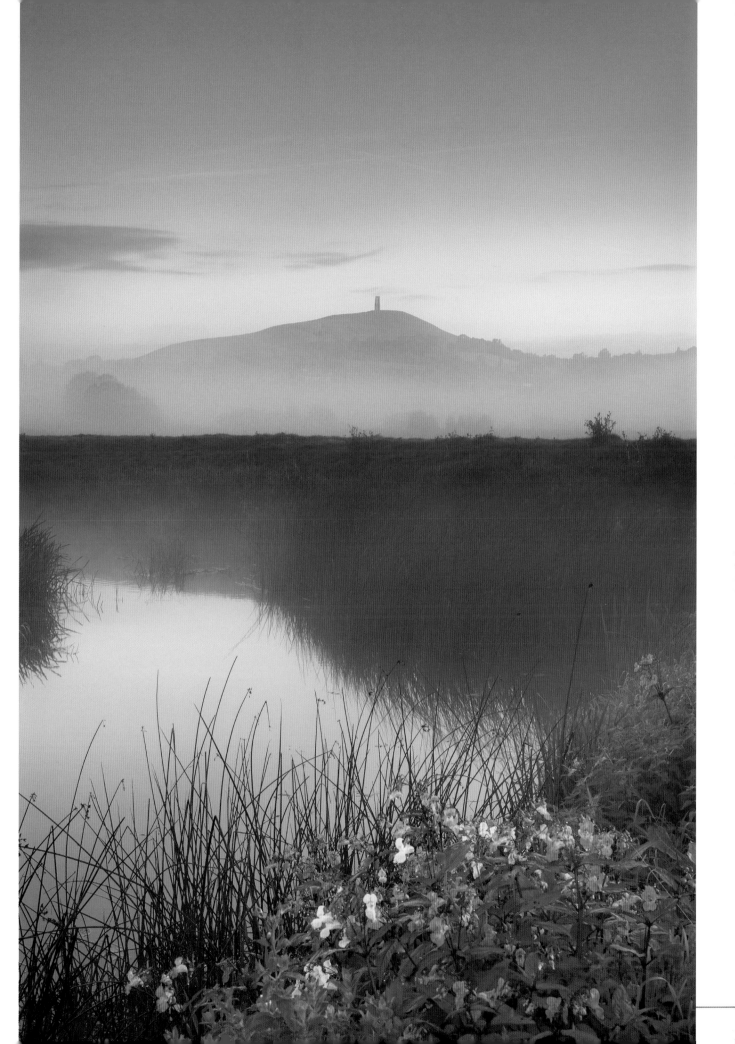

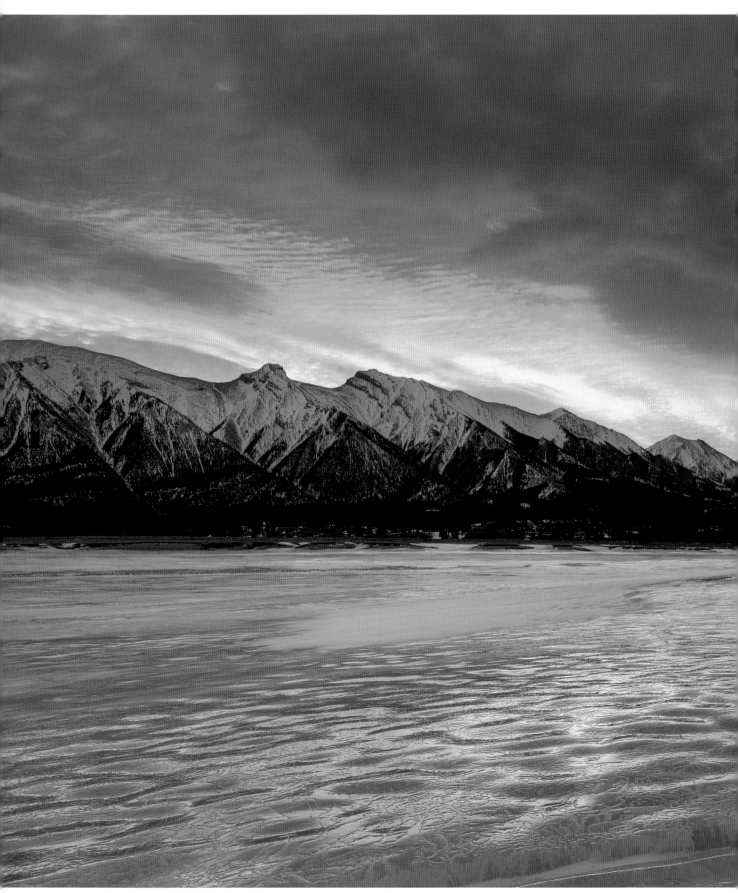

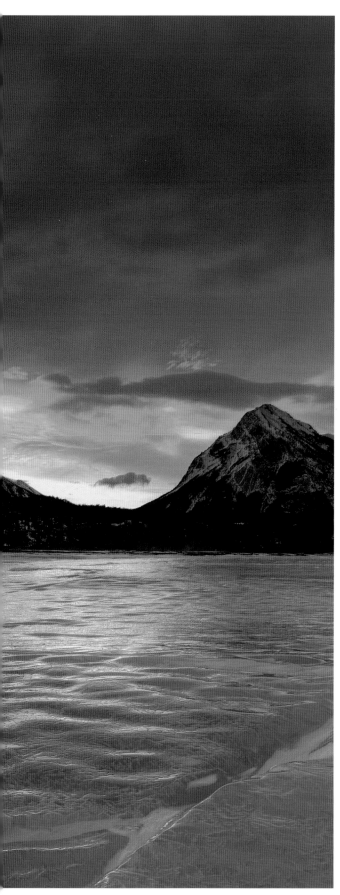

DARWIN WIGGETT

Camera:	Canon EOS-1Ds Mark III
Lenses:	Canon 24mm; TS-E 45mm; TS-E 90mm; 70–200mm; f/4 300mm
Tripod	Slik Professional 4 with Really Right Stuff BH-55 ball head
Bag:	I carry everything in a photo vest/backpack harness system that allows quick access to my lenses and filters
Accessories:	Set of 12 Singh-Ray neutral density graduated filters (1, 2, 3 and 4-stop in hard-edge, soft-edge and reverse versions); Singh-Ray LB polarizer; Gold-n-Blue polarizer; 5-stop solid neutral density filters; Cokin P-series holder permanently attached to each lens for quick filter changes

The equipment I use is often dictated by the subject matter or by my current vision in the photographic process. I want tools that give me the best optical sharpness, flexibility and creative options. I try to use a camera that offers portability and quick response time with the best quality available. Currently for me that camera is the Canon EOS-1Ds Mark III (a 21MP DSLR). My clients want big files of high quality. This camera gives me the equivalent of medium- or large-format film with the advantages of 35mm responsiveness.

Prime lenses, especially prime wide-angle lenses, give me better results than wide-angle zooms. First, the distortion of wide-angle zooms is often greater, with banana-shaped horizons and converging lines. These distortions are much reduced in prime wide-angle lenses. Second, the sharpness is lower with a wide-angle zoom, especially on the edges of the frame. Third, zooms flare more in backlit scenes (there is more glass to bounce light around and reflect in the lens). Fourth, many zooms often don't focus as close as primes (this is especially important in wide-angle work for getting a close foreground). And finally, wide-angle zooms tend to vignette with filter holders and filters, whereas primes are less likely to do so. And I use filters a lot! For all these reasons, I only use prime wide-angle lenses.

In the telephoto department, zoom lenses perform as well as primes, especially in the 70– or 80–200mm range. But there are disadvantages to super telephoto zooms, as the long ends of the zooms are really soft compared to a prime lens of the same focal length.

My landscape kit has five lenses. The tilt and shift lenses are specialist lenses that give me great advantages for landscape photography. They give me movements like a view camera that are useful, not only to correct converging lines, but also to give me incredible depth of field. The 70–200mm is a sharp, solid performing zoom, while the 300mm prime is my extractive landscape lens and is very sharp.

≪ **Winter ice on Abraham Lake, Kootenay Plains, Alberta, Canada. A Singh-Ray 2-stop hard-edge graduated filter over the sky allowed me to have a properly exposed foreground.**
Canon EOS-1Ds Mark II, 45mm TSE lens, 1/8 sec at f/16, ISO 100

TONY WOROBIEC

Camera:	Canon EOS 5D; Canon EOS 40D
Lenses:	EFS 14–85mm; 24–105L; 17–40mm
Tripod:	Gitzo 212
Bag:	Lowepro Photo Trekker Classic
Accessories:	Assorted filters from Lee Filters; Sekonic Flashmate meter

I have two camera bodies, which was not very well planned as I require different lenses for each of the bodies. I use the 40D for low-light photography, as it is better equipped for this. I use an EFS 14–85mm lens with the 40D and either a 24–105L lens or a 17–40mm zoom lens with the EOS 5D. I find their sheer flexibility invaluable, and while some people decry the quality of zooms over prime lenses, you really need to look hard to see a difference.

Second to my camera and lenses is my tripod; I use a Gitzo 212 with a ball and socket head. As I almost always use a low ISO rating and rarely photograph in full light, my tripod is in constant use. Not only does it allow me to select any aperture I wish, but I find it far easier to compose landscape images once the camera is fixed to the tripod. Some might argue that I should use a heavier tripod, but this could become an excuse not to carry it around. Moreover, as I do a great deal of travelling, it will (at a pinch) pack into my suitcase.

It is perhaps a reflection of how I worked in the past, but I find it hard to use the camera's very sophisticated metering system, preferring instead to use a handheld meter. As my camera is usually locked onto a tripod, making the light readings I require is not always that easy. In tricky lighting conditions, having the option of taking an incident or a reflected light reading is priceless. I use a Sekonic Flashmate for this. Finally, while I find that shooting digitally I need far fewer filters, I still greatly value my Lee system, particularly the neutral density and the soft graduated filters, which I often use to balance out the sky and foreground.

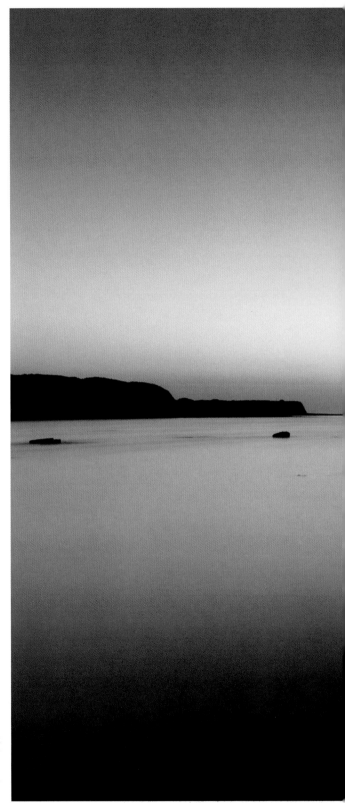

In addition to my camera, the two pieces of equipment I most value are my ≫ tripod and light meter, both of course invaluable when photographing landscape in low light. I generally use a Gitzo 212, which some might see as 'light-weight'; I also own a Benbo, but I must confess that I am reluctant to use it when a long trek is required. Despite the sophistication of the camera's metering system I continue to use a hand-held lightmeter because it allows me to make quick incident or reflected light readings off camera.

Canon EOS 5D, 17–40mm lens, 8 mins at f16, ISO 100

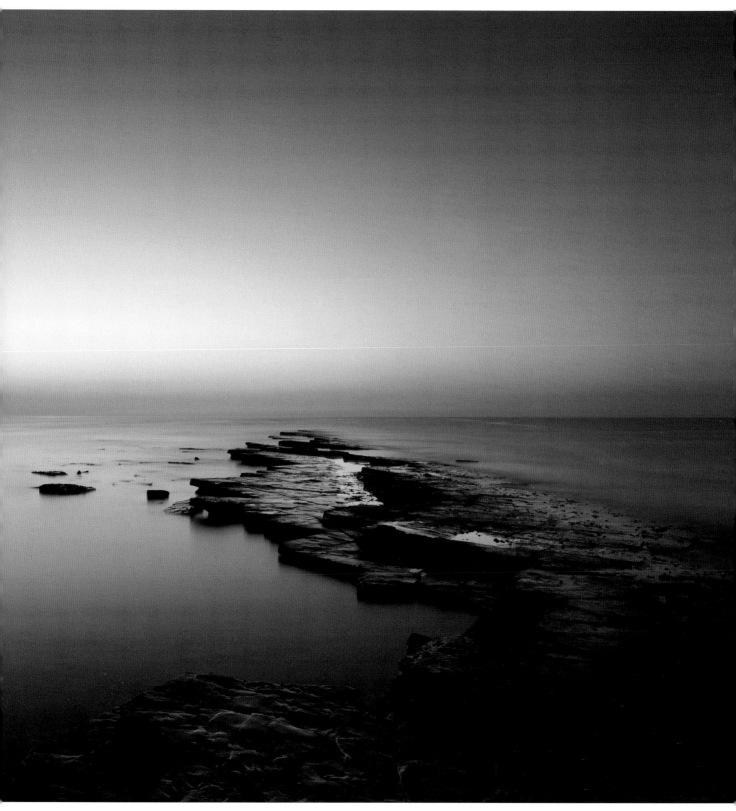

CHAPTER 1: CONTROLLING EXPOSURE
Darwin Wiggett

Photography is literally 'painting with light'. We use light to capture our subjects, and one of the most important things we need to learn to be successful at photography is that a camera records light differently from the human eye. In this chapter we look at the best way to record light with digital SLRs: which exposure settings will make the scene look the way we want; how to get the right exposure every time; and, finally, how to tame contrast in outdoor scenes to create an image that is true to the eye.

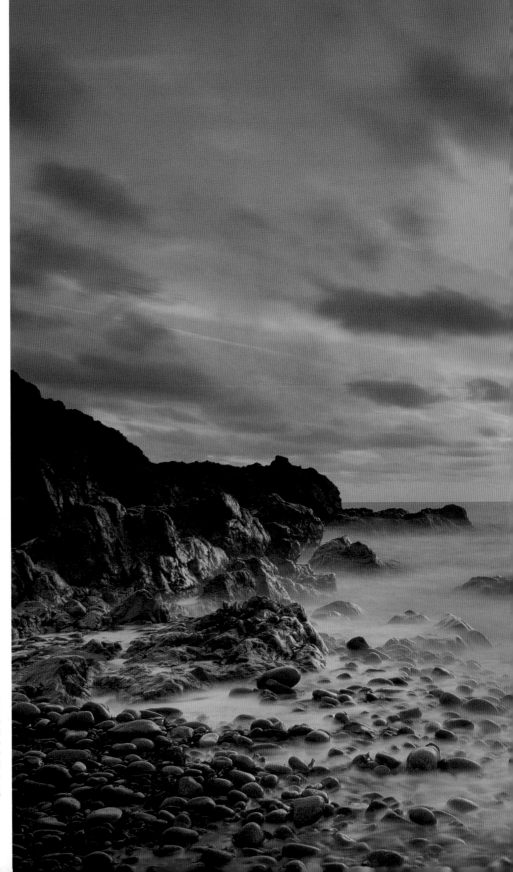

For this sunset at Corney Brook, Cape≫ Breton Highlands National Park, Nova Scotia, I used a Singh-Ray 3-stop hard-edge grad over the sky to hold back the fiery light from burning out. I also used a 5-stop solid neutral graduated filter to lengthen the exposure time to give me more build-up of colour in the scene and to turn the big surf into an ethereal mist.
Canon EOS-1Ds Mark II, 45mm lens, 1 minute at f/13, ISO 100

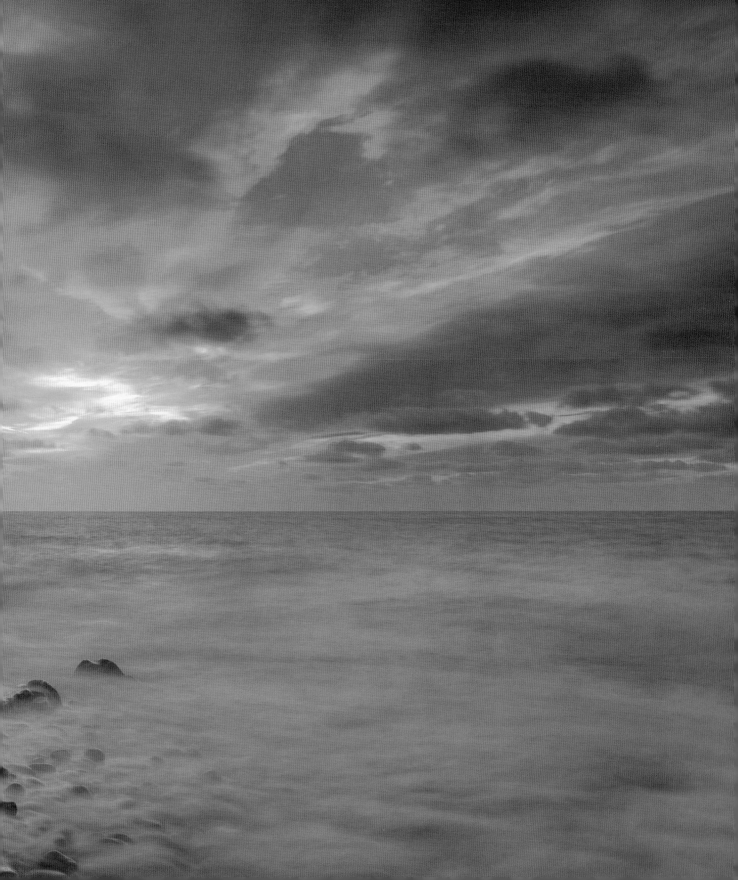

THE RAW ADVANTAGE

Anyone who uses a digital SLR is aware that images can be recorded as JPEG or RAW files. A RAW file is the untouched, unmanipulated pixel information captured on the imaging sensor. This is the equivalent of a digital negative. It needs to be processed using RAW-conversion software, a procedure that allows the photographer to 'develop' the image as he or she sees fit. A JPEG file, on the other hand, is a manipulated pixel information file that has been processed according to specifications built into the camera. The result is a 'finished' image created in-camera with algorithms designed by the camera manufacturer. In-camera JPEG conversion is the equivalent of taking your negatives to a one-hour lab for processing and printing, where you hand over all creative control to the lab technician.

WHY USE RAW?

For me, the answer is simple: control. I control what I photograph and how I capture the image in the field. Why would I hand over processing of my images to an algorithm built into a camera? By shooting in RAW I can take the digital negative and manipulate it in the digital darkroom for an end result that matches what I saw in my mind's eye. How would a camera know what I want my pictures to look like?

But wait a minute...can't you take an in-camera JPEG capture and run it through the digital darkroom to achieve the same end result, a personalized interpretation of the scene? The answer is yes, but you will make huge sacrifices in the quality of your final image. To create a JPEG file from the image sensor, the camera has to run the pixel information through several developmental steps, each of which reduces, degrades and compresses the information initially captured by the sensor. Camera manufacturers have had to make efficient and simple algorithms that work with the camera's processor to give us acceptable results in an instant press of the shutter button.

Developing a RAW image in RAW-conversion software requires similar processing steps to that done in-camera, but the software and our home computers have much better capabilities than that found in cameras. The choices we make during RAW conversion can help us preserve even more image data, for instance by using wide gamut colour modes or high bit in our images (see page 21). In RAW conversion you must also decide about colour balance, saturation, contrast, sharpening and the tonal values in your picture to give you a result that is really personal.

In short, using RAW image capture means you have control of the final look and quality of your photos. The downside with shooting RAW means much more time behind the computer; RAW capture requires that the photographer understands and correctly uses RAW-conversion software. If you like control and want the best images possible from your camera then use RAW, but if you want convenience and less time in front of the computer, opt for JPEG.

**I shot this at Lake Minnewanka, Banff National Park, Alberta, ≫
Canada, using RAW capture, developing it in the computer to
achieve the best file possible.**
Canon EOS-1Ds Mark II, 20mm lens, 1/4 sec at f/22, ISO 100

⌃ These images were captured using a point-and-shoot digital camera that offers both RAW and JPEG modes. The in-camera JPEG (left) looks snappy and acceptable, but it lacks the detail and quality of the RAW capture that was processed in RAW-conversion software (right). Specifically, the RAW image has more tonal detail because of a higher bit-depth used for processing. In the RAW file there are no washed-out highlights or overly dark shadows like we see in the JPEG capture. The RAW image also has less noise (graininess) in the shadows and better overall colour.
Left: Canon G9, 7.4mm lens, 1/50 sec at f/4, in-camera JPEG
Right: Canon G9, 7.4mm lens, 1/50 sec at f/4, RAW capture processed with Adobe Camera RAW version 4.2

BIT-DEPTH

Without going into a technical treatise on what bits are and how computers save colours numerically, let's just cut to the important facts. The most common bit-depth used in digital cameras is 8-bit. All that means is that each pixel on the sensor is capable of capturing 256 intensity values, or shades of black to white, for each of the three primary colours (red, green and blue). Many digital cameras can actually capture in 12- or 14-bit mode, where each pixel site can record 4,096 or 16,384 intensity values respectively.

The higher the bit-depth, the more possible colour and tonal information there is in the file, and the more you can manipulate the data without degrading it. Making alterations to the tonal range of an image with 256 values per pixel will have a greater proportional effect on each pixel than if you made alterations to an image with 14 bits of information. A strong edit using Curves in Photoshop can cause an 8-bit file to degrade and show 'banding' and colour issues, whereas the same edit of a higher-bit file will remain smooth in tonality.

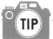
TIP

❝ Cameras toss out most of the high-bit data captured in the camera to create an 8-bit JPEG (JPEGS don't support 16-bit mode). Even though you paid for a camera that is capable of capturing in 12-, 14- or even 16-bit, when you shoot JPEGS you are just throwing away all that image information! Shooting in RAW lets you have the option of keeping all the information that your camera can capture. ❞

Darwin Wiggett

21

COLOUR SPACES

There are three commonly used colour spaces in photography, and the one you decide on depends on your end use of the photos.

sRGB

If you plan just to display your photos on websites and make small prints, then sRGB colour space (the default colour space for in-camera JPEGs) will work fine. This colour space was developed to match the typical colours available on a computer monitor and is considered the 'universal colour space' for computer graphics. It has the narrowest range of reproducible colours.

Adobe RGB

This space was designed to offer the full range of colours available in offset printing. If you plan to have your pictures published in books, magazines or on billboards, this is the colour space to use. It also works well for inkjet photo printers. Adobe RGB has a wider gamut than sRGB and, when combined with high-bit capture, gives exceptional image capture. The majority of advanced and professional photographers use this colour space.

Pro Photo RGB

Developed by Kodak, this colour space is designed to offer the widest range of colours possible. Many output devices like printers and monitors can't display all the colours in this space, but it does give the photographer the greatest amount of information possible for the future, when more devices will be compatible with it. Pro Photo RGB colour space must be used in conjunction with high bit-depth for the ultimate in file information. Many photographers use this colour space to capture and archive their images and then make copies of them in other colour spaces to use in printing or on the web.

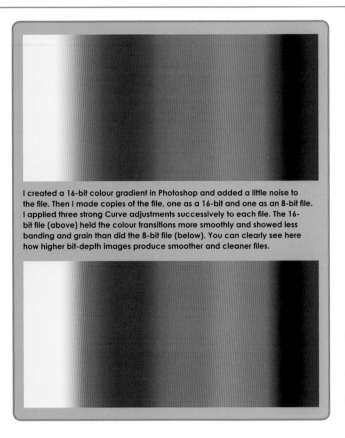

I created a 16-bit colour gradient in Photoshop and added a little noise to the file. Then I made copies of the file, one as a 16-bit and one as an 8-bit file. I applied three strong Curve adjustments successively to each file. The 16-bit file (above) held the colour transitions more smoothly and showed less banding and grain than did the 8-bit file (below). You can clearly see here how higher bit-depth images produce smoother and cleaner files.

ARCHIVING RAW FILES

One of the benefits in shooting RAW is that the original file can be processed over and over again without affecting the original information. This means that, as your skill in the digital darkroom improves, you can return to your digital negatives and reprocess them to create better results. Also, as RAW-conversion software continues to improve, you can reprocess RAW files to take advantage of newer technology.

This means that you need to archive your RAW images so they are easy to find in the future. I number my photos numerically and pair the final finished image with its RAW negative (so DW1092 is paired with DW1092RAW). The final image has embedded keywords; a quick search for the pertinent keyword brings up the pictures I want, including the paired RAW files. My RAW and finished images are stored in three places: on my large external hard drive in my office; on a back-up server hard drive, off-location; and on archived DVDs.

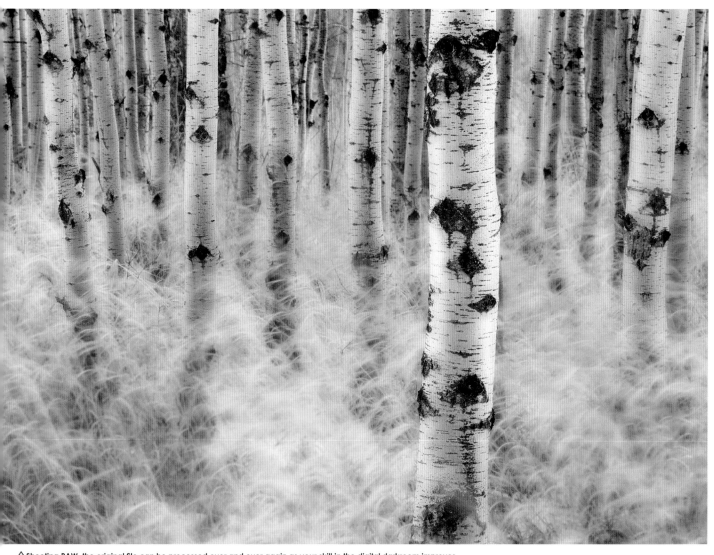

⋀ Shooting RAW, the original file can be processed over and over again as your skill in the digital darkroom improves, or to take advantage of new RAW-conversion software.
Canon EOS-1DS Mark 111, TS-E 90mm lens, 1/104 sec at f/18, ISO 100

I used RAW capture, processed the ≫
RAW image in 16-bit and used Adobe
1998 Color Space to get a file full of great
information in every part of the image.
*Canon EOS-1DS Mark 11, 24mm lens, 1/2
sec at f/11, ISO 100*

≪ For this agricultural scene in South
Eastern Alberta, Canada,
I stitched two photos together in
Photoshop to make a panoramic
image.
*Canon EOS-1Ds Mark II, 24mm lens,
1/30 sec at f/14, ISO 100*

Darwin Wiggett

APERTURE CHOICE AND THE WO-M-EN CONCEPT

When shooting landscapes, how do I decide which aperture is most appropriate? Well, I simply think about WOMEN. No, really … do the same and it will help you to choose the correct aperture every time. Here is how it works:

WO wide open (the widest aperture setting on your lens – e.g. f/2.8 or f/4).
M the middle aperture on your lens (e.g. f/8 or f/11).
EN the end or final aperture on your lens (e.g. f/22 or f/32).

Get your camera and set it to aperture priority. Pick f/4 and look through the lens, then pick f/8, and then f/22. No matter what aperture you choose, the view through the lens will look the same. Why doesn't the scene change when you choose different apertures? The reason is that the camera and lens do not physically switch to your chosen aperture setting until the moment the shutter is released. Since you can't see the effect of aperture changes in-camera (unless you have a depth-of-field preview button on your camera), you need a basic guideline on what apertures to use and when.

WIDE OPEN SETTINGS (WO)

If you like the way the scene appears when you look through your viewfinder, then just set your lens to the widest aperture: what you see in your viewfinder is what you will get as the final image. For example, in the photo of the bench (right), I liked all the out-of-focus foliage I saw in the viewfinder when looking through my lens zoomed to 200mm. I just wanted the bench in focus and used a wide aperture (f/2.8) to keep everything else blurred.

> 66 Almost every digital SLR has the ability to review images in a magnified form. I often look at images on my LCD at 100 per cent magnification to check sharpness in all parts of the picture. This way I can quickly see if the aperture and focus point I have chosen is appropriate to render the entire picture sharp from edge to edge. Check your camera manual for instructions on how to look at your images at high magnifications on your LCD. 99

TIP

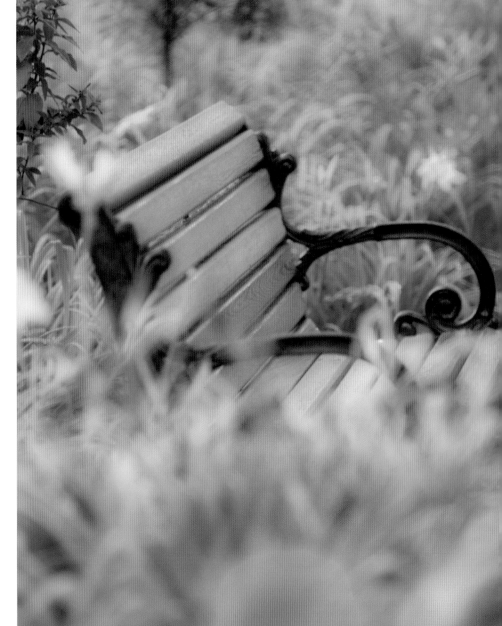

Using a focal length of 200mm I liked the ≫ blurred foliage I saw in the viewfinder and so used a wide aperture of f/2.8 (WO) to keep only the bench sharp.
Canon EOS-1Ds Mark II, 70–200mm lens, 1/30 sec at f/2.8, ISO 100

MIDDLE SETTINGS (M)

You should use the middle apertures (M) such as f/8 or f/11 when you are shooting scenes that are two-dimensional and have a single plane of focus, or with scenes that are distant, where your lens is focused at infinity. Most lenses are technically the sharpest (giving the finest resolution and detail) at f/8 or f/11, and when depth of field (the amount of the scene in apparent focus) is not a consideration you should always use the sharpest aperture setting possible.

END SETTINGS (EN)

Use your end (EN) apertures (f/22 or f/32) whenever you have a scene where you want as much as possible in focus. Often when you look through your lens, you will only be able to focus on one spot in the scene and the rest of it is blurry. But maybe what you want in the final photo is as much of the scene as possible to be in focus. The way you achieve that goal is to set your lens to the end aperture and then manually set your focus one-third of the way into the frame. The result will be the most depth of field that your lens can give you.

This image of leaves frozen in ice is an ≫ example of a subject that is in one plane of focus and would best be shot using a middle aperture (M) of f/8 or f/11.
Canon EOS-1Ds Mark II, Canon EF45mm TSE lens, 1/4 sec at f/8, ISO 100

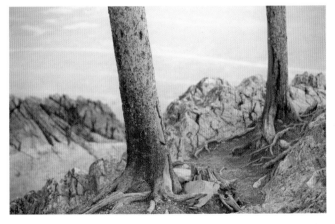 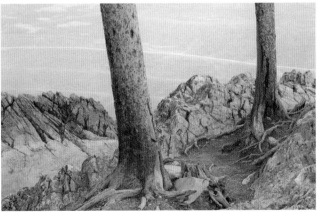

⋀ When you want as much of the scene as possible to be in focus, use your end (EN) aperture and manually focus one-third of the way into the frame. Compare the photo on the left, shot wide open at f/2.8, with the one on the right, shot at the end aperture of f/22.
Canon EOS-1Ds Mark II, Canon EF 70–200mm f2.8L lens at 70mm, ISO 100

Deciding which aperture to use is easy: do you like the scene as you see it in the viewfinder? If so, use wide open (WO). Are you shooting a distant, infinite-focus scene or a scene where the plane of focus is flat? If so, use f/8 or f/11 (the middle apertures – M). Do you want the whole scene in focus from front to back with maximum depth of field? Use the end (EN) apertures (e.g. f/22) and focus one-third into the scene. It really is that simple. Aperture choice should never be a problem for you again!

THE MODIFIED WO-M-EN RULE

Well… ok, maybe aperture choice is a little bit more complicated than the WO-M-EN concept.

Sharpness in a lens is best at middle apertures (f/8 or f/11), but smaller apertures give us a perception of more of the scene in focus (greater depth of field). This means that many people think that f/22 is the 'sharpest' aperture – but it is not. In fact, f/22 is most often the aperture that gives us the worst performance in terms of optical sharpness. I test each lens I own to determine where resolution starts to fall off significantly; generally anything beyond f/16 is no longer acceptable for me. Many professional photographers who demand the best optical performance from their lenses will not use the smallest aperture (f/22), but instead use f/16, which is a good compromise between great depth of field and good optical sharpness. The same holds true for wide-open apertures (f/2.8). Optical sharpness is lower with the widest aperture, but is increased by stopping down one stop from wide open, still leaving a very shallow depth of field (f/4).

So what does all this mean in a practical sense? The chart below summarizes the information.

If you want to find the easiest formula for aperture choice, just remember the WO-M-EN rule. But if you want to achieve the best optical performance possible, combined with aperture effects, then apply the modified WO-M-EN rule: remember to stop down one aperture from wide open for WO apertures, and to open up one aperture from closed down for the EN apertures.

PURPOSE OF APERTURE	APERTURE TO USE FOR GREATEST EFFECT	APERTURE TO USE FOR EFFECT BUT WITH OPTIMAL SHARPNESS
Shallow depth of field or 'WO' apertures	f/2.8 (or widest aperture on lens)	f/4 (or one stop closed down from the widest aperture)
Best sharpness or 'M' apertures	f/8 or f/11	f/8 or f/11
Greatest depth of field or 'EN' apertures	f/22 (or smallest aperture on lens)	f/16 (or one stop open from smallest aperture)

∨ To get this fence and distant lighthouse all in focus, I used the modified WO-M-EN guideline. I focused my lens one-third of the way down the fence and then stopped my lens down to f/16 for good depth of field combined with good resolution.
Canon EOS-1Ds Mark II, 300mm lens, 1/4 sec at f/8, ISO 200

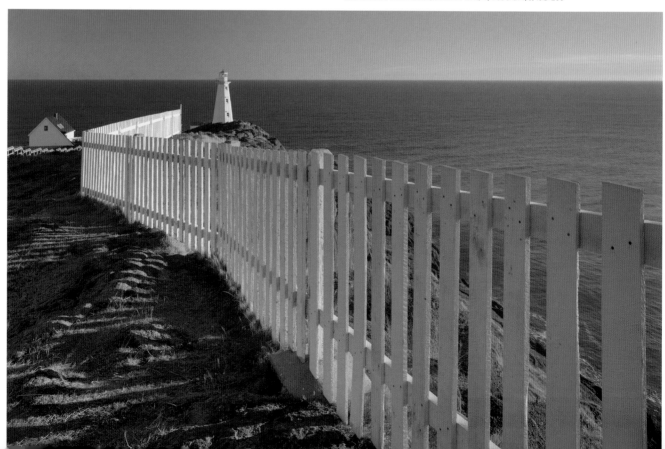

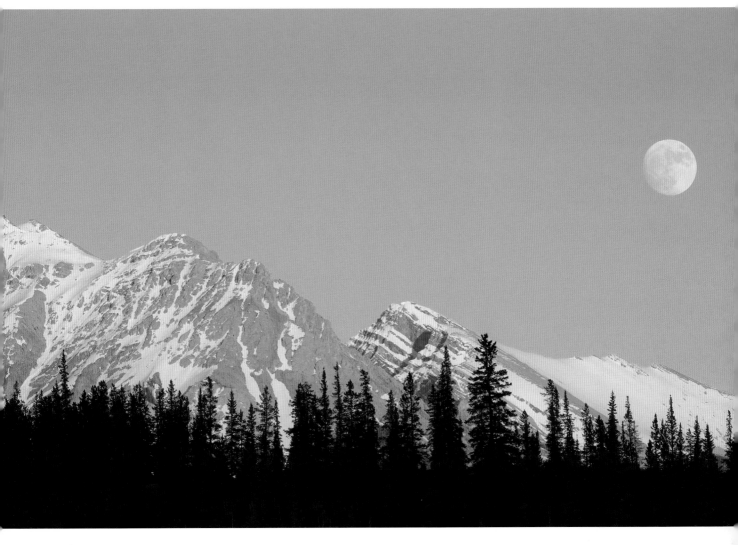

⌃ **Because this was a distant scene and my lens was focused at infinity, I did not need to worry about depth of field. Therefore, I picked the sharpest aperture on my 300mm lens, which, according to tests I have carried out, is f/8.**
Canon EOS-1Ds Mark II, 300mm lens, 1/4 sec at f/8, ISO 200

TILT AND SHIFT LENSES

In a perfect world, you would always use the sharpest aperture on your lens (for example, f/8 or f/11) and control depth of field independently of aperture choice. In fact, this control is one of the great benefits of view cameras – those big wooden cameras with accordion-like bellows used by legendary landscape photographer Ansel Adams (1902–1984). These cameras allow you to alter the plane of focus for the lens or film back so that the film plane is parallel to the subject plane. This means that minimal depth of field is required so you can shoot the scene as you would a flat surface, using f/8 or f/11.

Digital SLRs do not have this capability unless they are fitted with specialist lenses that can tilt independently of the camera. Several camera and lens manufacturers make such tilt lenses for DSLRs, and

these are great for landscape photographers who are looking for the ultimate in control of depth of field. Be aware that these lenses are not offered in autofocus or zoom configuration and so are not really useful for general photography. Imagine always having the entire scene in focus but being free to use any aperture. For example, you could use a wider aperture to give a faster shutter speed to stop movement of vegetation in wind, or use a smaller aperture to give a slower shutter speed to emphasize flowing water. In either case, you could retain precisely the depth of field you want.

Tilt capabilities are so important to me that I rarely use regular lenses in my landscape photography any more; I rely on Canon's complete line of TSE lenses in focal lengths of 24, 45 and 90mm to give me maximum flexibility over depth of field.

Darwin Wiggett

27

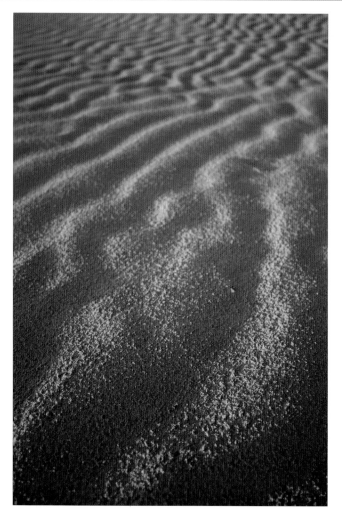 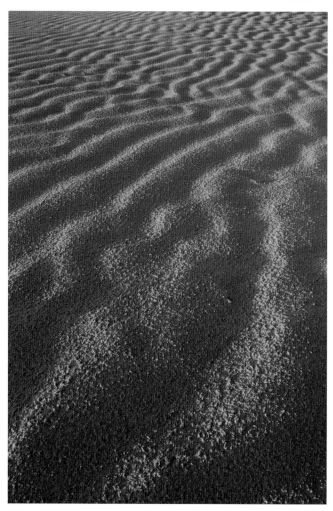

⌃ To see just how much depth of field can be gained by using special tilt lenses, compare these two photos of sand ripples. On the left, I used a wide aperture setting of f/3.5; the result is a shallow depth of field commonly seen with wide apertures. On the right, I used the same aperture setting but simply tilted the lens until the entire scene popped into sharp focus. The result is infinite focus but with a wide aperture – incredible!

DEPTH-OF-FIELD PREVIEW

Most digital SLRs have a depth-of-field preview button. This feature allows you to view the scene through your viewfinder at the aperture you have chosen. In theory, you should be able to tell exactly how much of the scene is in focus using this feature. In practice, things are not that easy. The smaller the aperture you pick, the darker the view through the viewfinder when using the depth-of-field preview. Often it is so dark in the viewfinder that you can barely see the scene, let alone tell how much is in focus.

I rarely use the depth-of-field preview any more. Instead, I manually focus my lens one-third of the way into the scene, use a small aperture setting like f/16, and take the photo. I then bring up the image on my LCD and magnify the photo to check for sharpness from foreground to background or on my main subject. If adjustments to the point of focus or to the aperture are necessary, I can make corrections and take another image. I find this method more accurate than using the depth-of-field preview.

LIVE PREVIEW

The latest DSLRs offer 'live preview', a feature that allows you to see the actual scene from your camera sensor in real time with the aperture setting that you have chosen. You can use the magnification feature on your LCD to check precise focus and depth of field across the scene and make adjustments before even taking the photo – which is very useful. Just be aware that using this feature can eat into the life of your camera battery significantly.

Lake Abraham in Alberta, Canada. ≫
For maximum depth of field, set your lens to
f/22 and manually focus one-third of the way
into the scene.
Canon EOS-1Ds Mark II, 24mm lens, 1/4 sec
at f/22, ISO 100

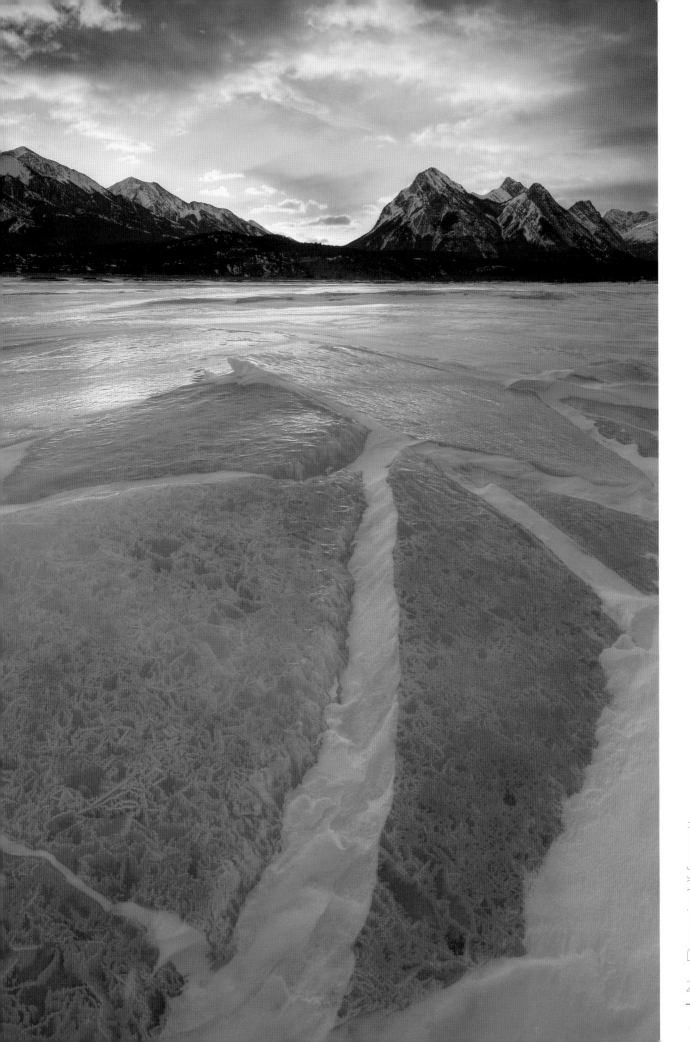

USING THE HISTOGRAM

One of the greatest technical hurdles photographers had to overcome with film cameras was in determining proper exposure. Much time was spent discussing things like grey cards, the sunny f/16 rule, incident light meters and spot metering. With digital cameras, we require a whole new way of thinking about exposure, and this involves new techniques and new tools.

HOW DIGITAL SENSORS RECORD LIGHT

Most digital cameras' sensors can record about six stops of dynamic range from pure black to pure white. In 12-bit mode this means that there are 4,096 levels of brightness (remember that 8-bit mode records only 256 levels of brightness, which is why it's better to work with high-bit files). The darkest tone that a sensor can record has a value of 0, while the lightest zone has a value of 4,096. All other tones are distributed between these two extremes. Because digital sensors record data in a linear fashion, the distribution of the levels of brightness is uneven over the dynamic range of the sensor. For example, the first stop of highlight data contains half of all the brightness levels in the image, and the next stop contains half of the remaining levels of brightness, and so on.

The illustration below shows the tonal information on a sensor divided into six stops of dynamic range. Here we can see that 75 per cent of the levels of brightness that an image holds are within the first two stops. The last four stops of dynamic range contain only 25 per cent of the brightness levels!

So what does this mean in a practical sense? In short, with digital SLRs we should bias exposure to the highlights whenever possible so that we get the most information available from the sensor. How do we do that? We use the camera's histogram to help us fine-tune our exposures to give us the best files possible.

WHAT IS A HISTOGRAM?

We all know and rely on the LCD display of a digital camera so we can review the photos captured. Many photographers also use the LCD to determine whether their photo is properly exposed. If the photo looks good on the LCD, they assume it is exposed correctly. Nothing could be further from the truth! The real tool we should be using to help us determine correct exposure is the histogram option on the LCD. All digital SLRs allow us to review photos on the LCD with the histogram option turned on.

Essentially, the histogram is just a graph displaying the distribution of pixel tones from dark to light in our photos. On the X-axis is the level of brightness and on the Y-axis is the number of pixels falling into each level of brightness. The range of brightness levels where pixels are distributed is called the tonal range.

The shape of the histogram will vary depending on the visual content of the image. We don't really care about the shape of the histogram; what we care about is the distribution of tones. In a perfect world, we want more of the tones to be towards the right side of the histogram (the highlights) but without going over (clipping). If the pixel tones spill over either the right or left side of the histogram, the image will have tones that are not captured by the sensor and thus can't provide us with image information.

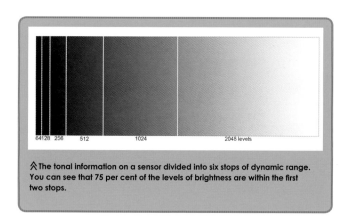

⌃ **The tonal information on a sensor divided into six stops of dynamic range. You can see that 75 per cent of the levels of brightness are within the first two stops.**

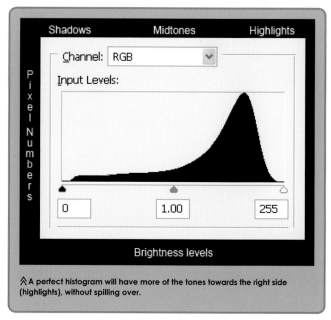

⌃ **A perfect histogram will have more of the tones towards the right side (highlights), without spilling over.**

ONE

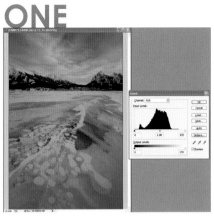

≪ This is the initial capture I made, using the camera in aperture priority mode. The histogram was too far to the left, revealing that it was underexposed.

TWO

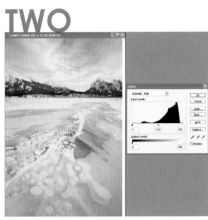

≪ For the second photo, I used aperture priority again, but dialled in +1 exposure compensation. It now looks washed-out, but that is of no concern because it has a great histogram and I can make the image look as good as it should do in RAW conversion and with adjustments in Photoshop.

THREE

≪ The final processed image of Abraham Lake, Alberta, Canada, created from the second photo that had the perfect histogram.
Canon EOS-1Ds Mark II, 24mm lens, 3.2 sec at f/11, ISO 100

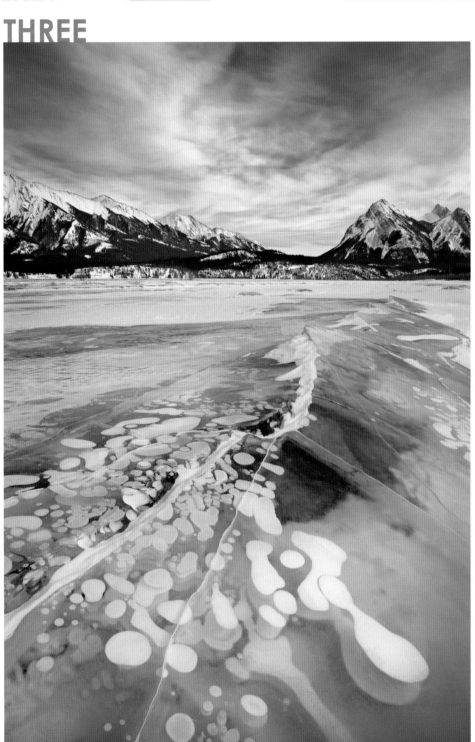

Darwin Wiggett

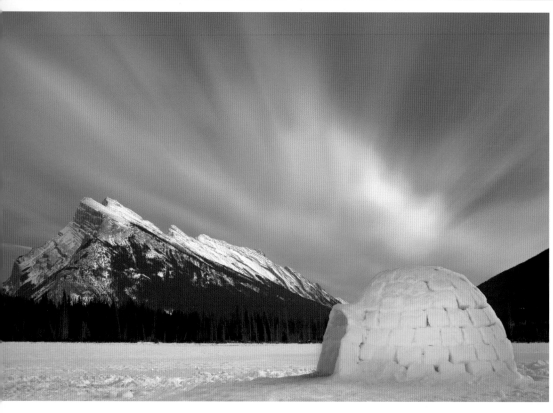

≪ **Igloo at Vermilion Lake, Banff National Park Alberta. To control the contrast in the scene, I used a 5-stop solid neutral density filter, which necessitated a long exposure of four minutes. The igloo was lit with a small flashlight.**
Canon EOS-1Ds Mark III, 45mm lens, 4 min at f/6.3, ISO 100

THE HISTOGRAM AS AN EXPOSURE TOOL

Let's look at a real-life example. In photo 1 (opposite), I took an image of a sunrise. The photo on the back of my LCD looked great, but the histogram information told me that the shadows were clipped and contained no information. I then re-exposed the scene so the histogram was biased to the right, meaning that I had details in both shadows and highlights. The resulting photo on my LCD looked washed-out and colourless, but the histogram looked great (photo 2).

When I converted both RAW files into finished images, the underexposed one had less shadow detail and much more digital noise because I was working with the lower end of the sensor range where there are fewer brightness levels to manipulate (photo 3). On the other hand, the overexposed-looking photo, which is actually properly exposed, is full of tonal information and creates a beautiful file once processed correctly (photo 4). The key here is not to judge exposure based on how your photos look on the LCD but instead to look at the histogram and make exposure adjustments until you get the best histogram possible – that is, expose for the right (EFTR), but without clipping important highlights.

THE EXPOSURE WORKFLOW

• In the field, use aperture priority and pick the aperture that you want for the depth of field you desire. Let the camera automatically pick the shutter speed.

• Take a photograph of the scene and then check your histogram. Look for a histogram biased as far to the right as you can get it without going over (EFTR).

• If you need to make a different exposure, set your exposure compensation dial to add in more or less exposure as the situation dictates. You can do this in increments of one stop (+1, +2, + 3 and so on). Check your histogram again and, once you are satisfied that you have the best exposure possible, take the picture and move on to the next composition.

THE FLASHING BLINKIES

Many digital SLR cameras have a feature where you can turn on a highlight alert to warn you of overexposed highlights. Generally the highlight areas will flash with greyed-out 'blinkies'. A lot of photographers find this feature helpful and they will adjust the exposure of the photo until the blinkies go away.

Be careful not to get trapped by those flashing pixels, though. Often, by reducing exposure to retain highlight detail, the photo will darken so much that most of the histogram is to the far left and the quality of the whole image suffers.

Many times the blinking highlights can simply be ignored because they represent areas such as bright specular highlights that we would not expect to see detail in anyway – features such as sparkles on water, glint on metal, highlights in eyes, or the sheen of ice. If the highlights are just bright spots to our eyes, they should remain that way in our camera files. So yes, the highlight warnings can be useful, but don't get too focused on eliminating them. It's better to look at your histogram to judge exposure than on flashing LCDs!

TIP

" Always ignore how the photo's exposure looks on your LCD (that is, whether it appears too light or dark). Instead, concentrate on getting a good histogram, weighted to the right whenever possible. The histogram should have no clipping of either important highlight or shadow detail. If the histogram has clipping in both the shadows and the highlights simultaneously, bring in the contrast control measures discussed in the following pages. "

ONE

≪ The image looks great on the camera LCD, but has a histogram that is skewed to the left (underexposed) and has no shadow detail.

THREE

≪ A detailed crop of the finished image created from the underexposed image, photo 1. Note the lack of shadow detail and the increase in noise compared with photo 4.

TWO

≪ The image looks overexposed on the LCD, but the histogram is exposed properly and biased to the right, with no loss of detail in either the shadows or the highlights.

FOUR

≪ A detailed crop of the finished image created from the properly exposed image, photo 2 (left). Notice the detail in the shadows and the lack of noise in the image.

FIVE

⋁ The final photo of Patricia Lake, Jasper National Park, Alberta, Canada, created from the properly exposed image.
Canon EOS-1Ds Mark II, 24mm lens, 2 sec at f/14, ISO 400

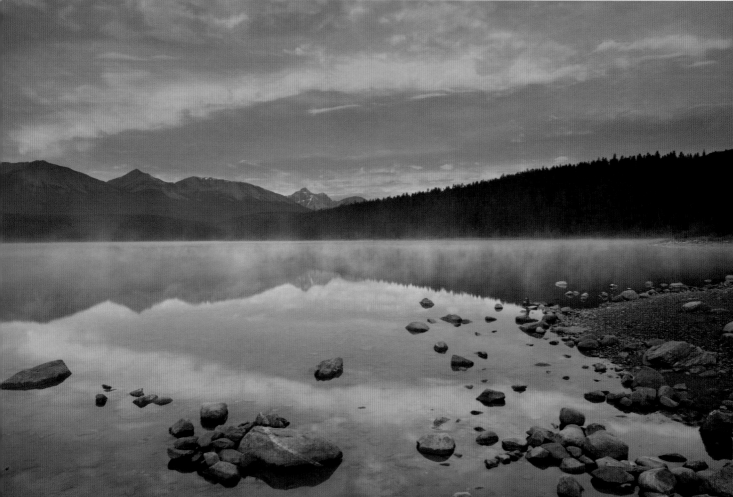

FIXING A BROKEN HISTOGRAM

We have seen that a 'good' histogram is one that is biased to the right side but without clipping of either shadow or highlight detail. Such histograms are easy to make in low-contrast light such as under cloudy skies or in the shade. But who only shoots under those conditions? Often we want to capture the full glory of the sun as it skims over the land, and most often our subjects are under mixed and high-contrast light.

Somehow we need to be able to get digital cameras to record on their sensors scenes with contrast beyond that which they can actually record. For example, in high-contrast light, a typical camera histogram might show clipping in both the shadows and the highlights – in other words, it is broken. Our job as photographers is to rope in the histogram to something recordable by the camera. Here are a few ways to achieve that end.

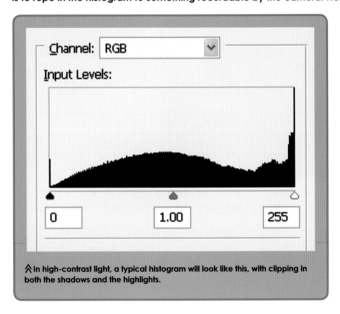

⌃ In high-contrast light, a typical histogram will look like this, with clipping in both the shadows and the highlights.

FILTERS FOR HIGHLIGHT CONTROL
One of the easiest ways to tame contrast is to darken the highlights. Two filters can do a great job of reducing the brightness of the highlights: the polarizer and the neutral density graduated filter.

The polarizer
Reflective glare in photos tends to wash out the highlights and reduce colour saturation. A polarizer reduces reflective glare in the highlights, darkens blue skies and increases colour saturation. Not only does the end result look better (compare the two photos of Cascades Pond on page 35), but the histogram for a polarized photo will have less contrast, or will less likely be clipped, than would be the case without the polarizer.

Using this filter is easy: just screw it on your lens, look through your viewfinder and then rotate it until you see the effect you want. Sometimes you won't see any change as you rotate the filter. This happens because polarizers work only when the light is perpendicular to the direction your camera is pointed. If the light is behind you or if you are shooting directly into the light, a polarizer has no effect. But if the light is to your right or left side, or directly overhead (midday sun, or overcast light), the filter will work its magic. If you have a broken histogram and the light is at a 90-degree angle to your subject, a polarizing filter might be all you need to fix it.

Graduated filters
The other filter that is absolutely necessary for in-camera contrast control is the neutral density graduated filter (grad filter or ND grad for short). These filters are a combination of one-half clear glass (or optical resin) and one-half neutral (grey) glass or resin. They come in different strengths of neutral density and with different blends between the dark and light portions – hard edge and soft edge.

The theory behind these filters is that often the sky is so much brighter than the land that film or digital cameras have a hard time retaining details in both areas of the scene. Without a grad filter, the resulting photo may have a bald, washed-out sky and a clipped histogram. With a grad filter, the sky retains proper detail and a usable histogram, as you can see by comparing the shots of Peggy's Cove Lighthouse (page 36).

There is a trick to using grad filters. First, note that they work well only with wide-angle or normal lenses (any lens shorter than about 85mm). Second, you will need a filter holder to hold the grad in place. Mount the grad filter in the filter holder on your lens. Now look through your viewfinder and pull the grad filter up and down in the holder until the feathered transition between grey and clear glass meets the transition between the sky and the land. You want the transition zone on the grad to blend into the horizon line (easier on a wide-open, flat landscape than in the mountains!). You can also rotate the filter holder, if your horizon line is angled, so the grad filter matches the horizon or light line.

For precise placement of the grad line, you will need a camera that has a depth-of-field preview button. Make sure that your camera is set at the aperture you want to take the photo at (smaller apertures give a harder edge to the grad filter's transition zone). Press your depth-of-field preview button and wiggle the grad filter in the filter holder until you see the grad line; then precisely place the filter line where you want it to blend – for example, on the horizon, over a reflection, or where light and shadow meet.

TIP

" Some photographers attach a Post-it note to the transition line on the graduated filter. That way they can precisely place the filter while looking through the lens. The Post-it note is easier to see than the grad line on the filter and thus, if the note is pulled down to meet the horizon, the grad filter will be placed properly. "

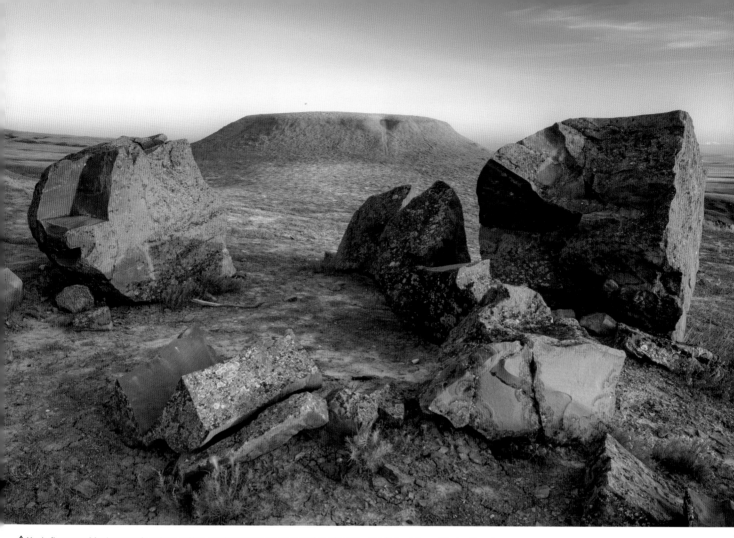

⚠ Most often our subjects are under mixed or high-contrast light, like this shot of Red Rock Coulee Natural Area, Alberta, Canada.
A Singh-Ray warm-tone polarizer was used to tame the contrast and achieve a more acceptable histogram.
Canon EOS-1Ds Mark II, 17–40mm lens at 29mm, f/14, ISO 100

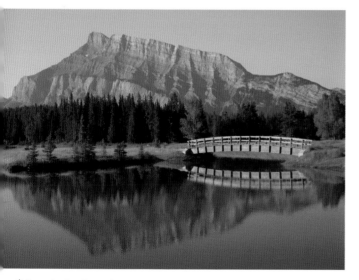

⚠ Cascades Pond in Banff National Park, Alberta, taken without a filter.
Canon EOS-1Ds Mark II, 24–70mm lens, 1/60 sec at f/11, ISO 100

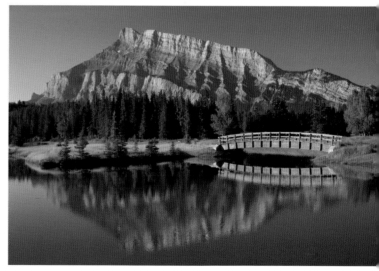

⚠ With a Singh-Ray warm-tone polarizer, the same scene has
increased colour saturation and less reflective glare in the highlights.
Canon EOS-1Ds Mark II, 24–70mm lens, 1/15 sec at f/11, ISO 100

Hard-edge and soft-edge grads

For advanced photographers, Singh-Ray Filters make two versions of grad filters with different types of transition zones, hard edge and soft edge, for different types of scenery. You use a hard-edge grad where the horizon or shadow line is distinct and a soft-edge grad where the horizon or shadow line is indistinct.

Grad filters come in various strengths – that is, the shaded part is between one and five stops darker than the clear part. I have a set of four grads that meet 90 per cent of my needs. These are Singh-Ray's 2- and 3-stop hard-edge and the 2- and 3-stop soft-edge neutral density grad filters. The 3-stop version, especially, lets me have a sunset or sunrise sky combined with a detailed and properly exposed foreground. Without the grad filter, the foreground would be black or the sky white with digital capture.

Combining grad and polarizing filters

I often use the highlight-taming abilities of both types of filters simultaneously. To do so, I use a sprocket polarizer that fits in the Cokin filter holder so I can stack a polarizer with a grad filter. Not only do the two filters really reduce contrast and give me a great in-camera histogram, the resulting photos are wonderfully saturated and dynamic compared to the same scene taken without filters – as you can see from the two shots of the Nova Scotia coastline below.

NO FILTER

WITH FILTER

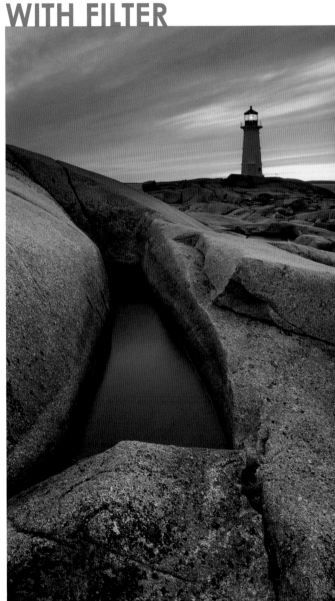

≪ **Peggy's Cove Lighthouse, Nova Scotia, Canada, photographed at dusk with no filters. The sky is washed-out and the histogram was clipped to the right.**
Canon EOS-1Ds Mark II, 24mm lens, 3.2 sec at f/16, ISO 100

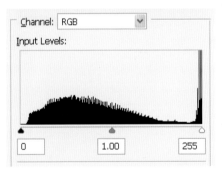

Adding a Singh-Ray 3-stop hard-edge grad filter over ≫ the sky ensures that all colour and detail are retained and the histogram is usable.
Canon EOS-1Ds Mark II, 24mm lens, 3.2 sec at f/16, ISO 100

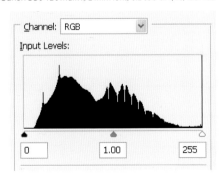

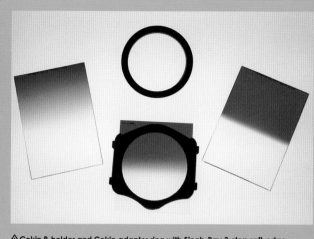

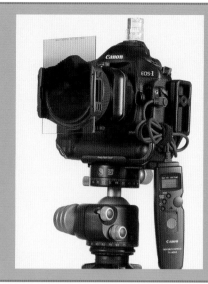

≪ A Canon EOS-1Ds Mark II with a 24mm TSE lens and a Cokin P-holder on the lens with a Singh-Ray sprocket-mount polarizer and a Singh-Ray grad filter.

⌃ Cokin P-holder and Cokin adapter ring with Singh-Ray 3-stop soft-edge grad (left), Singh-Ray 3-stop hard-edge grad (right) and Cokin medium-edge grad (centre).

NO FILTER

WITH FILTER

⌃ Kootenay Plains, Alberta, photographed without any filters. There is too much contrast in the scene to retain detail in both the foreground and the sky.
Canon EOS-1Ds Mark II, 24mm lens, 1/15 sec at f/14, ISO 200

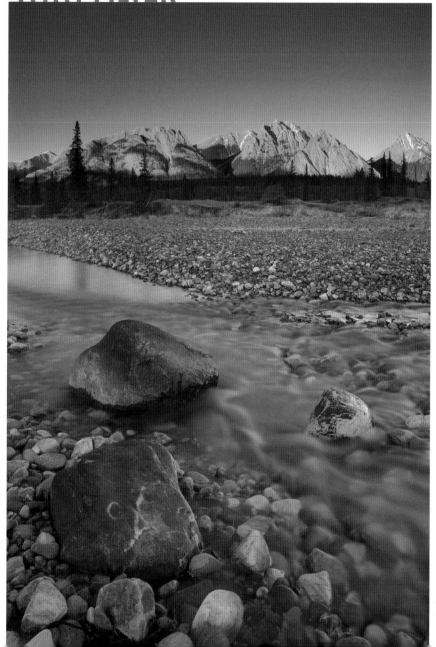

Here I used a Singh-Ray 3-stop ≫ hard-edge grad over the mountains and sky plus a 5-stop solid ND filter to increase overall exposure time to show more movement in the water. Both foreground and background are now properly exposed.
Canon EOS-1Ds Mark II, 24mm lens, 6 sec at f/14, ISO 200

Darwin Wiggett

POST-PRODUCTION CONTRAST CONTROL

There are occasions when it is not practical to use filters to control the contrast in an image. You might not have them with you when an opportunity for a photograph presents itself, or you might want to use a lens longer than around 85mm, or perhaps a 15mm fisheye. Neither of these will work well with neutral density grads. Fortunately, you do not have to abandon the hope of getting a great final image, as there are computer techniques that can come to the rescue. These are becoming more popular with digital photographers as they require no special gear to be taken into the field, just more time in front of the computer.

EXPOSURE BLENDING
In its simplest form, exposure blending involves taking two exposures of the same scene: one that is correct for the highlights (usually the sky), and another that is correct for the shadows (usually the foreground). These are then blended together using Photoshop or some other software program. As long as the camera is mounted on a tripod, it is easy to perfectly blend two different exposures using the Layers and Layer Mask feature in Photoshop. This is how it is done:

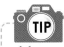

TIP

❝ When doing different exposures of the same scene for exposure blending, it is best to use the auto-bracketing feature along with continuous motordrive to take a sequence of exposures in a short time. Doing so will minimize the movements of clouds, ripples, and wind-blown vegetation between the various exposures making for better exposure blends. ❞

- Open up both the shadow and the highlight exposures in Photoshop. You need to move one exposure on top of the second exposure. Select the Move tool by pressing the letter 'v' on the keyboard. Touch the title bar of the shadow exposure image so that it is active. Now place your cursor on to the shadow-exposed photo and you will see the Move tool cursor come up. On your keyboard hold down the shift key (PC) or the option key (Mac) and drag the shadow exposure on to the highlight exposure. Release the mouse button first and then release the shift or option key. The two photos will stack up perfectly in line, one on top of the other. Close the highlight photo.

- Bring up the Layers palette by pressing F7 on your keyboard. If you look at the Layers palette you'll see the shadow exposure on top and the highlight exposure underneath.

ONE

TWO

THREE

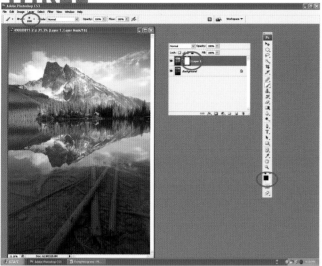

Now use a Layer Mask to blend the two photos together. Go to the Layer menu and select Layer > Layer Mask > Reveal All. Look at your Layer palette – you'll see a white square appear on the top layer. Press the letter 'B' on the keyboard to pick a paintbrush. Look at your toolbar and make sure the foreground colour is set to black. Make sure the Layer Mask is active by clicking on the white square of the upper layer. Now you are ready to paint through the top layer to reveal the bottom layer below. Make sure you have a soft-edge brush by adjusting brush hardness and size from the brush options.

FOUR

Brush over the picture to reveal the darker highlight details from the layer below. If you make a mistake, go to the toolbar and switch the paint from black to white and paint back the areas you messed up. Paint areas of the picture until you get a great balance between the shadow and the highlight exposures. Once the image is the way you want it, flatten the layers (Layers > Flatten Image) and continue to do your usual finishing by adjusting Levels, Curves and Saturation.

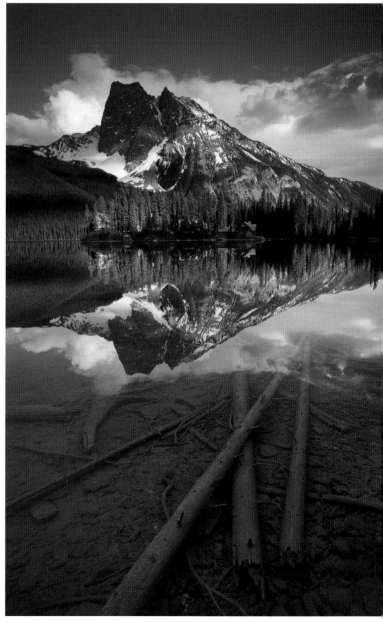

⋁ **The final composite image of Emerald Lake, Yoho National Park, British Columbia. The lake, mountains and sky are all now properly exposed.**
Canon EOS-1Ds, 20mm lens, 1/4 sec at f/16, ISO 100

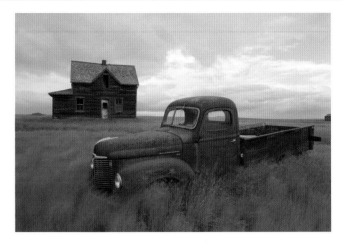

⩘ An exposure for the midtones (1 sec at f/14).

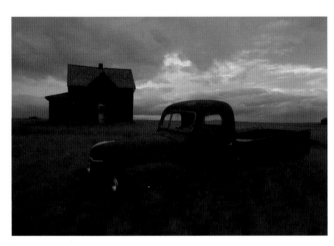

⩘ An exposure for the shadows (2/5 sec at f/14).

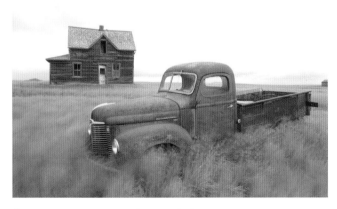

⩘ An exposure for the highlights (1/4 sec at f/14).

Prairie relics, Saskatchewan, Canada. ≫
The final HDR image was created by
blending the three exposures with
Photomatix software.

HDR PHOTOGRAPHY

Digital camera sensors can see about five to seven stops of tonal range, whereas the human eye can see over 20 stops. HDR (high dynamic range) imaging allows us to capture the entire tonal range of a scene that we can see with our eyes and then display these tonal values in a finished image.

HDR requires that you capture several different exposures of the scene and then 'map' these into one image. For a high-contrast scene where the histogram is clipped at both ends, the photographer simply takes three exposures of the scene using a constant aperture and varying the shutter speed to give properly exposed midtone, shadow and highlight versions. These three exposures are brought into the computer and then

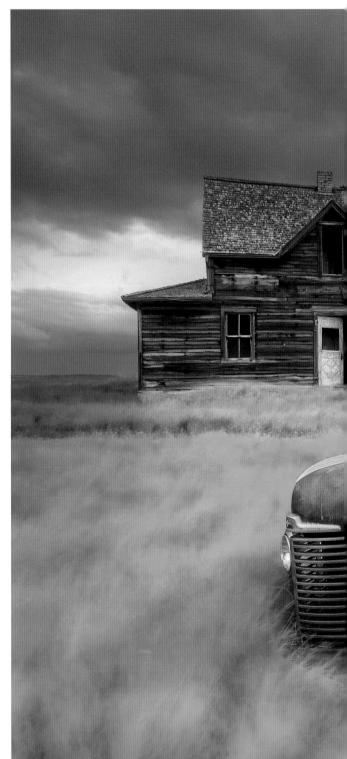

merged together automatically using HDR software such as Photomatix. Photomatix is an easy and robust program that allows you to visually merge the three photos until you achieve a look that you like. Photoshop also has the ability to make HDR images, but the interface and tools are not as easy to use, so most photographers who do HDR imaging use Photomatix software.

Although Photomatix does a great job most of the time, some scenes that contain moving objects such as flowing water, moving cloud or blowing grasses can give bizarre ghosting effects in HDR blends.

For a great place to start learning more about the emerging technique of HDR photography, go to www.hdrlabs.com.

TIP

With both exposure blending in Photoshop and HDR photography, it is essential that you use a tripod when taking the different exposures from exactly the same position, to ensure that the layers merge together perfectly.

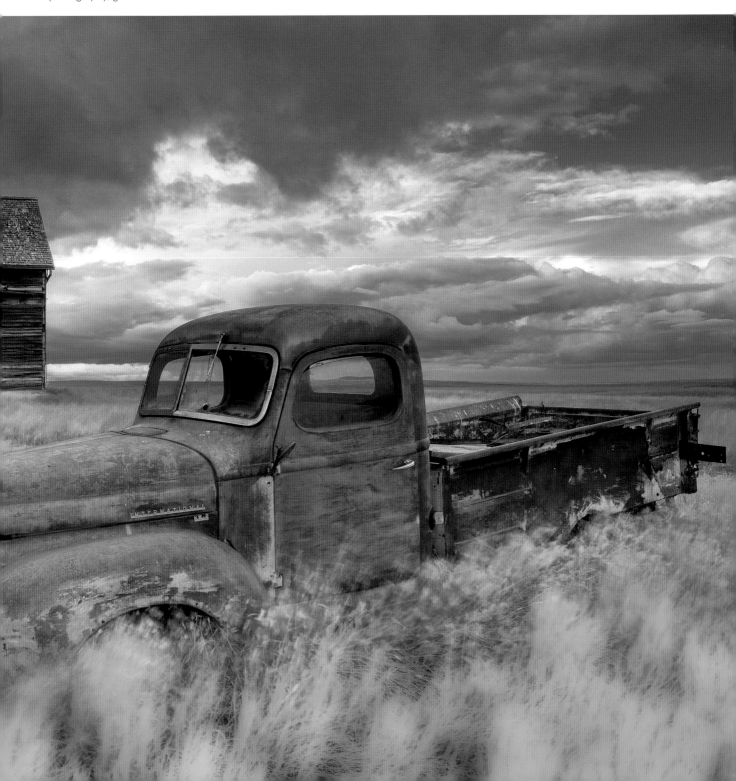

CHAPTER 2: UNDERSTANDING LIGHT
David Noton

Light is the most fundamental thing a photographer can work with. A picture taken in the wrong light just will not work, no matter how dramatic the subject, whereas with the right light a lump of coal can look good. Getting yourself in the right place when the light is near-perfect for a shot is an all-consuming activity for the landscape photographer. It's probably the biggest difference between making a great shot and a snapshot. This chapter looks at how to develop an understanding of the changing nature of light to give you the best possible chance of success.

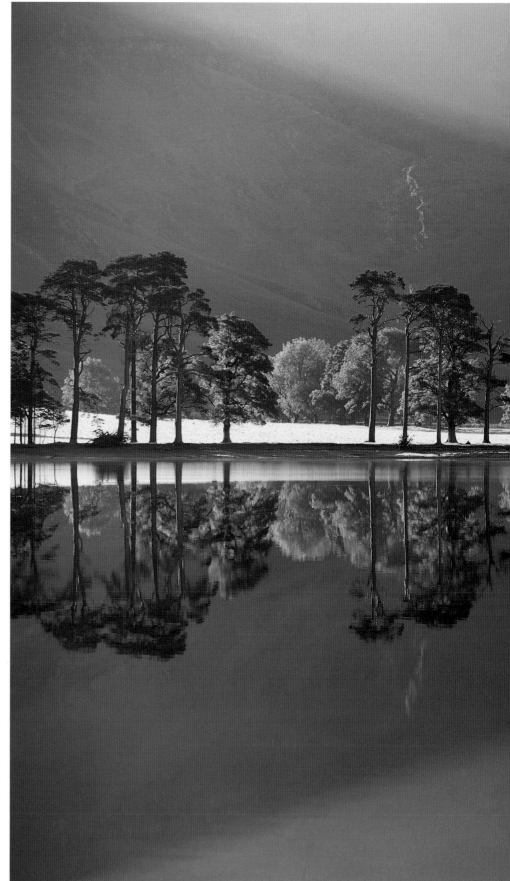

Perfect reflections on Buttermere ≫ in England's Lake District, shot with the Canon EOS-1Ds Mark II with a 70–200mm f/2.8 lens with image stabilization. In the early days I used to lust after optics such as this lens in the mistaken belief that they would improve my photography. It doesn't; no equipment does.
Canon EOS-1Ds Mark II, Canon EF 70–200mm lens, 1/85 sec at f/4, ISO 100

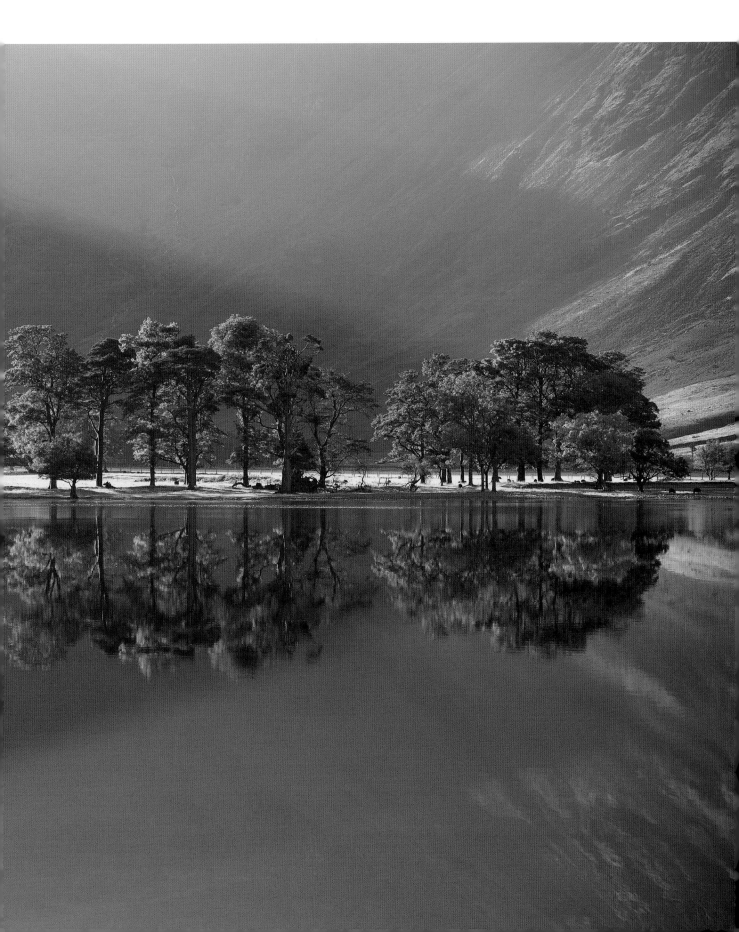

A FEEL FOR LIGHT

Most people don't think in terms of light; they think in terms of weather – is it sunny or cloudy? Wet or dry? It's something to be taken for granted. Photographers, however, become totally obsessed with light and we find ourselves endlessly analysing it. There are so many subtleties and variations to it – the time of day, the direction and the atmospheric conditions. Landscape photographers, more than those working in any other field, are totally at the mercy of natural conditions. It can be tough, but the rewards are great. Nature can deliver some incredible lighting situations, which can never be exactly foreseen because they are so variable.

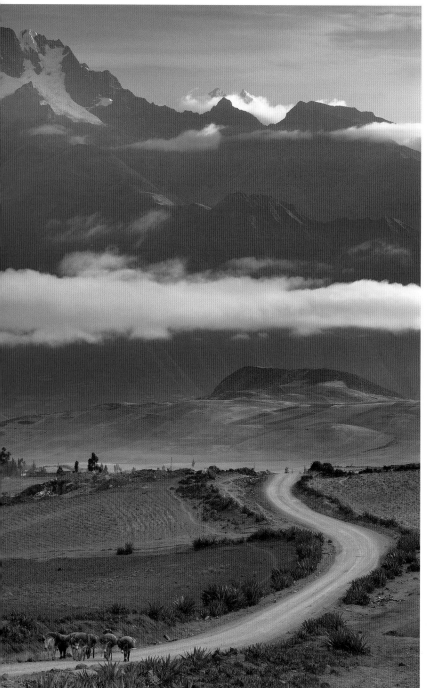

A lot of the hard work in photography is done before even touching the camera. It's done, particularly in landscape photography, by making sure that you have planned where you need to be when photographic situations arise. You could say, for example, that to be standing above a landscape when a shaft of sunlight comes through the cloud and illuminates the vista below is a lucky break. But if you weren't at the right place at the right time, you wouldn't be able to take advantage of that good fortune.

So how do you develop an understanding of light? Mostly it comes down to experience and putting the hours in, but the most important thing is that you use your eyes. You must develop a photographer's vision, which is receptive to changes of light, and to colour and composition. The best thing to do is experiment – there is no substitute for practice. You never stop learning about light, or appreciating the wonder of it. I am still enthralled by how natural light can transform a view. To watch the light paint across the landscape in front of you is one of the great joys of photography.

It isn't just about seeing, though. You have to be able to translate that into the camera. You need a firm understanding of how the digital sensor is going to respond in different situations. This takes practice and, since digital is free, you can afford to learn from your mistakes as well as your successes; never be afraid to have a go.

Another key discipline is the ability to previsualize how a scene could look in different lighting situations. You may be standing before a landscape under grey clouds on a dull day, but to imagine how that location might be transformed by dawn light or dusk light is an important skill to learn.

≪I spent four days working on this shot. I found the location, near Cusco, Peru, on the first day, with the road winding into the frame and the massive Andes looming over the Sacred Valley. For the first few mornings the cloud was low and the peaks lost in the murk. I spent many hours waiting for gaps to materialize that never did. On the fourth day, strands of cloud were draped over the Cordillera, emphasizing their majesty. The light was coming from an oblique angle, not quite backlit, but not sidelit either. Just as a splash of weak light was subtly lifting the foreground, a farmer drove his donkeys down the road. Luck? Undoubtedly, but I had been there, on duty by the tripod, for four mornings. You make your own luck.
Canon EOS-1Ds Mark II, 70–200mm lens, 1/15 sec at f/11, ISO 100

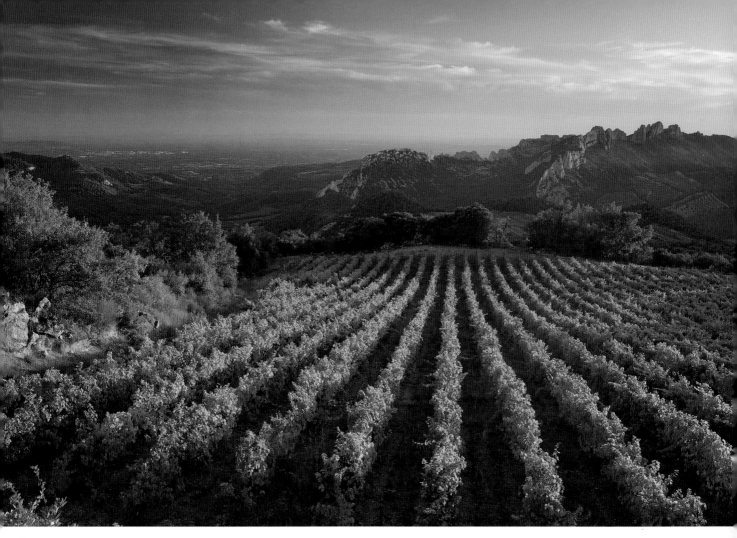

⌃ Beautiful golden evening light bathes the landscape in Provence, France. The strong lines of the vineyard lead into the frame. Find the location, previsualize how it will look at different times of the day, decide when to shoot it and return at the chosen hour to await Mother Nature's favour.
Canon EOS-1Ds Mark II, 17–40mm lens, 1/30 sec at f/11, ISO 100

TIP

❝ Whenever you look at a picture that has worked, try to analyse where the light was coming from and why that picture is successful. Equally, when you've photographed something that hasn't worked, ask yourself what went wrong. You learn more from your mistakes than you do from your triumphs. ❞

Here at Sleepy Bay, Tasmania, the light has ≫ a crystal-clear quality due to the complete absence of any haze, or indeed ozone, in the atmosphere. The sun has just popped over the horizon and is still relatively weak, but the first soft, orange light is providing directional but still low-contrast sidelighting. At this time of day, the light goes through some magical transformations. If you have a strong composition framed in your eyepiece, it's worth sticking with it and shooting multiple variations as the light paints the landscape.
Canon EOS-1Ds Mark II, 70–200mm lens, 2 sec at f/22, ISO 50

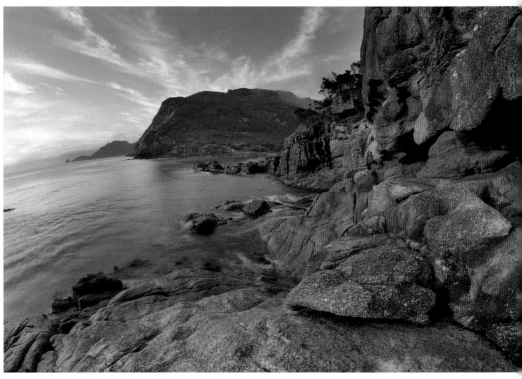

TIME OF DAY: FROM DAWN TO DUSK

The light changes massively throughout the 24-hour cycle, creating shadows of different length and intensity and varying colour hues. How it changes depends on the time of day, the weather conditions, the season and the atmospheric conditions. It's all about the angle of the light in the sky, how high the sun is and whether its passage through the atmosphere has been affected by factors such as cloud, haze or mist. The photographer has to be able to understand all those variables to pick the right conditions for a specific image.

Generally, landscape photographers put all their efforts into being at their chosen location during what we call 'happy hour'. The photographic action kicks off about an hour before sunrise when indirect light from the sun lurking below the horizon is reflected down on the landscape by clouds and the atmosphere itself. The colour temperature of this pre-glow goes through some wonderful phases as the sun's appearance becomes more imminent. It's a soft, low-contrast light that becomes more and more directional as time passes until the sun nudges over the eastern horizon.

At this point, direct rays from the sun start to paint the landscape, but because those rays have to slice through so much atmosphere to reach us, they are relatively weak and very warm and orange. As the sun rises and gains in intensity, the contrast steadily rises, as does the colour temperature, until we have the hard, contrasty, white light of day.

⋁ The moon over Cathedral Cove, Coromandel Peninsula, North Island, New Zealand. I found this location the day before the shoot and was in position in the cave, which I wanted to use to frame the image, by 5am. This was shot with just the very first cool light of twilight seeping through the sky. Moonlight is backlighting the sea stack.
Canon EOS-1Ds Mark II, 24–70mm lens, 1/16 sec at f/8, ISO 400

ONE

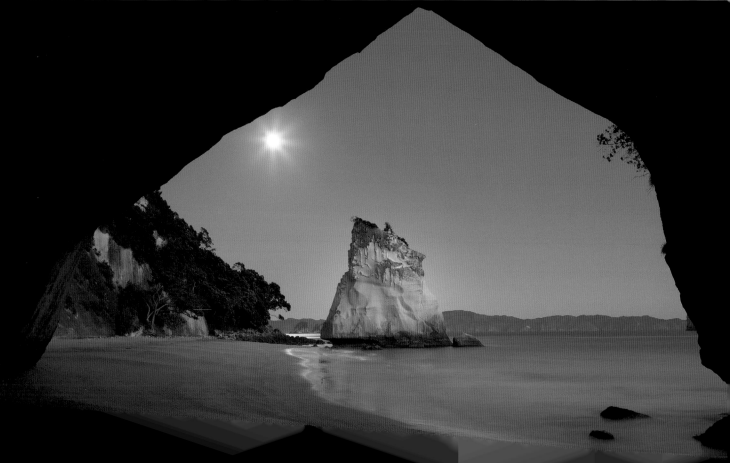

TWO

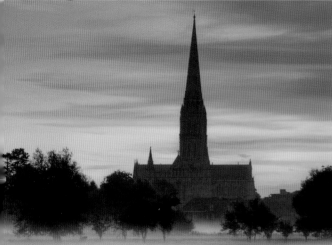

⌃ Next, there is the first dawn light. The sun is still well below the horizon, reflecting off the bottom of the clouds and backlighting this picture of Salisbury Cathedral, England, rising above the mist on Harnham Water Meadows. You can stand and watch the pinks spreading through the sky from the east to the west.
Canon EOS-1Ds Mark II, 70–200mm lens, 1/4 sec at f/14, ISO 100

THREE

The sun is just popping over the horizon here, near Corton Denham in Somerset, ⟫ England. It's still not strong enough to give any kind of effect on the landscape, but it's giving a wonderful 'happy hour' sky. If I had left it any longer, the sun would have become much stronger and I would have had real problems shooting from this angle with the sun boring into the lens. The light still has a very diffuse, directional quality. As the sun comes up it becomes harder and harder and you start to see shadows developing. But at this stage it is very soft.
Canon EOS-1Ds Mark II, 17–40mm lens, 1/30 sec at f/22, ISO 100

FOUR

At around 10am, the autumn sun is ⟫ well up in Abruzzo National Park, Italy. It has lost much of the subtlety of earlier in the morning, but this light can work well with certain images.
Canon EOS-1Ds Mark II, 24–70mm lens, 1/100 sec at f/6.3, ISO 100

David Noton

Of course, the unknown variable in all this is the cloud cover, overhead, on the eastern horizon and draped over the land as mist, which means no two sunrises are likely to be the same (apart from in the Atacama Desert, where the weather never changes). At sunset and dusk the whole thing happens again, but in reverse.

Having said that, there are many occasions when you can work with the light at other times, and even at night under moonlight. During the middle of the day, however, when the sun is at its highest and brightest, you are nearly always better off putting the camera away because the angle of the light and the high contrast do not produce the most pleasing results. Even then, though, there are certain situations and locations where it can work.

The following pictures, taken in various parts of the world, show some of the characteristics of the light on the landscape as the sun moves across the sky at different times of day.

SIX

It's late afternoon now in the Scottish ≫ Highlands and we have that sidelighting back on the landscape, giving wonderful texture to the peaks. Things have calmed down and there are perfect reflections on the loch. Of course, there are also clouds, which are fundamental to the picture. Often at dusk, clouds can disappear, and they are so important to a landscape. This is like a carbon copy of the lighting we had just after sunrise but, obviously, with the light coming from the west. The light is starting to get that warm feel.

Canon EOS-1Ds Mark II, 17–40mm lens, 1/30 sec at f/11, ISO 100

FIVE

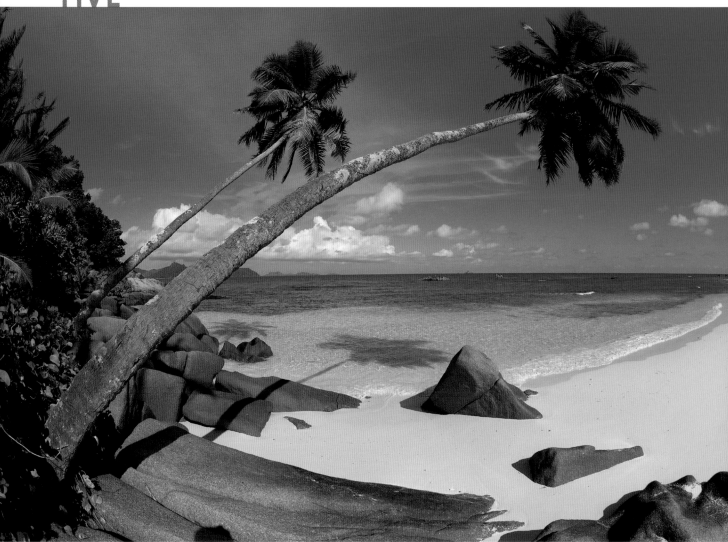

⌃ For a few hours before and after midday – depending on the time of year – I don't generally touch the camera. This shot of La Digue in the Seychelles is one of the exceptions. Midday light works perfectly in situations like this because the toplighting gives colour to the tropical waters, which you wouldn't get with sidelighting.
Canon EOS-1Ds Mark II, 15mm fisheye lens, 1/400 sec at f/10, ISO 100

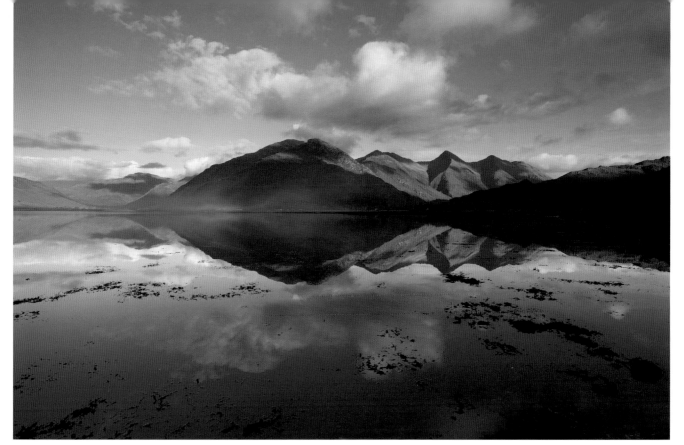

SEVEN

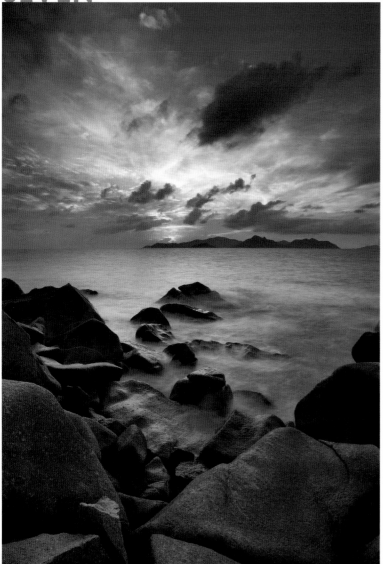

≪ The sun has dropped down now at La Digue, Seychelles. The directional quality of the light is even softer at twilight. We're getting diffuse light from over the horizon. As the light permeates through the sky from the setting sun to the west, it's starting to hit the clouds in the sky from below as well. At this time of the evening, the light goes through some magical, very rapid, transformations.
Canon EOS-1Ds Mark II, 17–40mm lens, 2.6 sec at f/22, ISO 50

EIGHT

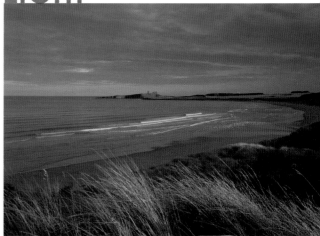

⌃ The last rays of sunlight are just kissing the coast of Northumberland, England, here. The light has a really soft quality now. It's still directional and still giving a texture to the landscape, but it's relatively low-contrast compared to the light you would get at midday, for example. It's adding warmth to the foreground and there is patched light on the castle and beyond.
Canon EOS-1Ds Mark II, 24–70mm lens, 1/4 sec at f/13, ISO 100

COLOUR TEMPERATURE: USE IT OR LOSE IT

We've talked about the time of day and how the nature of the light changes, but the colour temperature of light changes as well. All light sources have a colour temperature, which is a measure of chromaticity and is expressed in degrees Kelvin. What we know as daylight colour temperature is deemed to be about 5,200K at midday, whereas a domestic tungsten light bulb glows at a relatively cool 3,200K. The cool bulb emits an orange light that we think of as warm. So warm is cool and cool is warm – just the opposite of what you would expect. If that is confusing, think of a gas burner where the hottest part is the blue flame.

On an overcast day, the colour temperature of light goes as high as 10,000K. At twilight, only the blue end of the spectrum is left bouncing around the atmosphere after the sun has departed and the temperature is even higher. Photographs taken at this time will have a very cool tone to them if left uncorrected, even though our eyes do a sort of auto white balance and so do not detect this at the time. On a clear blue sky at noon, those parts of the landscape hit by direct sunlight will have a neutral colour; snow will be white, for example. In the shade, however, light reflected from the sky, with a high proportion of scattered blue wavelengths, produces a strong blue cast.

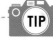

TIP

" The camera sees the shifts in colour temperature during different times of day, but our eyes don't as our brains do a kind of auto white balance. The key thing is to look at a landscape, for example, before dawn, and know that the light is very blue. "

St Michael's Mount, Cornwall, England. It's dawn and the sun is not yet up. ⌄
The overall tone of the picture is very cool because the temperature of the ambient light is very high. It's a long exposure, as you can see from the movement on the water and on the clouds.
Canon EOS-1Ds Mark II, 16–35mm lens, 21 sec at f/22, ISO 50

ONE

TWO

This is 20 minutes later and you're starting to see the colour temperature shift. The >> first sunrise effect is spreading through the sky; there's pink on the clouds there, but the ambient colour temperature is still very cool.
Canon EOS-1Ds Mark II, 16–35mm lens, 16 sec at f/22, ISO 50

WARM TONES

The light at around sunrise and sunset is much cooler and yet it has those characteristic warm tones that we so love to capture. That's because, at this time of day, the rays from the sun are coming at an angle and have to slice through more of the atmosphere than they do at midday when it is coming straight down. In the atmosphere, there are dust particles, water vapour and smog that absorb the blue wavelengths, letting those at the red-orange end through. That is why the setting sun appears orange and the direct sunlight at this time of day is so warm and golden.

Because the camera picks up the colour of light, landscape photographers always consider the colour temperature and decide whether they want to use the shifts it goes through at different times of day to give a certain feel to a picture, or whether they want to use various methods to neutralize it.

My sequence of shots taken at St. Michael's Mount, Cornwall, England, shows how the colour temperature and the nature of the light changes by looking at the effects it has on the landscape. In all of these, the white balance on the camera was set to Daylight and the colour tones are just as they were recorded on the RAW files, without any adjustments.

THREE

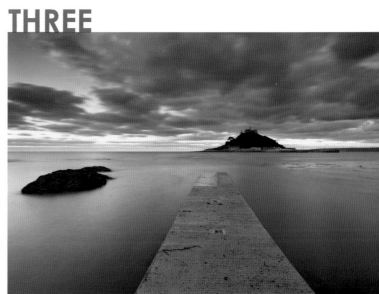

A further 20 minutes later, and the first directional light from the rising sun is >> apparent on the top of the Mount, just giving a very soft, pinkish sidelight to the image. The ambient colour temperature is still cool, but it is starting to warm up, and we're getting this marbling of the sky with the first directional light through the clouds.
Canon EOS-1Ds Mark II, 16–35mm lens, 12 sec at f/20, ISO 50

FOUR

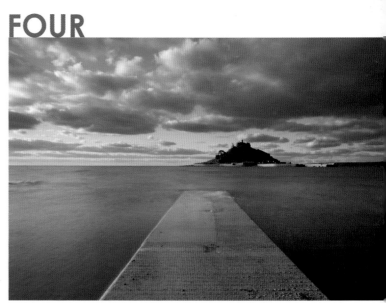

Now the sun is up and we can see how much the colour temperature has changed. >> It's a fairly warm sidelighting we're getting now, which is much more directional – you can see how harsh the shadows are. Notice how the exposure has changed: the camera was on aperture priority at f/22 and the required shutter speed has become gradually faster as the sun rises.
Canon EOS-1Ds Mark II, 16–35mm lens, 4 sec at f/22, ISO 50

WHITE BALANCE CONTROLS

Film is not like our eyes and doesn't automatically adjust depending on the colour temperature. Instead, it is balanced for a specific light source – daylight, tungsten or infrared. Daylight film will still render blue tones blue and photographers using this medium often compensate for this by using a warm-up filter. Digital cameras are much more flexible when dealing with variable and mixed light sources, and that is one of their major advantages. We can set the DSLR to a specific colour temperature, such as Cloudy, which will warm up the blue tone of an overcast day. Alternatively, we can use auto white balance and leave it to the camera to sort out.

When you are shooting RAW, however, choosing the right white balance is not absolutely essential, as your colour corrections, if any, are done at the post-production stage. The white balance control will determine how the image will look on the monitor, however. If it's set to Daylight (5,200K) then, if the light is warm and golden, it will appear as such without the camera trying to correct it.

For landscape photography, I very rarely try to alter the colour balance of an image and my Canon is permanently set to Daylight. The colour of the light is all part of the changing mood that nature provides us with, and I like to work with it as it is. Sometimes, though, you might want to make subtle and selective changes, perhaps warming up the light on the landscape in the foreground, for example. That's certainly a useful technique to deploy now and then and it can be done at the RAW conversion stage.

ALTERING COLOUR TEMPERATURE AT RAW CONVERSION

All the well-known RAW-conversion software programs include a means to control the colour temperature. You can simply select the temperature that you want – expressed in degrees Kelvin – and the tone of the image will change accordingly. If, for example, you have a very cool-looking image, taken in the shade during the middle of the day, you can warm it up by reducing the colour temperature from 10,000K to 3,500K.

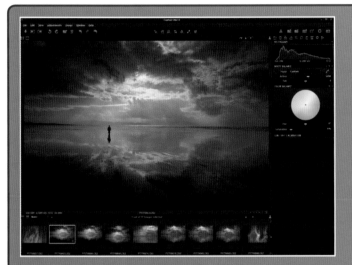

⌃ Here I'm using Capture One RAW conversion software (although all the RAW converters have this control). This is the image as shot in daylight, with the balance set to 5,200K. This is about the same colour temperature as the ambient light, so the colours appear very neutral.

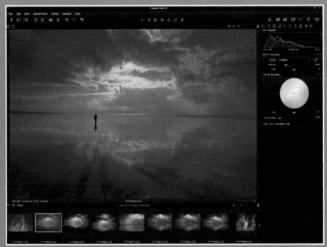

⌃ Go the other way to balance the image for a low colour temperature and the image appears very blue. The effects here are very extreme and totally gruesome, but it does show just how flexible you can be shooting RAW and tweaking the colour balance subsequently.

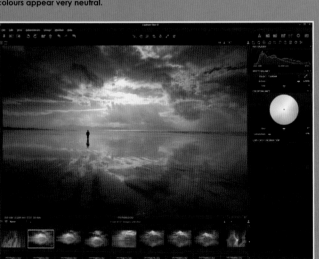

⌃ By moving the slider to the right, I balance the image for a high colour temperature of 12,800K, which has the effect of making the image shot in daylight appear very orange.

⌃ In the end, I settled on a setting of 4,400K for the balance I'm happiest with, but it is totally subjective.

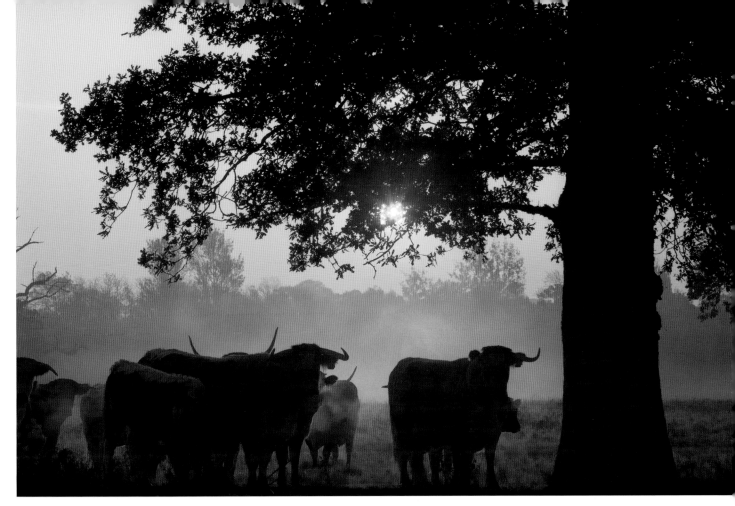

Warming up an image can sometimes be desirable. In the old days we did this with 81 or 85 filters, but now we do it at the RAW conversion stage. For vegetation, stonework and so on, it can give an attractive warm glow, but go too far and it all starts to look like a car ad from the 1980s! Personally, I very rarely warm up the whole image as it tends to make the sky look a bit sludgy. I think it's far better to selectively adjust a chosen area of the image. To do that you'll need to make two or more RAW conversions of the same image with different colour temperatures and merge them subsequently in Photoshop.

∧ The sun is up but still low in the sky. We can see very well in this autumn picture how warm that early-morning light is, despite the colour temperature being very cool.
Canon EOS-1Ds Mark II, 70–200mm lens, 1/500 sec at f/16, ISO 1600

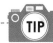
TIP

❝ Working digitally, we have ultimate control of the colour balance of an image. It's possible to fine-tune it to a remarkable degree. This is one of the great advantages of shooting in RAW. ❞

≪ This picture, shot in the Swiss Alps, shows the contrast between the first directional rays of sunlight, which are outrageously pink, and the other mountains, which are not yet lit by the rising sun. They are still blue and cold because they are lit by the ambient light (that is, the non-directional light bouncing around the atmosphere), which is very cool.
Canon EOS-1Ds Mark II, 100–400mm lens, 1/4 sec at f/16, ISO 100

David Noton

53

COLOUR QUALITY: FULL THROTTLE OR WATERCOLOUR?

We have seen how the colour temperature of the light can affect the overall tone of an image, but you also need to consider how vibrant you want the colours in your photograph to be. You can go for a full-throttle, highly saturated colour or a kind of delicate watercolour wash over the landscape. Then there is monochromatic colour, where you have varying tones of just one hue from any part of the spectrum, or, sometimes, just the effect of a single colour, though it is made up of several different ones. Colour can be so faint you hardly notice it and, of course, you can do without it all together and use black and white.

Which of these options you choose will depend on the atmosphere and mood you are trying to convey in the image, probably influenced by the subject matter. If you want to capture the array of yellows, oranges and reds of autumn trees, for example, or perhaps a field full of poppies in the summer, then you may well want the full-on, saturated approach. On the other hand, a misty, dawn landscape will naturally have muted, watercolour hues that you can use to convey a sense of stillness and tranquillity.

As your photographic vision develops, a more considered, subtle approach to using colour will develop. The initial tendency is to always try to maximize colour, and there certainly is a time and place for doing this. By taking care to expose correctly and optimizing the tonal range of the image both in camera and subsequently in post-production, you will maximize the punch of your photography's colour content. But it is easy to go over the top with the saturation slider, both at the RAW conversion stage and later when editing in Photoshop. Sometimes the merest hint of colour can be more powerful.

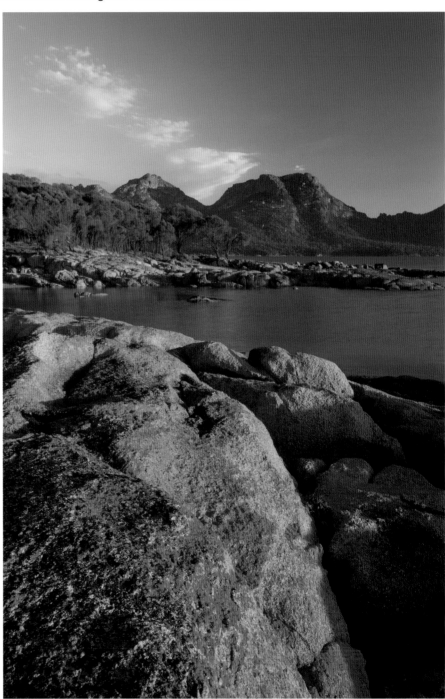

The lichen on these rocks on the east coast of ≫ Tasmania was a vivid red; I wanted to emphasize that by using strong, directional sidelighting to give full-on, vibrant colour.
Canon EOS-1Ds Mark II, 17–40mm lens, 1/8 sec at f/22, ISO 100

A dawn shot of Old Sherborne Castle, Dorset, England. You can see the first ⌃ sunlight of the morning just kissing the left wall of the abbey. There is a very muted look to the image, with subtle colour toned down further by the mist. You can't fight that; it's determined by nature. This may not be a dramatic shot, but it does work to create a mood.
Canon EOS-1Ds Mark II, 100–400mm lens, 1/8 sec at f/11, ISO 100

TIP

❝ Changing the camera position can greatly alter the angle at which the light strikes the subjects and the colours that it reveals. Experiment with this by shooting a single subject, without much distracting detail, from various positions all around it and see how the colours change. ❞

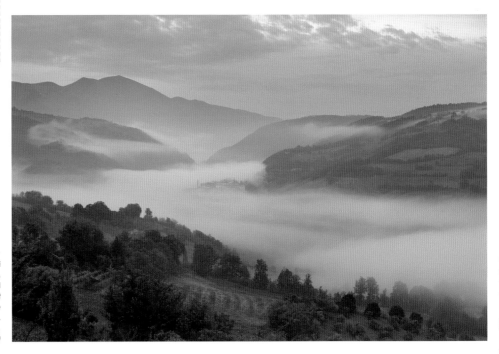

The village of Preci appearing through the ≫ morning mist with the mountains of Monti Sibillini National Park, Umbria, Italy, beyond. There is a subtle variation in the layered tones of the mountains and the slight pinkiness just lifts the sky and echoes the colour of the fields in the foreground.
Canon EOS-1Ds Mark II, 24–70mm lens, 1/30 sec at f/6.3, ISO 100

David Noton

55

CONTRAST AND COLOUR

How a photographer works with colour is usually determined by the nature of the light he or she is looking at. Contrast and colour are inextricably linked, so high-contrast light from direct sunshine hitting the subject will generally provide full-throttle colour. Low-contrast, soft, diffuse lighting from an open sky or bright clouds gives much more muted colours.

It's far easier to put contrast into a picture, through judicious tweaking of Levels and Curves in Photoshop, than to take it out. Too much contrast in the original scene will produce dense, black shadows and burnt-out highlights that you can do nothing with. Boosting contrast can help a lacklustre image and accentuate colours, but you can't wind up colour that nature didn't provide. It is so easy with digital, at the RAW conversion stage, to overdo it and produce a result that looks unnatural.

There are many times when you are hoping for perfect conditions and nature does not deliver them, so you have to make the most of what there is. If it's a bit hazy or the light is a little soft, you have to try to use that quality rather than fight it. The idea that bright is beautiful is often hard to resist, but colour does not have to be vibrant to be effective. I have been shooting stock for picture libraries for more than 20 years and a lot has changed since then. In the mid-1980s, blue sky and light fluffy clouds were called for most often, but now the libraries are far more interested in drama, mood and atmosphere.

A dramatic dawn light in Provence, France. Often you have to boost the colour saturation in post-production, but here I had to desaturate it because it was almost too rich to be believed.
Canon EOS-1Ds Mark II, 17–40mm lens, 5 sec at f/16, ISO 100

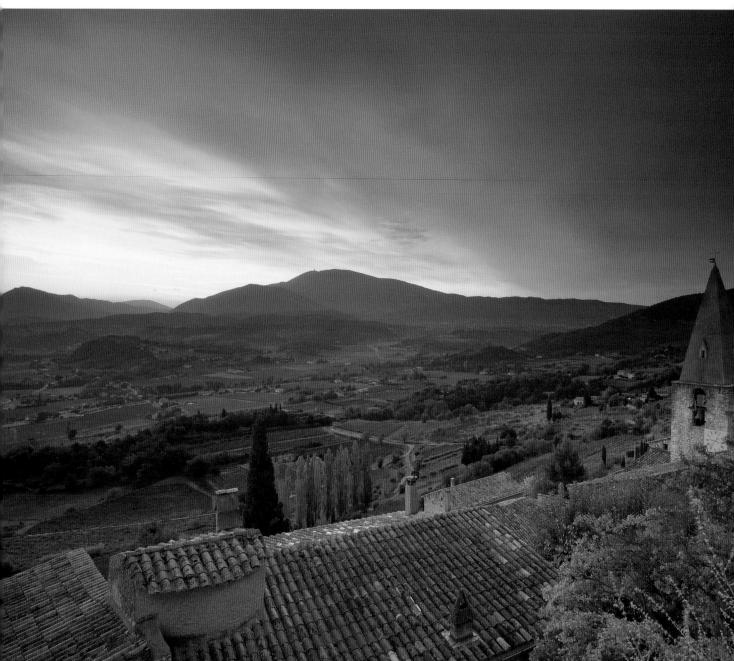

︽ Vibrant colours are so immediate and accessible that it takes time to train your eye to appreciate the subtlety of muted colours in soft, low-contrast light. This Italian olive grove has a lovely watercolour feel and beautifully conveys the mood of the location in the early morning.
Canon EOS-1Ds Mark II, 24–70mm lens, 1/60 sec at f/16, ISO 100

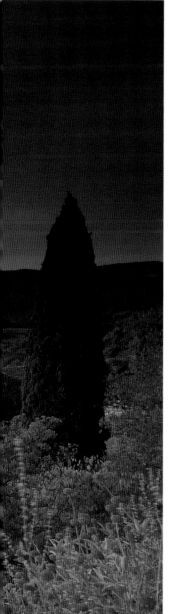

︾ The vivid, autumn colours of this tree, contrasting with the conifers beyond and the bright blue sky, demanded a full-throttle approach, which the direct afternoon sun coming from in front of the subject provided. The Mistral wind in Languedoc, France, created the dramatic blurring during a long exposure.
Canon EOS-1Ds Mark II, 24–70mm lens, 8 sec at f/22, ISO 50

David Noton

57

A SENSE OF DIRECTION

When you're searching for locations and you spot a landscape, think about what effect the direction of light is having on it and how an image might be improved if the sun was coming from a different angle. You could decide to return at a certain time on a summer's evening when the sun will strike the subject from the side and produce just the right shadows to reveal texture, for example. Or you might want the scene backlit by the first rays of sun rising above the horizon.

It is vital for a photographer to know where the sun is going to rise and set with the passing of the seasons and to use that knowledge to previsualize when the picture will look best. On your first visit to a location, when conditions are rarely perfect, it is useful to take a shot anyway, even using a little phone camera, to make a record of it. It helps to jog your memory about when you planned to return.

Lighting direction falls into three main categories: backlighting, sidelighting and frontlighting. There can also be various combinations of the three. Generally, sidelighting is preferable for most landscape photographs, but there are many exceptions to this and you need to explore all the options as you approach different situations.

As the sun set over the Jurassic coast ≫ from the Golden Cap in Dorset, England, I wanted to shoot straight into it to capture the wonderful effect on the clouds. The contrast range in the different parts of the scene was too great for the sensor to cope with as a single exposure, so I made three separate exposures for the sky, the middle landscape and the foreground and merged them together in Photoshop.
Canon EOS-1Ds Mark II, 15mm lens, 1/30 sec at f/16, ISO 100

Look how the sidelight is just picking out and highlighting certain aspects of this ⋁ picture, giving texture to the derelict barn and autumnal trees. Think how different it would appear if the sun were coming from directly behind the camera. It would flatten it totally. There again, if I were shooting straight into the light then the texture would also be lost.
Canon EOS-1Ds Mark II, 70–200mm lens, 1/30 sec at f/16, ISO 50

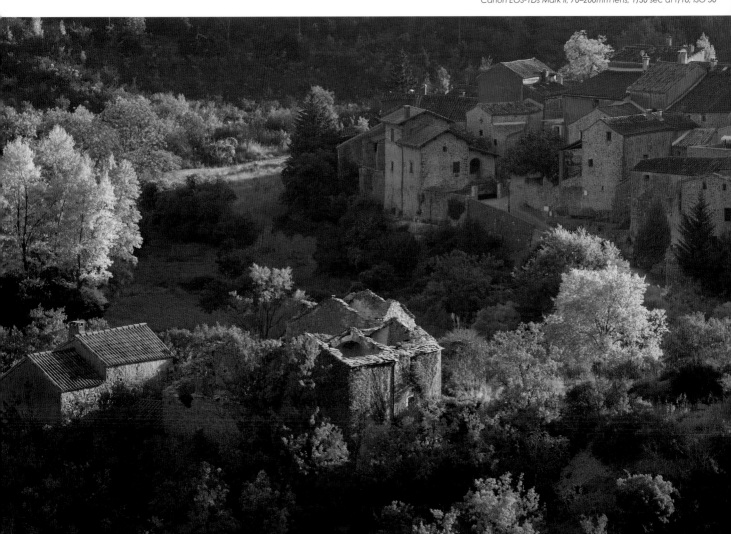

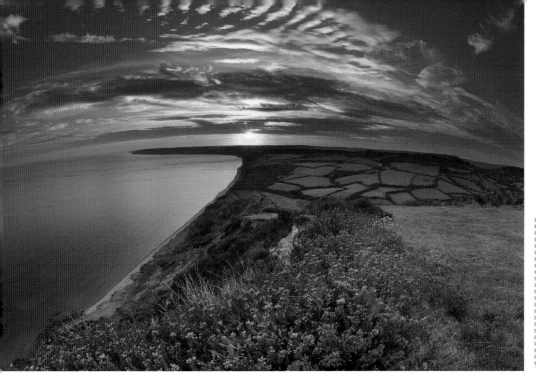

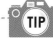

BACKLIGHTING

Shooting into the sun can produce a magical atmosphere, especially for translucent subjects such as leaves, flower petals and clouds. At its extreme, key features will become silhouettes without colour, detail or texture. Shape is therefore all-important and you should look for strong, graphic outlines and try to balance light and shade in an interesting way within the composition.

Backlighting needs a lot of care with both flare from the sun and exposure. Flare usually shows up as circular shapes across the frame as the light hits the front element of the lens and reflections bounce around between the elements inside. Weakened colour and lack of contrast are another effect; this can happen even on a bright overcast day when you are not aware of any flare. A lens hood, which protrudes out from the lens to shield it, is an essential accessory when flare is a possibility. I have a hood made by Lee Filters that is adjustable for different focal lengths and has a slot for two filters.

Even with a lens hood, you generally need to wait until the first or last moments of the day, when the sun is really low on the horizon, to use backlighting to its greatest effect. Otherwise, you can use something like the foliage of a tree or a passing cloud to partially mask the sun.

Using backlighting, you are always going to have a problem of contrast between the sky and the landscape in the foreground; there may be three stops' difference in brightness between them. Forgiving as it is, the digital sensor cannot cope with that. You can choose to expose correctly for the sky and let the foreground drop into silhouette or, if the contrast is less extreme, use a neutral density graduated filter to expose for detail in the foreground while retaining drama and detail in the sky.

Alternatively, you can do as I did for the shot of the Golden Cap, Dorset, and take three different shots, exposing correctly for the sky, the main body of the landscape and the foreground detail in turn, and then merge them together on the computer. You can do this using HDR (High Dynamic Range) software, but I prefer the effect of the more painstaking route in Photoshop – making selections, dragging and dropping, feathering and erasing layers. You can obtain very fine control that way. It is important that the different exposures are identically framed, otherwise the registration of the layers may not be perfect where they merge. A tripod is therefore essential.

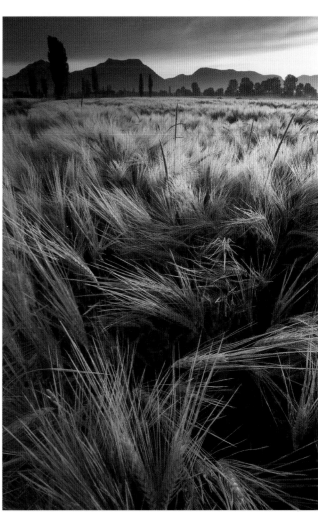

⌃ There's an element of backlighting here; you can see how it's catching the bits of barley in this field in Umbria, Italy, and the mountains are recording as black shapes. There's also enough sidelighting to give texture and other information as well. This is a perfect example of how a neutral density graduated filter was used to retain detail in the sky. Without it, to expose for detail at the bottom of image, the sky would burn out completely.
Canon EOS-1Ds Mark II, 17–40mm lens, 1/5 sec at f/22, ISO 100

David Noton

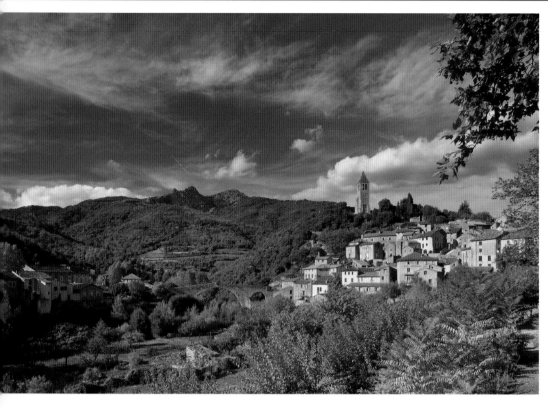

<< In this shot of the French village of Olargues in the Languedoc, the light was coming from over my left shoulder, so it wasn't quite sidelighting and wasn't quite frontlighting. I had to time the shot just right when the warm sidelighting was still on the village but the encroaching shadow from a hill had not yet engulfed the 12th-century bridge. The drama of the sky was also crucial in this shot.
Canon EOS-1Ds Mark II, 24–70mm lens, 1/50 sec at f/11, ISO 100

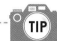 **TIP**

" Working digitally allows incredible versatility, both in-camera and post-production, particularly for merging different exposures to overcome extremes of contrast. You need to be meticulous in the visualization, execution and processing of an image. Think through all the stages of how you will achieve the final image before you even touch the camera. "

SIDELIGHTING

My favourite and most used form of lighting is sidelight, when the sun is about 90 degrees to the camera. It gives a wonderful texture to the landscape, providing shadows down the sides of trees, mountains, rocks and buildings and revealing their form in three-dimensional relief. Working up in the extremes of latitude, like the Canadian Arctic, you get 24-hour daylight in the summer. The sun just bounces around the horizon and gives this beautiful, low sidelighting permanently. It's difficult to know when to go to bed!

Often you're working in a situation where there's a bit of backlighting and a bit of sidelighting, so the sun is coming from an oblique angle. I made use of this in the shot of the barley fields in Umbria (page 59) to record the mountains and trees as black shapes while retaining the texture and detail in the foreground. Again, there can be a big problem with flare. You really have to watch the direct sunlight playing across the front element of the lens and take steps to eliminate it.

FRONTLIGHTING

Shooting with the sun behind you may be fine for a flattering portrait when you want to smooth out the skin tones and avoid harsh shadows across the face. It will have just the same effect on a landscape; that is, to flatten out tones and eliminate any sense of texture. For this reason it is best avoided when you want to reveal the form of landscape features, and in all likelihood this will be most of the time. It does have its place, however, when the scene has strong tones and contrasting colours, such as yellow leaves or white bark against a dark blue sky.

OTHER FACTORS

It isn't just front, back or side that you have to think about with lighting directions; there are other considerations too. When I arrived at the village of Olargues in France (above), and thought what time of day would be best for photography, I could see that in the morning the light would be on the wrong side for the village, so I had to go for an afternoon shot. There was a hill just out of the frame to the west, which was increasingly going to cast a shadow across the landscape as the light went down. So while I wanted to wait until I had the last of that warm sidelighting on the village, I couldn't wait too long or there would be a shadow right across the bridge and on the foreground. I had to pick that critical moment when there was still detail in the image where I wanted it, but when I also had late afternoon directional sunlight.

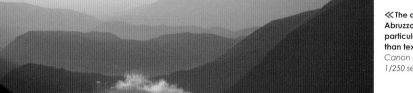

<< The dawn sun backlights the mountains of Abruzzo National Park, Italy. Backlighting works particularly well when shape matters more than texture to create a graphic image.
Canon EOS-1Ds Mark II, 100–400mm lens, 1/250 sec at f/6.3, ISO 200

You can see the first rays of light playing >> across the image here, adding wonderful texture. In this case, the landscape is just a few centimetres from the front element of the lens.
Canon EOS-1Ds Mark II, 24mm lens, 1/6 sec at f/22, ISO 250

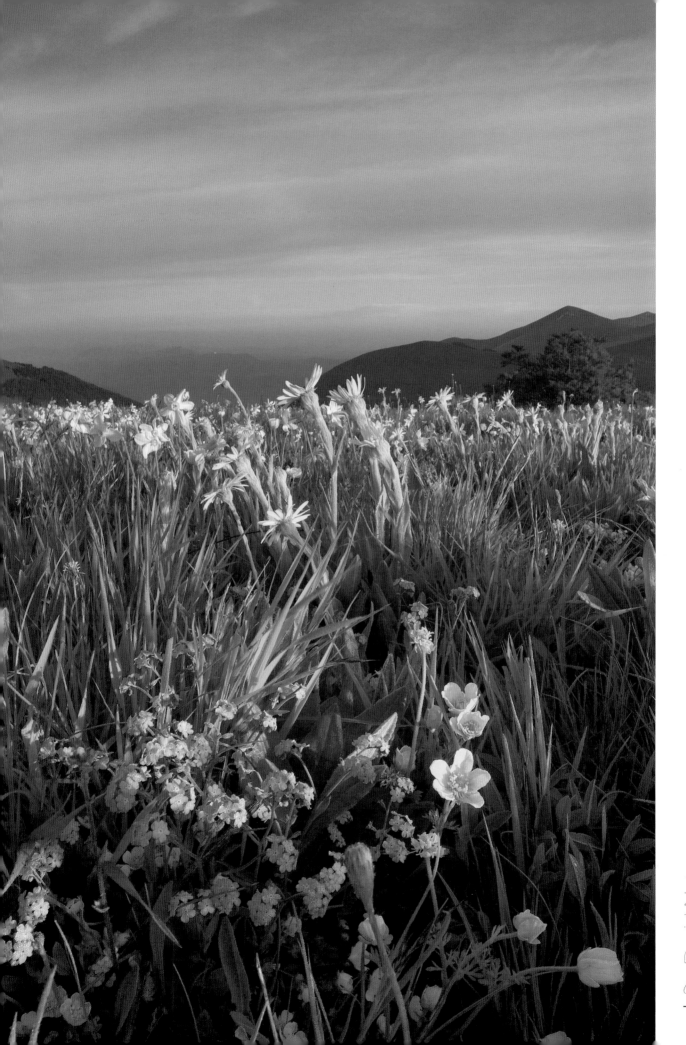

David Noton

WEATHER: DODGING THE RAIN CLOUDS

There's an old adage that the best pictures are taken in the worst weather. I don't think that's quite true, but extreme weather can certainly be very interesting, with the most dynamic lighting. It's wonderful to be outside on a beautiful sunny day with a blue sky, but it's a picture-postcard situation and most photographers are looking for more drama than that. I've been to places many times where the weather has been perfect every day, and after a while you start longing for a cloud. Then again, I spent two weeks in the Norwegian fjords when it rained incessantly. I had one morning session of photography and came back with a single shot! It's true that the most beautiful places in the world often have the worst weather.

READING THE FORECAST

Like most landscape photographers, I have had to become a weather expert. I have the forecast as my homepage on my computer and I consult it daily, or sometimes hourly, looking for those situations where a front is coming through, which gives very changeable weather but often the most dramatic lighting conditions. Unfortunately, a standard forecast is not geared up for the needs of photographers. There are more specific and detailed sources on the Internet, but you still need to learn to read between the lines of the information they provide.

Mist is one feature of the weather that is often possible to predict from the previous night's forecast – a settled high-pressure system, no wind, clear skies and a big drop in temperature overnight. All photographers love mist, especially when it is lying low and backlit by the rising sun. The moisture in the air diffuses the light, softening colour and contrast for the subtle effects I talked about earlier in the chapter. Local knowledge is really useful here; mist tends to collect in the same areas, so you can plan ahead more easily than with other weather patterns.

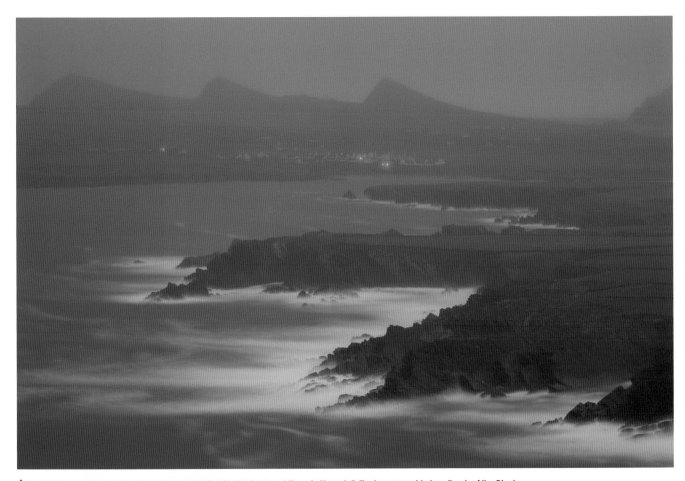

⌃ Standing in the wind and the rain on the western tip of Ireland seemed like a fruitless vigil. The incomparable headlands of the Dingle Peninsula receded into the murk as the first dawn twilight filtered through the heavily laden sky. I set up and started a long exposure, more out of habit than hope. But as I paced by the tripod, waiting for the shutter to close again, I reflected on the ethereal nature of the scene: monochromatic, murky, sodden, but fantastically atmospheric. Always experiment. What have you got to lose?
Canon EOS-1Ds Mark II, 70–200mm lens, 30 sec at f/13, ISO 50

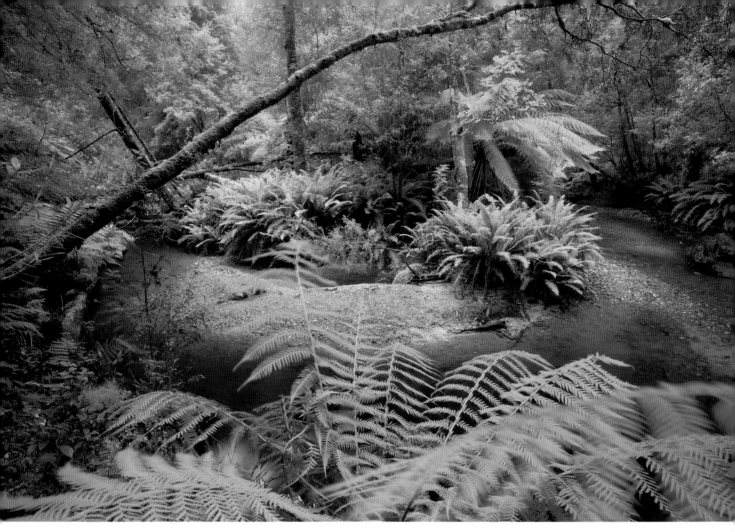

⌃ In forests, you want a dull, overcast day to give a low-contrast light source. If you tried to photograph this shot, taken in the Tasmanian rainforest, with hard sunlight filtering through the trees there, the contrast would be sky-high. There's no way you'd get detail under the ferns.
Canon EOS-1Ds Mark II, 17–40mm lens, 8 sec at f/22, ISO 160

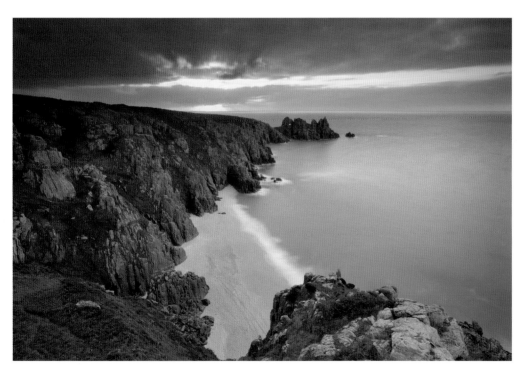

≪ When I got up before dawn at Porthcurno on the Cornish coast of England, I was pretty certain it was going to be a futile session. The weather looked fairly overcast and I didn't think there was much chance of any light coming through. But don't to be too ready to give in. Put yourself in the right place at the right time, be patient, and sooner or later dramatic lighting situations will come about. Too many times I've looked at the sky and thought nothing was going to happen. I've packed up and realized later on that I should have stuck it out. It only takes a 15-second burst of light to change your fortune.
Canon EOS-1Ds Mark II, 17–40mm lens, 3 sec at f/22, ISO 50

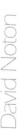

David Noton

WINTER WEATHER

Frosty mornings and wintery, snowy weather are much sought after. The combination of crisp, low light and frost is always a winner. Such conditions for those of us living in temperate locations are rare, but patience and persistence are rewarded. Even without the extra magic of snow and frost, winter has many advantages for photography. The light is low in the sky virtually all the day, which means that you can work with it most of the day – unlike during the long hours of midsummer. Summer also brings with it those hot, high-pressure systems where the haze builds up. Haze is the one thing that is a real killer photographically.

On a fine winter's day, the air has a cold freshness that gives clarity to colours and, even in more subdued light, the bleakness of the landscape can inspire powerfully atmospheric pictures. The weather is more turbulent towards winter, producing strong winds. If you're photographing a rugged coastline when the wind is battering huge great waves on to the headlands, it's a dramatic situation that lends itself to strong pictures. Unfortunately, it can cause real problems because it's almost impossible to keep the camera steady, even with the most solid of tripods.

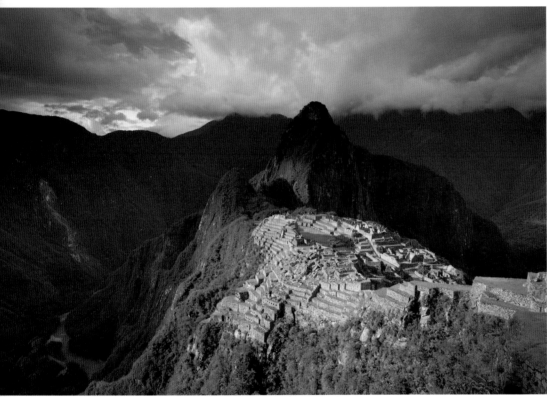

≪ This is an example where dramatic weather can give very interesting lighting. It had been raining all afternoon and just for a few seconds the clouds parted and this shaft of late-afternoon sunlight hit Machu Picchu, Peru, to contrast with the heavy cloud sitting on the mountains.
Canon EOS-1Ds Mark II, 17–40mm lens, 1/25 sec at f/13, ISO 100

A misty dawn in the Blackmore Vale in Dorset, ≫ England. Low-lying mist in pinky dawn light is always a classic. It is possible to predict mist from the previous night's weather forecast and it tends to settle in the same areas, making it possible to pre-plan a shot.
Canon EOS-1Ds Mark II, 70–200mm lens, 1/5 sec at f/16, ISO 100

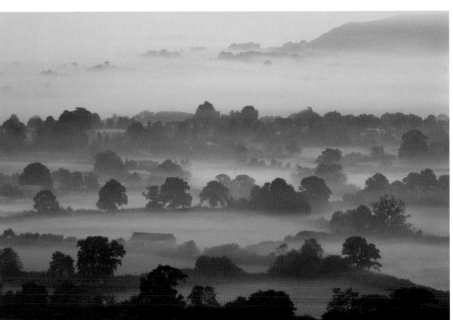

TIP

❝ Photographers love their gadgets and a really useful one is the Casio Pro Trek watch. It is solar-powered and has a compass, altimeter and barometer, so you can look as though you are an expert on occluded fronts and anti-cyclones! ❞

This picture illustrates to me just how >> flexible shooting digitally is. It was shot at dawn, just before the sun came up, so light levels were quite low. I was commissioned to photograph these animals in their environment on an estate. To get this kind of picture I had to increase the ISO to 1600 and yet the quality is still superb. I just couldn't have captured this image with film.
Canon EOS-1Ds Mark II, 100–400mm lens, 1/12 sec at f/16, ISO 1600

CLOUD COVER

The combination of wind and dense cloud yields those dramatic skies we love to capture. It only takes a few seconds to transform a location when shafts of light come through the clouds, as the picture of Porthcurno in Cornwall (page 63) demonstrates. The digital SLR really comes into its own in such rapidly changing light. With my big panoramic camera that I used for years, I'd have to change film every few frames. It always seemed to me that I was changing film just when the light was perfect. With digital, it's as though you are shooting away with a camera that never needs reloading. With a 4GB card in there, you can go on all day.

If there is little wind to break up the cloud and it is lying in a thick grey layer that looks like setting in for the day, then your photographic opportunities are limited. Instead of going for a wider view of a landscape, you can look for smaller details – a waterfall or forest where flat light is an advantage. I've been in the bizarre situation where I've been in Costa Rica in the rainforest, wanting to do jungle photography, and it's been too sunny; I had to wait for some cloud. Photographers are very rarely completely happy!

⅋ Crisp, low light together with frost is highly sought after, especially combined with the heavy, dramatic sky that photographers love. You need patience and persistence to capture such situations, as they do not happen often.
Canon EOS-1Ds Mark II, 17-40mm lens, 1/30 sec at f/8, ISO 100

David Noton

Composition in landscape photography is about making choices. What aspects of the scene are you going to include in the rectangle of your viewfinder and how might they best be arranged within the frame? This chapter aims to help you make those decisions by looking at the relationships between foreground and background, texture and pattern, lines, form and colour that occur in nature.

Dramatic clouds and desert ≫ haze made for a graphically dynamic composition in Death Valley National Park, California. I was taking a break from my normal 'off before dawn' routine, staying around my campsite, but this sunrise was too wonderful to pass up on.
Canon EOS-1Ds Mark II, 70–200mm lens, 1/3200 sec at f/3.2, ISO 200

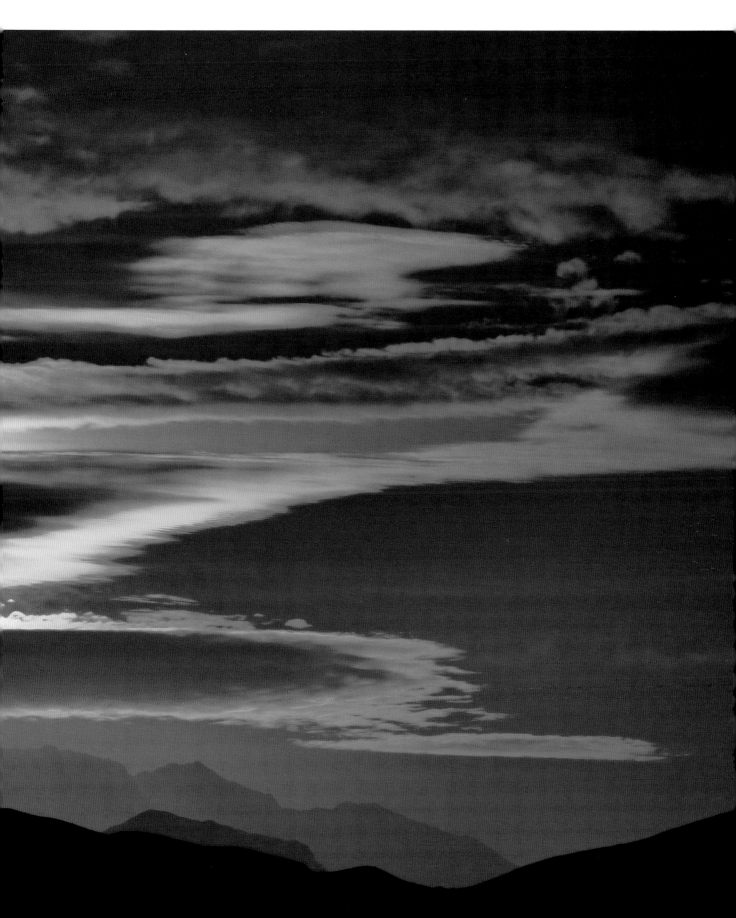

USING THE FRAME

When looking through a DSLR camera, the viewfinder provides a frame with which we see out through the lens and into the world. Defined by the chosen lens, the viewfinder is where photographic composition begins.

As we move the camera, the relationships of objects within the frame change in terms of spacing between them, the scale and how the lines and shapes move through the rectangle. To fully explore the possibilities of any worthy situation, it is important to thoroughly explore the scene and experiment with the many options. This is one of the most exciting aspects of photography – the arrangement of objects within the rectangle. By taking the extra time to carefully observe the relationships of lines and forms, foreground and background, and the balance of tones, your work will greatly benefit.

CONSIDERING THE EDGES

Distractions around the edge of a frame can ruin an otherwise good photograph. A bright piece of sky in the corner of a darkly lit, low-key image will pull the viewer's eye out of the frame. An out-of-focus branch in an otherwise sharp image will do the same. When you are excited about capturing a landscape in front of you, it is easy to become so absorbed with your main subject that you overlook small details like this, but they will leap out at you when you view your results.

Moonrise over Manley Beacon, Zabriskie ⋁
Point, Death Valley National Park, California.
Take time to consider how the balance of
tones and the relationships between objects
work within the frame.
*Canon EOS-1Ds Mark III, 70–200mm lens,
1/60 sec at f/2.8, ISO 800*

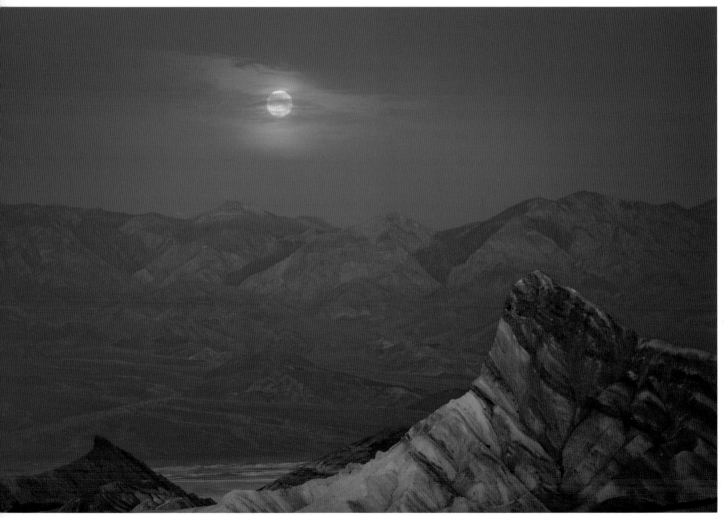

Train your eye to examine the edges of every image as well as the rest of the frame. Once you start watching for these distractions, you will find yourself easily solving these small but critical issues by repositioning the camera, changing lenses or moving your feet.

TEXTURAL PATTERNS

One of my favourite compositional techniques is to fill the frame with a textural pattern. The subject is evenly distributed and sometimes the image can give the effect of fabric or wallpaper.

In the Burney Falls image on page 70, the pattern of rock and water move in an even rhythm through the frame. No sky or distracting bright areas are included, nor is any foreground shown. This gives the composition a flatness of scale that heightens the textural effect. In the Pines in Fog image on page 71, for example, the branches spread throughout the frame. In my Zabriskie Point photograph (see pages 72–73), even though there is some sense of depth, the even positioning of erosion patterns fill the frame. By not including sky or near foreground elements, the pattern is emphasized and heightened.

SPACE AROUND THE SUBJECT

Some subjects require a completely different approach to filling the frame – it is more about emptying it to give the main focus of the composition space to 'breathe'. In this case you are looking to highlight the shape, form or colour of the subject, and the space around it should complement it rather than fight for attention. An even tone of water, sky or greenery can be an appropriate backdrop here.

This is analogous to the art technique of using negative space. The space around and between objects define this negative or, perhaps more accurately, neutral space. It is always important to be aware of both the positive space, usually the main subject, and the negative space around the subject.

⋀ This close-up of a maple leaf demonstrates the idea of taking the subject to the edges of the frame, and also the importance of negative space.
Canon EOS-1Ds Mark III, EF 50mm compact macro lens, 0.6 sec at f/32, ISO 100

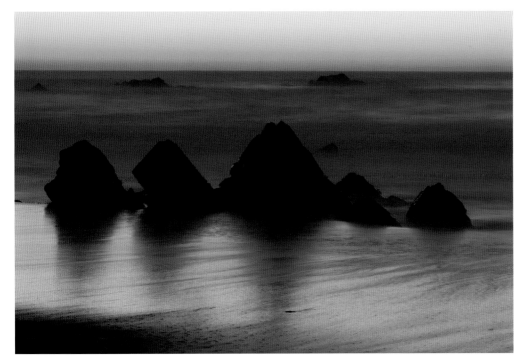

≪ This image of Big Sur, California, at twilight was made with my 70–200mm lens. Longer focal lengths are very useful for isolating a pattern from the larger view. Looking for some balance of colour and form, I found an angle where the rocks were separated into clear and repeating shapes that created rhythm across the frame. This is often a process of trial and error, that of setting up the tripod, looking through the viewfinder, and moving again until all elements come together.
Canon EOS-1Ds, 70–200mm lens, 30 sec at f/32, ISO 100

William Neill

PLACING THE FOCAL POINT

Many good photographs have a focal point; a convergence of lines, form or subjects that holds the most interest in a composition. The focal point in a work of art is the centre of visual attention, and is often different from the physical centre of the work.

Where you place trees, rocks, flowers, mountains or rivers in landscape photographs is a critical part of good composition. This placement is affected by the realities of the local topography and flora, such as which tree grows in front of an especially photogenic river. The tree may be markedly unspectacular or even clumsy in form and, even though we may be tempted to combine the two elements, restraint may be necessary! We can't create a strong photograph from weak elements. We also can't control what tree grows where, or which mountain is framed between wonderful trees along a graceful river.

We can, however, control which combination of subjects we choose to aim our cameras at. We can also control where we stand and how we arrange objects in the frame. It is important to realize that good composition is a highly selective process, where the photographer makes the final choice. If a composition does not work, it is no one else's fault. Excuses about where one had to stand, or that one could not find a better foreground, do not improve the image!

TIP

❝ When composing any photograph, move your eyes around the edge of the frame, then through the entire frame. When doing this, watch carefully for intrusions and distractions that take attention away from the subject. Bright areas along the edges are especially distracting, as are out-of-focus objects in an otherwise sharp image. ❞

⩔ I have concentrated on the rhythmic pattern of rocks and water through the frame in this picture of Burney Falls, California. The tones are even, with no sky or bright areas to distract the viewer's attention.
Canon EOS-1D, 70–200mm lens, 1/4 sec at f/22, ISO 100

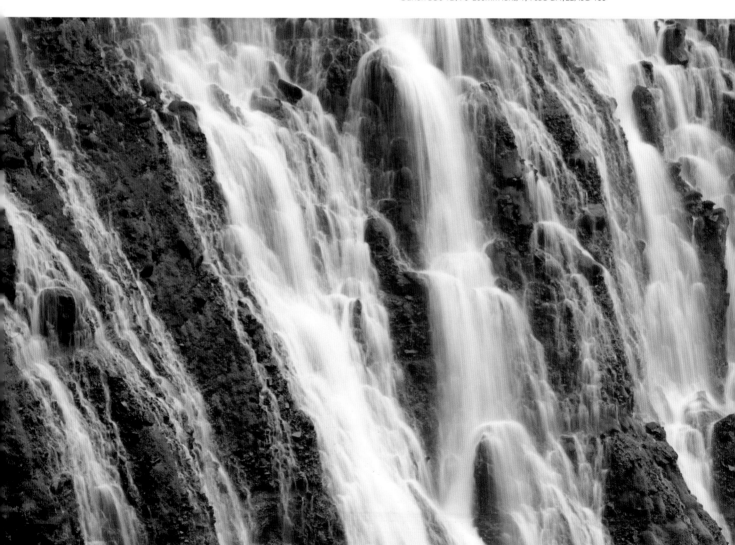

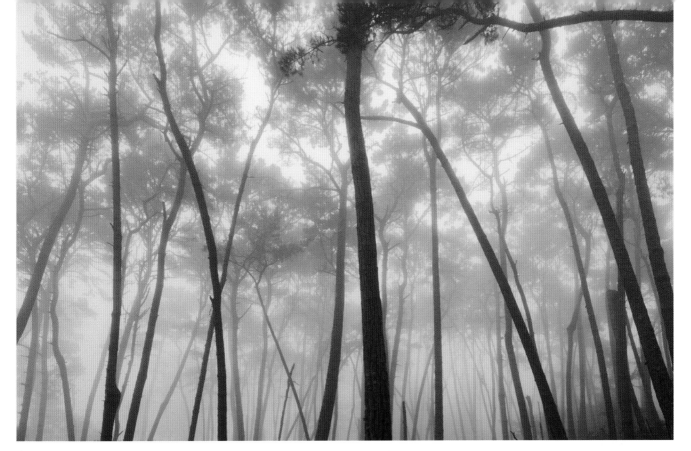

⌃ The branches spread out throughout this image of pine trees in fog, but the viewer's eye is contained within the frame by the angle of the trees at the outer edges.
Canon EOS-1Ds Mark II, Tilt Shift 24mm lens, 1/4 sec at f/16, ISO 100

THE RULE OF THIRDS

The rule of thirds is a suggested way to place key subjects within the frame. By dividing the frame into thirds both horizontally and vertically, four focal points are formed at the intersection of those lines. The intersections are often referred to as 'power points'. The theory is that objects placed on or near these points will give more focus, energy and interest to the overall image. Many photography books and instructors advocate the use of these four points to align key elements. It is a good way to remember that centring a subject in the middle of the frame is often not the best choice.

I agree that this technique is very useful as a guideline, though I have never consciously used it myself. I only consider what I see in the viewfinder, arranging my compositions in a very intuitive way. I have found that I have a good, instinctive sense of design, and over the years have learned to trust it. However, when looking back to edit and study my past efforts, I have noticed situations where I have composed in a way that follows the rule.

If you are just beginning in photography, or feel that your compositional skills need some help, then by all means consider the rule of thirds to help guide your image designs. If you are feeling stuck with a composition, it can certainly help you see a way forward. Be aware, though, that, as with all photographic 'rules' it can too easily become dogma that inhibits creative experimentation. Many successful images do not follow the rule of thirds.

Sunset clouds, Sierra Nevada Mountains, ≫
California. The rule of thirds, as followed here,
can be a reliable aid to composition, but
need not be followed slavishly.
Canon EOS-1Ds Mark II, 28–135mm lens,
1/80 sec at f/5, ISO 100

William Neill

71

ORDER OUT OF CHAOS

When the composition of a photograph fails, it is usually because there are distracting elements within the frame. If the subject of the photograph is not clearly defined by its graphic design, the image will not have as much impact or clarity of intent. Think in terms of paring down your compositions to the essential elements.

We often react to many aspects of a scene, such as the sounds and smells, as well as what it looks like. Our brains can take in many senses at once, including the full scope of our vision, and our first instinct is to include as much as possible, simply because we are experiencing all of it. The disciplined image designer will understand and overcome this instinct by realizing that one picture can't encompass all to which we respond. As you have probably experienced, slapping on a wide-angle lens in order to include all these elements doesn't always translate your experience in the final result.

Creating order out of chaos is an exciting challenge. When I first started making photographs, they were mostly close-up images. The process of isolating a tiny piece of nature helped me learn to see simple compositions. The shallow depth of field I used made it fairly easy to separate the subject from a blurred background. When photographing a blade of grass, I could see how lines moved through the frame and as I moved the camera to adjust the composition, the division of space in the frame would either look balanced or not.

This process was a good lesson in image design. I still look for simply composed images with strong graphic design, but I don't shy away from more complex situations. Of course, nature is so full of visual intricacies that it would be very hard not to deal with busy scenes. A busy landscape can be hard to compose with a well-balanced design, but looking for how lines fit and flow in the rectangle is helpful. Visualizing, or even sketching out, the primary design just using a few lines, should help you judge the composition.

With any subject, even with an image filled with an overall pattern, such as the grasses in a meadow, look for a curve or repeating lines that will serve as the graphic underpinnings of the image. Such a foundation, even if not readily apparent, will give the image a cohesive feel.

TIP

❝ Look for a balance and a rhythm to lines and shapes when you compose your photographs. The more you develop and trust your sense of design, the more you will be able to deal with complex subjects. There is order in chaos if you are willing to search for it! ❞

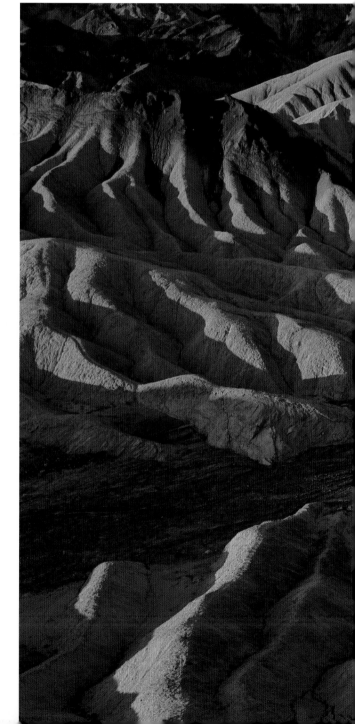

Filling the frame with pattern is one of my favourite composition techniques. ≫ It works particularly well when the subject is full of texture, like these cliff erosions, with their form emphasized by the play of light and shadow, at Zabriskie Point, California.

Canon EOS-1Ds Mark III, 16–35mm lens, 1/125 sec at f/8, ISO 100

The waterfall composition shown here looks very simple, with the water >> framed by rocks on either side. However, I paid close attention to eliminate some distracting branches. I had to find the right angle to do this, which required that I set up my tripod in the stream while I balanced precariously on some small rocks.

Canon EOS-1Ds Mark II, 70–200mm lens, 4sec at f/22, ISO 100

William Neill

73

≪ With broader landscape scenes like the classic view of Emerald Bay in Lake Tahoe, California, the foreground, middle ground and distance subjects are pared down to the bare minimum. If I had taken a wider view and included more of those elements, it would have lessened their impact.
Canon EOS-1Ds Mark II, 70–200mm lens, 1/40 sec at f/5, ISO 100

⋀ The famous Half Dome mountain in Yosemite, lit by late afternoon light, contrasts with the darker ridge in the foreground. The horizontal angle of this adds a dynamic element to the composition. Because of the high contrast range within the scene, I took three different exposures and blended them with HDR software (see pages 40–41).
Canon EOS-1Ds Mark III, 70–200mm lens, ISO 100

PARING DOWN THE ELEMENTS

A good exercise, as you look through your camera, is to see how little information of the key elements can be used to convey the essence of that place and its mood. In the image of Emerald Bay above, for example, the trees at the bottom started to lose their graphic shapes and merge to black so I just included the tops of the trees, silhouetted against the lake. Those foreground shapes are also seen in the middle area of trees, thus repeating the pattern.

LIGHT AND SHADE

The relationships between light and shadow often serve to define the shapes in our images. In the Cottonwoods image opposite, the shadowed forest and cliffs behind this grove of trees work well in terms of popping out the bright shapes. This type of situation can be found often in the landscape, especially where topography is uneven and the light low-angled. Look for deep shadows behind graphic subjects, especially trees.

Light and shadows are also important for bringing out textures. The graphics formed by the light become a major aspect of the image design. The textures of Zabriskie Point's eroded mud hills (see pages 72–73) are emphasized by the strong sidelighting.

LINES AND ANGLES

When there is so much going on in a landscape, our compositions can easily become messy and unfocused. Lines, curves and angles occur everywhere in nature, and you can use these to provide some graphic structure or softer rhythm to a photograph.

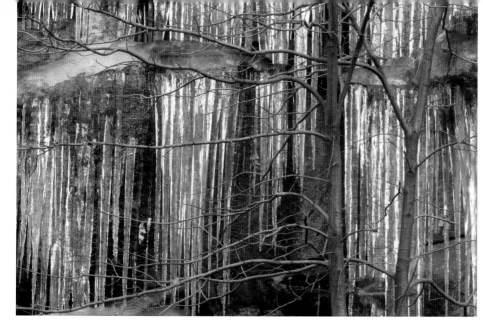

Diagonal lines often add a dynamic element to an image design. The image of Half Dome opposite makes use of the cliffs of Glacier Point to frame the famous rock face in Yosemite. Two factors make this ridge complement the main subject of the mountain. First, the line is diagonal, and second, it is darker and doesn't compete with the main subject. The use of a telephoto lens helps compress space and makes Half Dome seem closer to the ridge than it really is.

Vertical lines appear everywhere in natural structures and can be emphasized to give a sense of strength to the composition. They appeared in dramatic fashion in the form of icicles in Yosemite National Park and, in my image Oak and Ice (above), I wanted to contrast these powerful lines with the delicate horizontal branches of the tree. I paid close attention to arrange the tree branches in a balanced manner, as if the ice were not there. Next, I watched carefully and moved slightly until the relationship between tree and ice worked well for me.

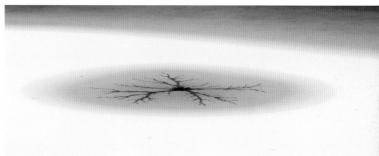

⋀ Extracting a small detail, like this crack in a frozen lake, from a broader landscape can help train your eye to dispense with unwanted detail in a composition. This image is a good example of using negative space as an important element in itself. The white area not only implies the empty spaces created in winter, but it more obviously isolates the strong pattern in the ice to dramatic effect.
Canon EOS-1Ds, 70–200mm lens, 1/400 sec at f/9, ISO 100

⋁ Using light and shade is a good device to emphasize a subject and make it stand out from the background. The cottonwood trees in Yosemite, catching the sun, pop out of the picture and the dark forest behind provides no distraction.
Canon EOS-1Ds Mark III, 70–200mm lens, 1/90 sec at f/2.8, ISO 100

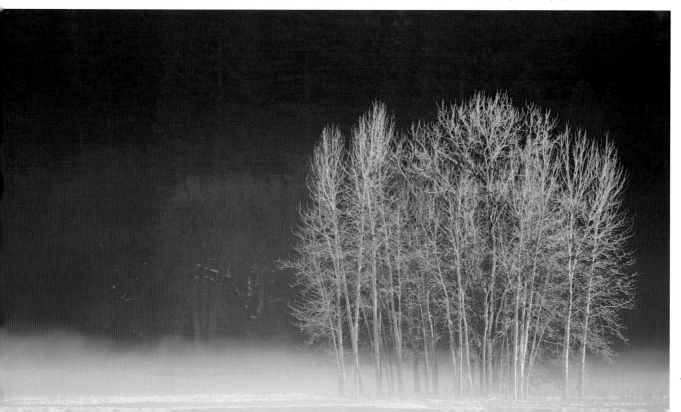

William Neill

DEPTH IN THE LANDSCAPE

It is important to consider the relationship of background and foreground elements in your composition in order to give the whole image a sense of cohesion. Sometimes this relationship can be carefully constructed to help provide depth to the image and make it appear more three-dimensional.

FOCUS ON THE FOREGROUND

In landscape photography, the foreground is often an important element in composing a photograph. The use of nearby objects such as flowers, a flowing river or the branches of a tree is a common way to lead the viewer back into the scene towards the major geographic landmarks of a place. A field of poppies leads the eye back towards green, rolling hills. A meandering stream wanders across the image frame to reveal golden desert cliffs beyond.

When a prominent subject is included as a device to provide depth, a wide-angle lens placed low and close to the foreground object will make it appear larger than if the camera were at standing height. Since a wide-angle lens makes objects look smaller, this technique makes the foreground a major design element while the distant objects recede into the background.

The great advantage of this approach is that the viewer is given a strong sense of immediacy. In a way, it is more a transportive device of composition than an interpretive one. It is ideal for stock photography, as it provides editors and publishers with descriptive photos that make their readers feel present in the scene. If you are shooting with stock sales in mind, including the eye-catching foreground in a scenic image, with perhaps a dramatic sky, will improve your chances of having your work published.

⋁ **The cliffs of El Capitan and Cathedral Rocks at Gates of the Valley, Yosemite National Park, are the main subjects here, but the snow-covered rocks in the foreground help to lead the viewer's eye towards them.**
Canon EOS-1Ds, 20–35mm lens, 1/15 sec at f/22, ISO 100

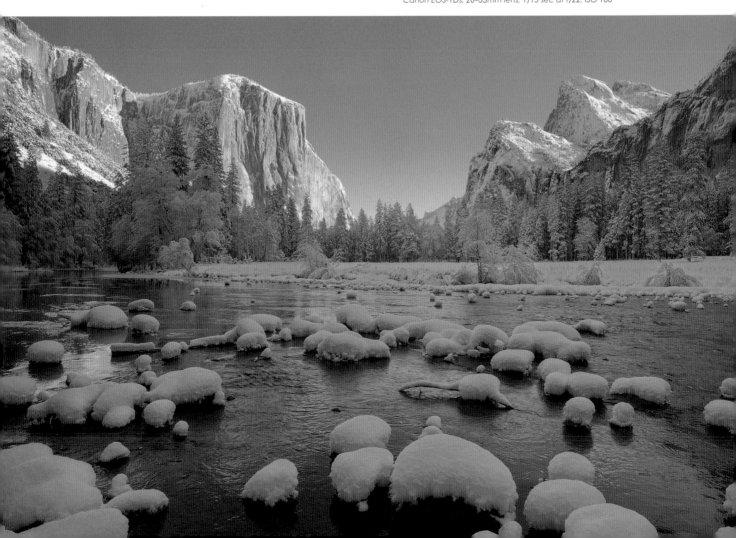

⌃ While photographing this amazing winter morning, I noticed how the rocks in the foreground mimicked the massive peaks of the Sierra Nevada Mountains, California. Although the mountains draw the most attention in this composition, the repetitive ridgelines of rocks and peaks form a pleasing graphical balance.
Canon EOS-1Ds Mark II, 70–200mm lens, 1/640 sec at f/5.6, ISO 100

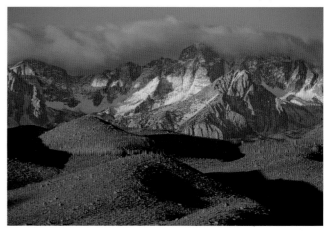

⌃ As I was standing before the great Sierra Nevada mountains in early morning light, the peaks were revealed by strong sidelighting, as was the foreground desert sage and rabbitbrush. With the camera ready, decisions had to be made quickly as the light wasn't waiting! The intuitive process of selecting a composition started to kick in as I saw the light bring out the textures of the scene as I aimed my camera at a perpendicular angle to it. The texture extended right to my feet, providing a graphic foreground in the first image. For the second version, I zoomed in closer to the mountains to emphasize the rolling hills with soaring peaks above. Personally, I enjoy the tighter composition.
Canon EOS-1Ds Mark II, 70–200mm lens, 1/160 sec at f/14, ISO 400
Canon EOS-1Ds Mark II, 140–400mm lens, 1/250 sec at f/5.6, ISO 100

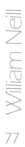

William Neill

77

The image of El Capitan and Cathedral Rocks (page 76) is a version of this style. The dramatic cliffs are the key elements, but the strong, graphic shapes of the snow-covered rocks lead the eye back to the cliffs. The reflective river adds an important foundation to the composition. The camera was set on my tripod at standing height so as to gain space between the rocks. Had the tripod been lower, these shapes would merge too much and their graphic contribution lessen.

The next time you make landscape photographs, remember how important it is to have strong graphic interest in your compositions. Be very selective when picking your foregrounds. They need to be just as cleanly designed and well lit as any other part of your composition. Think of the foreground as providing a clear and interesting pathway into the scene. Pay attention to the shapes and forms of the foreground to see how they might relate to objects beyond. The image can often be enhanced by contrasts, such as delicate flowers before rugged mountains, or by similarities, such as rounded beach pebbles before wave-worn sea cliffs. Most importantly, experiment and have fun!

˄ This image illustrates a favourite style of mine, one you might call an 'isolation' technique. Major clues as to scale, such as the sky, are removed. I was especially interested in the singular rock and worked the composition so that the slope of the rock ridge flows downwards, which greatly helps to make the rock a major focal point in the frame in spite of its small scale.
Canon EOS-1Ds Mark III, 70–200mm lens, 1/20 sec at f/22, ISO 100

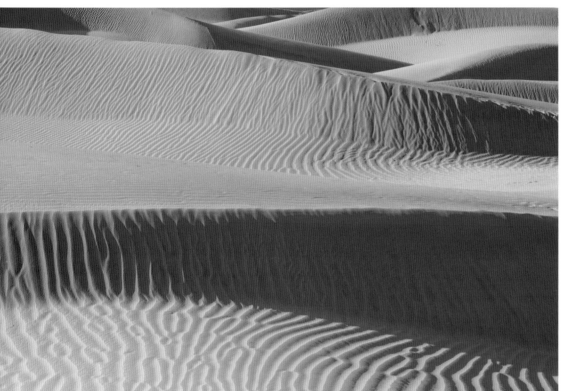

≪ The use of a telephoto lens compressed the sense of space between the ridges of these dunes. At one glance, one sees the great depth of field in the scene, but the compression effect also helps to create an abstract design of strongly graphic lines.
Canon EOS-1Ds Mark III, 70–200mm lens, 1/8 sec at f/32, ISO 100

DEPTH COMPRESSION

However popular it might be, the 'strong foreground' technique is not the only approach to photographing scenery and it is important to explore other creative options. In much of my work, I prefer not to provide much context, so I tend to remove visual clues as to the scene's depth. Although you could consider this style as ambiguous, I would see it another way. The lack of reference adds intrigue to the composition, and engages the viewer in what they are seeing. I would rather create an image that asks a question than one that answers one; one that inspires wonder rather than merely describing the scene.

The normal clues for depth and scale ≫
are minimized in this image
– no sky and no close foreground.
Canon EOS-1Ds Mark III, 70–200mm lens, 1/20 sec at f/22, ISO 100

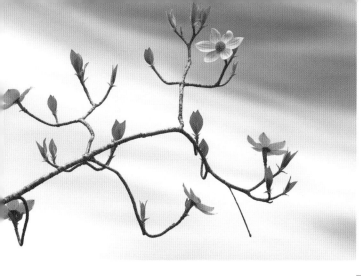

CHOOSING BACKGROUNDS

Finding good subjects is hard enough, but finding them with good backgrounds is still harder. When composing your photographs, be sure to look carefully throughout the frame. Make sure to make good use of your camera's LCD to inspect your compositions. Even on the small screen, key factors that could be distracting can be spotted and corrected in the field. It is much easier to fix problems with composition at the location than in post-processing!

I often look for situations in the landscape that provide a simple background, such as moving water in the close-up of dogwood (above), or fog behind trees (right). I also like situations where the background is darker and therefore helps the brighter subject 'pop'. There are also instances where the background is part of the subject.

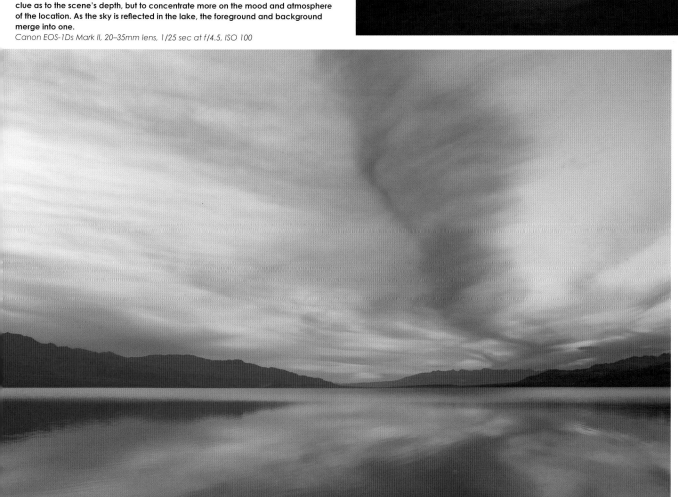

William Neill

CROPPING

I grew up in photography's version of the old school where 'the purity of vision is king'. Ansel Adams was one of my first mentors when I worked for his gallery in Yosemite. Cropping was frowned upon; if you had to do it, maybe you were not paying attention out there behind the camera.

By eliminating the option of post-exposure cropping as I learned to photograph, I learned the discipline of precise, in-camera composition. I am thankful that I did. Even using Photoshop, it is difficult to solve problems if you don't initially record the essential elements for your composition clearly.

If your photographic skills are developed with Photoshop as your primary darkroom tool, how dependent are you on the cropping crutch? I feel that compositional skills should be learned, refined and applied in the field. Depending on Photoshop alone to correct carelessness will often bring disappointment.

By understanding the limitations of the process, one can make cropping a tool, not a crutch. It is especially difficult to correct for poor camera position, where lines or forms are not aligned well. On the other hand, simply refining the edges of an image, by cutting off an intruding form or bright spot, can improve an image greatly without serious manipulation.

Some photographers will always refuse to crop their images, wanting to preserve their vision at the moment of exposure. I fully respect that position, and adhere to it most of the time myself. However, with clear recognition of its limitations, cropping can be done wisely. Assuming your goal is to make the best possible image, and you have an image that can be improved with cropping, then do so judiciously.

Cropping can be a learning process too, as a way of discovering how one might have better composed an image. This reminds me of what my friend Philip Hyde would say when critiquing an image: 'There is a good photograph in there somewhere!'

TIP

66 When another version is created after cropping, I find that the new image has different post-processing needs because the relationships between colours, shadows and so on will have changed. The histogram will be different, too. 99

Use Photoshop Guides to serve as ≫ crop reference lines for future resizing and repurposing.

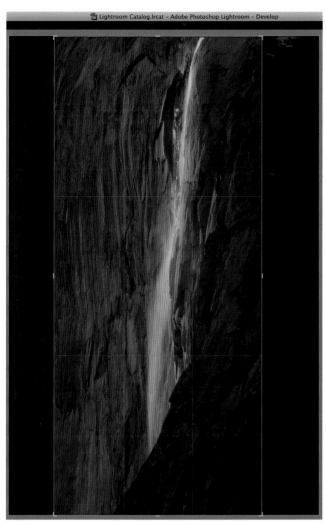

⋀ Adobe Lightroom offers a convenient and reversible way to crop your images. In order to focus the image clearly on the waterfall, I chose this long and tall format.

⋀ Here is an example of cropping using Photoshop. I set the Guides carefully to crop out a tree in the lower right, and the snow at the top. The guides can be left on the master file for future reference. To finish the crop and make it permanent, click on the Check button or double-click on the image itself.

CROPPING WITH PHOTOSHOP

There are several approaches to cropping using Photoshop. One popular method is to leave the image proportions intact and then use the Guides that are accessible when the Rulers (View > Rulers) option is selected. Simply click on the Ruler when visible and drag out the Guide on to the image. The idea is to preserve the master file (the original processed capture file with all layers included as adjustment layers). The Guides can be used to mark where you want to crop, left in place, and whenever the image is sized for various uses, the Guides are there as a final cropping aid. One key advantage is that it is easy to revert to the original image, or change the Guides to re-crop.

Personally, I use a less efficient method. I treat the cropped image as a new creation by executing the crop and then saving the image with a new unique name. Another way to do this in Adobe Lightroom is to create a Virtual Copy and crop in the Develop module using the Crop Overlay tool.

Here I cropped the original frame to greatly improve the image. High-megapixel ≫ cameras, like the 21.7MP used here, make it more feasible to crop to this degree when large reproduction is needed.

William Neill

WORKING THE SCENE

Work the scene by moving your feet. A step to the left, or a step backwards, can make a huge difference to the design of the image. Try changing lenses to help find a different perspective. With digital capture, there is no more worry about film and processing expenses, so don't be too timid with your experimentations. It is not unusual for a pro to take dozens of images on one given composition while trying different options.

With any digital SLR camera, you can review your different compositions on the screen. This will help you see what worked well and what did not. When I am not sure what to do next, I stop and scroll through my previous images to see if they stimulate other ideas. Sometimes they assure me that I have captured what I wanted and I can move on; other times, I will spot additional ways to compose the scene.

Later on, your computer becomes your lightbox to judge your efforts. Using most digital asset software, you can compare the various compositions. Subtle variations can be viewed side by side and ranked (usually with a five-star rating system) according to success. This stage of editing is vital in learning how better to compose your images. Unsuccessful efforts teach us what to avoid next time.

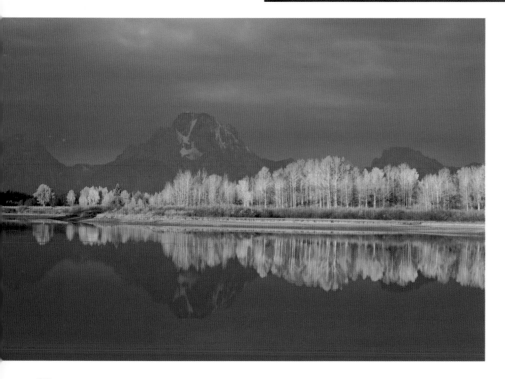

When you find an exciting subject, work the scene by trying different compositions. Here are two different photographs from the same session. The light on the aspen trees only lasted a minute and so I was able to adjust the zoom and made just three exposures, including the two shown here. I prefer the tighter framing, but I am glad I gave myself a few options. Naturally, had the light lasted longer, I would have made many more.
⌃ *Canon EOS-1DS, 28–135mm lens, 1/50 sec at f/9*
⟪ *Canon EOS-1DS, 28–135mm lens, 1/60 sec at f/7.1, ISO 100*

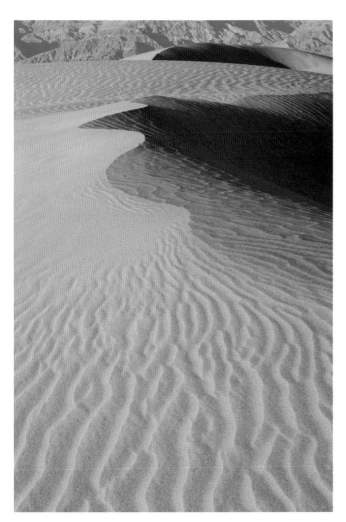

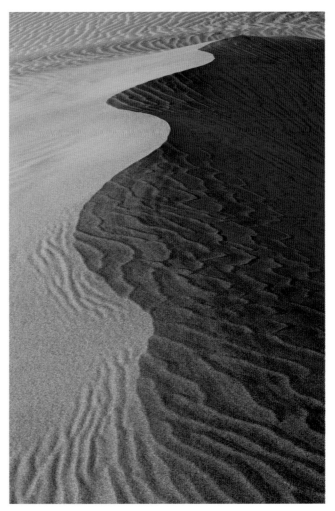

⌃ As the light was rapidly disappearing, I looked for features that would give strong foreground interest to the Funeral Mountains behind. The sky was not as dramatic as I would have liked, but the composition captures the tranquillity of the evening.
Canon EOS-1Ds Mark III, Tilt Shift-E 90mm lens, 1/8 sec at f/2.8, ISO 100

⌃ Photographing the Mesquite Flat dunes, I was attracted to the snake-like patterns here and used the dune first as a foreground to a broader landscape and then focused in close to concentrate on the pattern, making several different variations on the same theme.
Canon EOS-1Ds Mark III, Tilt Shift-E 90mm lens, 1/8 sec at f/2.8, ISO 100

SAND DUNE VARIATIONS

In Death Valley National Park in California, I photographed the dunes of the famous Mesquite Flats at sunset. I have been photographing these dunes since 1979 and still love the place. As often as it has been photographed, its ever-changing nature makes it a worthy lure for landscape photographers. I'm very attracted to photographing nature's designs, and there are always new sand patterns that blow me away!

On one hike into the dunes, I was looking for some scenic compositions that I needed for clients of mine. For practical reasons, I often have to remind myself not to focus on abstract patterns. The net result in any given shooting session is that I create images both for commerce and for my own pleasure.

To begin with, I was captivated with a snake-like pattern of one particular dune and I started photographing it as a foreground element for a broader landscape composition. I worked the scene with various compositions, both horizontal and vertical, mostly using my 90mm tilt and shift lens.

Next, I started to photograph the pattern as an isolated shape. Again I worked on several different framings of the pattern. The sun was going down and I made the image that I felt worked best, shown here, with the sun low to the sky but not yet blocked by clouds to the west.

I wandered off in search of other foreground elements, but I found nothing as exciting. While doing this, the sun went behind clouds for the evening. I waited to see if some nice sunset colours would appear in the sky and on the peaks to the east. The broader image shown, with the Funeral Mountains in the background, captured the serenity of the evening for me. Although I wouldn't have minded if this sunset had been more dramatic, I appreciated the peace and beauty of the moment.

PLACING THE HORIZON

One of the key decisions to make when composing a scenic landscape image is where the horizon line is placed. The standard textbook solution is to place it two-thirds of the way into the frame. If you were following the rule of thirds (see page 71), this would be along the top gridline.

There are many occasions when this works perfectly well and provides the most pleasing solution. Often, though, much more drama can be introduced to the composition by tilting the camera up or down to give greater emphasis to either the sky or the foreground area. Exploring both options, and all those in between, will help you realize the potential of a landscape location.

Keeping the horizon straight

There is nothing more irritating than a horizon that is slightly askew. If it is obviously tilted as a compositional device, that is one thing, but if it is meant to be straight and just misses, the impact of the image will be ruined. This is a surprisingly easy mistake to make, especially when handholding the camera, but also when the camera is supported on a tripod that is placed on uneven ground and, working outdoors, that is most of the time.

⌃ **The sky over Mono Lake, California, was amazing during this sunset scene. I selected a wide-angle lens and aimed upwards to include a large proportion of sky.**
Canon EOS-1Ds Mark III, 28–135mm lens, 1/60 sec at f/9, ISO 100

⌄ **When I made this long exposure along the Pacific coast in Big Sur, California, the interplay of rocks and surf was my central interest. Therefore, I aimed downwards, placing the horizon about two-thirds into the frame.**
Canon EOS-1Ds, 20–35mm lens, 8 sec at f/19, ISO 100

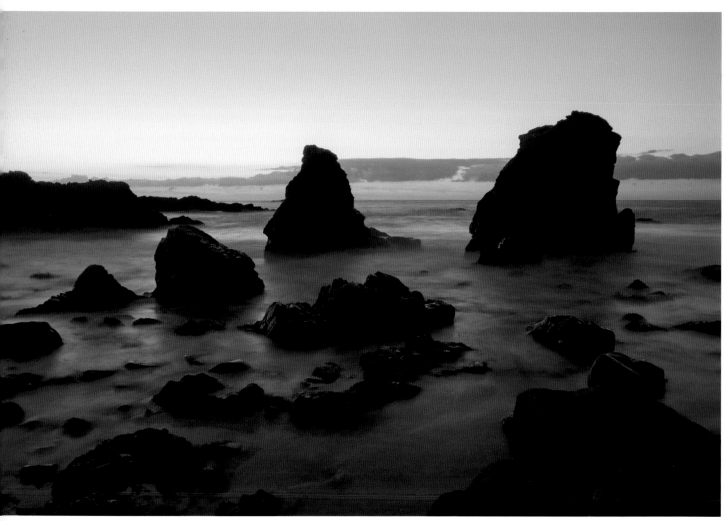

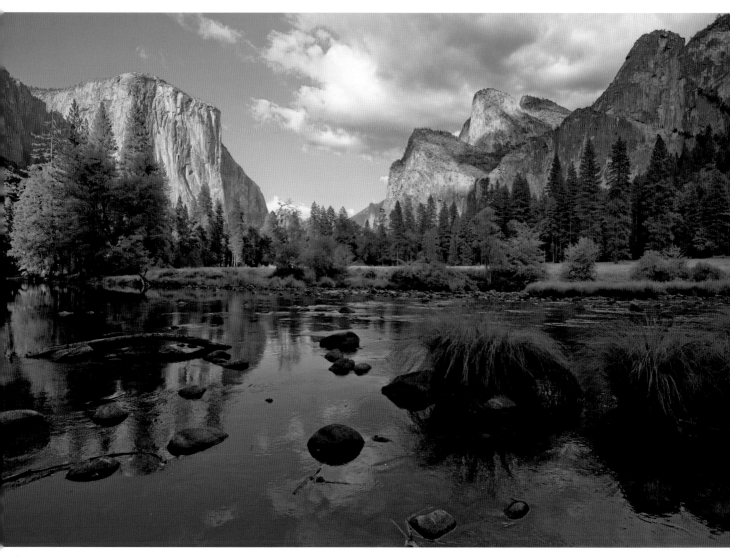

⋏ Although there is a 'rule' that states we are not allowed to centre things, including the horizon line, in our compositions, I have found many situations where that is the best option. I recommend that you try adjusting the horizon's position, and take many frames as you experiment with balancing the image design.
Canon EOS-1Ds Mark II, 20–35mm lens, 1/250 sec at f/7.1, ISO 100

Many serious landscape photographers use a small spirit level mounted to the hotshoe of the camera or the tripod head to ensure the horizon is correct. If you do not have one of these, it is very simple to correct a crooked horizon in Photoshop.

• With the image open, go to the Tool menu and select the Eyedropper tool. Right-click (ctrl-click in Mac) to expand and select the Measure tool (Ruler Tool in CS3) from the three choices.
• Click on one edge of the horizon and drag a line to the other side of the horizon. Zoom in to place this line accurately.
• View the image full-screen and, with the line drawn on your image, go to the toolbar and select Image > Rotate Canvas > Arbitrary.
• A dialog box shows the degree needed to correct the horizon, according to the drawn line. Click OK to level the horizon.
• To get rid of the untidy angled edges, use the Crop tool to drag the edges of the crop frame.

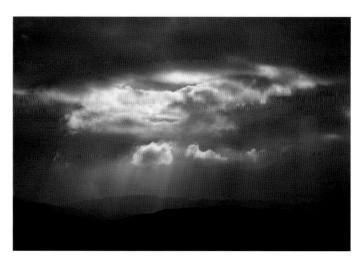

⋏ The clouds in this scene were my central interest, so I zoomed in to avoid the foreground and placed the hills at the bottom of the frame to let the clouds have the loudest voice!
Canon EOS-1Ds Mark II, 70–200mm lens, 1/64 sec at f/5, ISO 100

William Neill

CREATING A PANORAMA

Panoramic photography has had a devoted following among landscape photographers for many years but, until recently, it was a specialist field as it involved the use of cameras built specifically for the task. Photoshop has changed that, as it is relatively easy to create panoramas by 'stitching' together several different frames taken on a DSLR. The most straightforward way to do this is with one of the many software packages designed for the task, including Photomerge in Photoshop CS3.

If you have an earlier version of Photoshop, stitching can be done manually by placing the photos you want to join together as separate layers, so they overlap, then carefully deleting the upper layer to reveal the one underneath. Disguise the join using the Eraser tool with a soft brush, use Levels to ensure the tones are the same in the different parts, then select Merge Layers to combine the images.

SHOOTING FOR A PANORAMA

The easiest way to align the multiple frames when taking the initial photographs is to use a spirit level placed on the hotshoe of your camera or one on your tripod head. The more accurate way to expose frames for merging is to use a specialized 'pano' tripod head, which helps you keep the camera level, or by using tilt and shift lenses (see page 27).

One day I spotted a wonderful buckeye tree, and experimented with a regular (not TS) lens and no tripod. I found that I could be less accurate, even handholding the camera, and still make a successful composite. It did have mismatched edges where the three frames overlapped, so cropping was necessary. I prefer to be more precise, but if one plans for a little leeway around the edges, the framing can be refined in Photoshop.

USING PHOTOMERGE

- Photograph a series of images, either horizontal or vertical, overlapping by about 20 per cent and maintaining alignment of each frame as much as possible. Without fancy tools like tilt and shift lenses or specialized tripod heads made for panoramic photography, you can compose a broader view.
- Start the Photomerge process in Photoshop CS3 by going to File > Automate > Photomerge.
- Once you have selected the files for a panoramic merge set, Photoshop processes the files, calculates where data overlaps and matches the files to assemble the 'stitched together' new file.
- Crop the new image to get rid of any mismatched edges.

> **TIP**
>
> 66 Watch out for movement in images that you take to merge as a panorama. Drifting clouds, blowing foliage or light that alters in the time it takes to make multiple frames can cause imperfect joins. 99

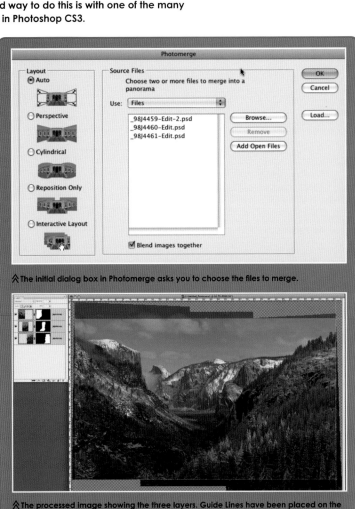

⌃ The initial dialog box in Photomerge asks you to choose the files to merge.

⌃ The processed image showing the three layers. Guide Lines have been placed on the file, and the Crop box set to eliminate the extra area left from my imprecise turning of the tripod. Greater accuracy is obtained when the tripod is properly levelled.

⌃ The merged files after cropping.

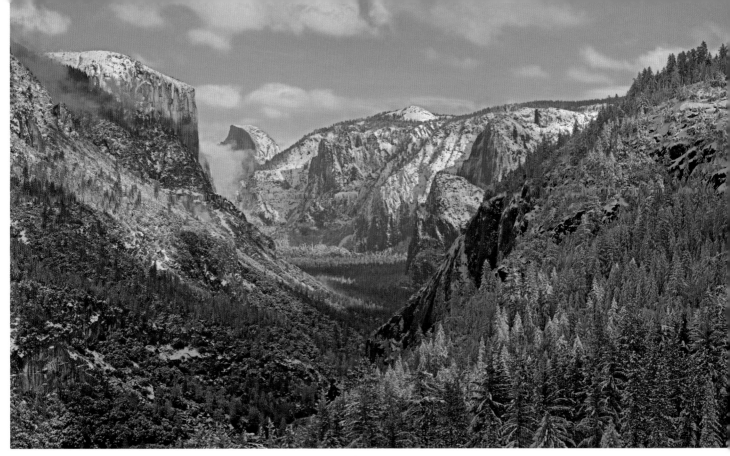

PHOTOMERGE FOR QUALITY

Spotting some pumpkins at a local sale, I decided to experiment with Photomerge to see what the quality would be like in the final image. I made three exposures with my camera, each time raising the lens upwards to include more of the pumpkins. I would usually try for an overlap of around 20 per cent between each frame, but in this image it was more than that. Photoshop stitched together the three files easily. The result was a 300MB file (unflattened) that gave me resolution that would rival a scanned 4x5in transparency at mural-sized enlargements.

I see this as a great way to emulate the quality of a 4x5 camera but with the many advantages of wider lens choice, ease of use and convenience of a DSLR. For many amateur photographers who don't require a high-megapixel camera, the use of Photomerge or other photo-stitching software can be even more beneficial. From any digital SLR, you can create images from multiple frames for composite files that could be printed at a much higher quality than a single frame.

Three overlapping exposures of the pumpkins were merged with Photomerge ≫ to give this final image, which has a resolution that would rival a scanned 4-inch transparency.
Canon EOS-1Ds Mark III, Tilt Shift-E 90mm lens, 1/6 sec at f/2.8, ISO 100

⌃ The final panorama does justice to the grandeur of the Yosemite Valley view.
Canon EOS-1Ds Mark III, 70–200mm lens, 1/30 sec at f/16, ISO 100

≪ An alternative use for Photomerge is to photograph in a grid pattern. I tried this out here by making four images with the 1Ds Mark III in a grid, two rows of two. I used a 90mm tilt and shift lens, using the shift to overlap the four frames. I also used the camera's Live View feature to compose and check focus for each frame via the large LCD. This feature greatly aided both the ease of framing and focusing, and the accuracy. The file when assembled is nearly 300MB.
Canon EOS-1Ds Mark III, Tilt Shift-E 90mm lens, 1/2 sec at f/2.8, ISO 100

William Neill

87

DESCRIPTION VS. INTERPRETATION

The creation of my images is guided by my efforts to interpret the landscape distinctively, an approach suggested to me many years ago by Ansel Adams: 'Create for one's soul, apply with the mind.' Adams said he never exposed an image for conservation purposes, yet fervently used his art towards that cause. His approach was to make the most expressive photographs possible. He believed that his passion to do so gave him the greatest chance for creative success while also elevating the images' value for environmental purposes. Merely descriptive images would not do for Ansel!

It is a relatively simple matter to describe the scene before us with a photograph. Capture the exposure correctly using a well-balanced image design and you will have a technically successful image. We have all seen beautiful photographs that are pleasant to look at but don't move us emotionally. They look similar to many others. My goal, since early in my career, has been to make images that show my subject in a magical and mysterious way, one that makes the viewer feel as if they are seeing a familiar set of elements (river, mountains, clouds) in a fresh, new way.

In spite of my best efforts, I have unintentionally made many images derivative of other photographs. It is all too easy to make images that look like all the rest, especially living next to Yosemite National Park for 30 years! But as long as one's goal is not to copy or remake another's work, it becomes an editing decision how or whether to make use of derivative photographs. My own guidelines relate to the possible usage.

For example, if I take an image of Half Dome at sunset (an iconic view), I will make a mental note of how it might be used commercially, perhaps as a stock image for a calendar. The very same image, however, would never be printed for a portfolio or included in a gallery exhibit featuring my best creative work. This approach, although not ideal from an artistic perspective, has been helpful in providing a wider market for my images.

Many photographers, especially beginners, focus on creating photos that will sell or win competitions, regardless of their interests. Passion for your subject is an essential ingredient for building a career and a body of work that reflects a deep connection to the subject from a unique viewpoint. Making commercial compromises is fine in my opinion, as long as the overriding goal and effort is made to create highly personal and interpretive imagery. I hope that these ideas will help guide your photographic endeavours. Good luck!

≪ **Giant sequoias, Mariposa Grove, Yosemite National Park, California, from my 'Impressions of Light' series.**
Canon EOS-1Ds Mark II, 70–200mm lens, 1.3 sec at f/13, ISO 100

⩘ **Bridal Veil Fall, Sierra Nevada Mountains, California.**
Canon EOS-1Ds Mark II, 70–200mm lens, 1/25 sec at f/32, ISO 100

CHAPTER 4: LANDSCAPE LOCATIONS
Tom Mackie

So vital are locations to the landscape photographer that we spend far more of our time and energy seeking them out than we do taking pictures. This chapter looks at how research and preparation can cut down on the element of chance and explains some of the techniques that apply to specific types of location both close to home and further afield.

The Holy Monastery of Rousanou,≫ Meteora, Greece. The instant display of the DSLR enabled me to achieve the desired effect with filtration by darkening the sky down with an ND grad. It's reassuring to know at the location that I've captured a successful image rather than waiting till the film comes back from the lab and discovering that I didn't get what I wanted.
Canon EOS 5D, 24mm–105mm lens, 1/8 sec at f/14, Lee 0.9 ND grad filter, ISO 100

RESEARCH AND PLANNING

Planning and preparation are crucial to capturing the scene as you had visualized it. Professional photographers can invest the time and energy to give ourselves the very best chance of doing this, building up knowledge of a wide range of locations in the process. I do not think twice, for example, about flying to another country at short notice to get a single shot that I am after. I also know that specific hotel rooms in certain locations will give me an unrivalled view of a building or other feature in the landscape. It's harder to do this when you are restricted to holidays. They rarely fall at the perfect time and it isn't usually feasible to cancel a long-awaited trip because torrential rain is forecast for the week. Nonetheless, it is possible to get more consistently good results by doing your homework.

GATHERING INSPIRATION

The first step is to decide on the location you are going to visit and to plan a wish list of shots you would like to take there. To do this you need inspiration from books, magazines, on the Internet and even television documentaries. The aim is to study the aspects of the scene that excite you and to work out how you can best carry out your own interpretation of the place. How would it look if the light were coming from a different direction? Might the atmosphere be improved at a different time of day? Can you see another possible viewpoint, higher or lower, that would be worth exploring? Researching locations is as much a part of the image-making process as the end result. The journey is just as important as the destination. It's not the same if someone gives you all the vital information so all you do is turn up and press the shutter. Spend time learning as much about the location yourself so the photographic experience is one to remember.

Use all the resources you can think of to gather as much information as you can on your chosen location – word of mouth, guidebooks, tourist information, clues on photographers' websites and so on. Pay particular attention to the time of year of your visit, especially if you want to capture short-lived features such as the autumn colours of New England or wild flowers in the desert. Often it is better to plan a trip out of season to avoid crowds, but that is no use if the predicted weather will give you nothing in return.

USING TOOLS

Landscape photographers need to have at least a passing knowledge of geography, especially when it comes to reading maps. Detailed maps showing contours and heights are invaluable for planning shots. They can help you find a footpath to take you to a viewpoint, pinpoint features such as windmills, churches and lighthouses that can be used for focal points, reveal the elevations of mountains and the locations of lakes. You can plot where the sun will be in relation to your subject and, if the light is not right for your intended shot, you can find a back-up such as a waterfall or woodland.

On the Internet, you can find moon tables, giving dates and phases of the moon, which can be useful for evening shots. For seascapes, tables giving you the day's high and low tides are valuable if you want to include rocks in the foreground or tide pools, for example. Bear in mind that it is easier to photograph when the tide is going out than when it is coming in, since you won't have to keep moving your equipment as the waves chase you up the beach.

No matter how much planning and research you do on a location, certain variables can interfere with getting the pictures. Bad weather is an obvious problem. Scaffolding on iconic buildings or structures can also be bad news, although sometimes webcams can point out obvious scaffolding. Artificial lights on buildings such as castles and cathedrals are not necessarily turned on every night, as I found out to my cost when photographing Alcazar Castle in Segovia, Spain. It is only illuminated during the summer months, weekends and holidays!

When you are working outdoors with natural light, there are things that can occur unexpectedly. Be prepared to seize the moment if they work in your favour and make the best of the situation when they don't.

Hot air balloon over Fairy Chimneys, near Goreme, Cappadocia, Turkey. After ≫ spending a week exploring the valleys of rock formations in Cappadocia, I knew that these formations in Honey Valley would be best at sunrise. The wind direction that morning happened to blow the balloons over the chimneys.
Canon EOS 5D, 24–105mm lens, 1/13 sec at f/13, ISO 100

Cappella di Vitaleta, Val d'Orcia, Tuscany, Italy. What stood out most about the ≫ area surrounding this much-photographed little chapel were the soft grasses that complemented the strong graphic shapes of the chapel and cypress trees. I used a Canon 24mm tilt and shift lens to keep the verticals straight.
Canon EOS 5D, 24mm tilt and shift lens, 1/4 sec at f/20, ISO 100

≪ **Mist below San Miniato, Tuscany, Italy.** I first came across this location whilst shooting in Tuscany during May. I felt that the light and chances of getting mist in the valley would be better in October so I booked a room in a hotel close to the viewpoint. On the first morning, the whole valley was covered in a wonderful mist and I finally achieved the image that I pre-visualized. The next morning there was no mist. You could say it was luck, but I say it was preparation!
Canon EOS 5D, 24–105mm lens, 1/60 sec at f/16, ISO 100

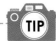

TIP

" I have a handy little gadget that has a compass and a table that determines where the sun is going to rise and set at any time of year. It is used by film companies to plan schedules and is available from Flight Logistics at www. flightlogistics.com. "

Tom Mackie

WATER IN THE LANDSCAPE

Water has always had an irresistible draw for painters and photographers, both as a subject in its own right and as a complementary element to the scenery around it. No matter how landlocked your home location, you never have to travel far to find water, be it a small pond, a manmade canal or a dramatic waterfall. Whatever form it takes, there are various techniques to getting the best out of it in your pictures.

EXPOSING FOR WATER

Whereas the aperture is the most important consideration for most landscapes, with water, and other moving subjects, it is the shutter speed that needs careful thought. A fast shutter can be used to illustrate the force and power of, for example, crashing waves, whereas a slow shutter can make flowing water look like a silky blur. Your choice will depend on the atmosphere you are trying to create. It's a tremendous advantage of the DSLR that you can experiment with different speeds and check the effects on the image while still at the location.

I find that blurring moving water with a slow shutter of between one second and several seconds often produces the most pleasing results. To do this, your camera must be mounted on a sturdy tripod. Depending on the amount of water and the speed it is travelling, start with a shutter speed of one second and vary the time in subsequent frames to capture different amounts of texture on the water's surface.

You will need to set your ISO to its smallest number. This may only be ISO 200 with some cameras, so in order to achieve a shutter speed slow enough, attach a polarizing filter. This will reduce your exposure by as much as two stops. If it is still not slow enough, use a neutral density filter as well, which will further cut the amount of light reaching the lens.

⌃ I wanted to create an image of the surf encircling this starfish in Barbuda in the Caribbean. The surf needed to be just breaking over the starfish; not freezing the water completely, but giving just enough movement in the wave to portray action. Timing was crucial, and without the convenience of instant display I would have been many miles, days and expenses away before I even knew if I had captured what I intended.
Canon EOS 5D, 24–105mm lens, 1/85 sec at f/14, ISO 100

COASTLINES

Photographing coastlines, particularly beaches, has to be my favourite type of landscape work. Maybe growing up in Iowa, thousands of miles from any coast, has something to do with this! The start of each day brings a clean palette to work with because, with each tide, the previous day's activities have been washed away.

One of the joys of shooting with a DSLR rather than a bulky medium-format outfit is that everything I need fits nicely into a belt pack. I can easily work either on a wet beach or up to my knees in the surf to get the angle I want. It allows me to operate quickly and spontaneously in changing light.

As in so many cases, sunrise and sunset are usually the best times on the coast. However, tropical beaches also look great photographed when the sun is high overhead, directly penetrating the water. In order to bring out the turquoise colour of the water, you need to use a polarizing filter to cut the reflections from the surface. This will not only increase colour saturation, but will darken the blue sky and make any clouds really stand out against it. Keep the sun at a 90-degree angle to the subject for maximum polarization.

⌃ I wanted more movement in the water for this image and so experimented with slightly slower shutter speeds. If it was too slow, the starfish blurred when the wave hit. I particularly liked the symmetry of the wave approaching from the top corner of the frame.
Canon EOS 5D, 24–105mm lens, 1/40 sec at f/16, ISO 100

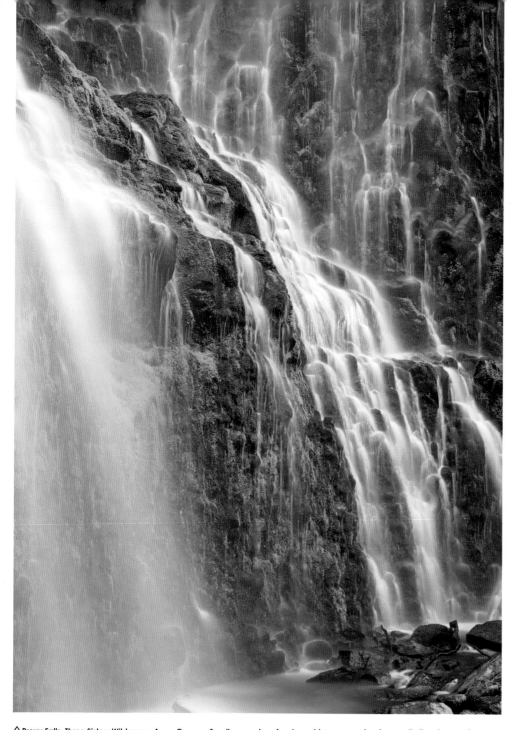

∀ The undulating line of the tide serves here to lead the viewer's eye into the frame. Tropical beaches, like this in Barbuda in the Caribbean, are one subject that photograph well when the sun is overhead, penetrating the water. Use a polarizing filter to bring out the turquoise colour and darken the sky.
Canon EOS 5D, 24–105mm lens, 1/80 sec at f/18, ISO 100

⋏ Proxy Falls, Three Sisters Wilderness Area, Oregon. Small cascades of water achieve more pleasing results than large volumes that tend to white-out. I chose an angle with one fall close to the left side of the frame to give a further dimension to the photograph. I kept checking for any spray on the lens and wiped it off with a soft lens cloth.
Canon EOS 5D, 24–105mm lens, 2 sec at f/14, ISO 100

When on the beach, look out for reflections in tide pools and wet sand. Also, use a line of approaching waves to lead into the frame. Foreground elements, such as rocks, driftwood or grasses will help add depth to the image, especially if you go in really close. If the coastline is rocky and the weather is right, look for waves crashing on to rocks – use a fast shutter speed to freeze them or slow down to 1/4 sec for an explosive effect. As the waves retreat, you can find small cascades over rocks and select a shutter speed of several minutes to achieve a misty effect around them.

TIP

❝ Watch your horizons when photographing the coast. Use a spirit level attached to the camera's hotshoe to get it right when you shoot; if you get it wrong, refer to page 85 for correcting tilting horizons with Photoshop. Placing the horizon straight on, so it intersects the scene, gives the illusion of calm and peace, whereas a diagonal horizon in the frame suggests action and drama. ❞

Tom Mackie

95

RIVERS

Choose your precise location on the river carefully because the bank can be included as an important part of the composition. You can use it as a lead-in line to direct the viewer into the scene or include flowers or foliage on the bank as a foreground. Water tumbling over rocks can also be a good foreground – put some waterproof boots on to get in close so it has plenty of impact.

Winter is a great time to capture icicles and snow on rocks in the river. Go out after a fresh snowfall to catch the snow when it sparkles. Autumn is also good for close-ups of colourful leaves on rocks in the river, especially if they are tinged with an early frost.

Boat and jetty at sunrise, Elterwater,≫ Cumbria, England. I carefully positioned the camera so the angles of the jetty and boat did not merge into the dark reflections of the treeline. A Lee .09 ND grad was necessary to compress the large exposure range between the bright sunrise and the dark foreground.
Canon EOS 5D, 24–105mm lens, 1/20 sec at f/14, ISO 100

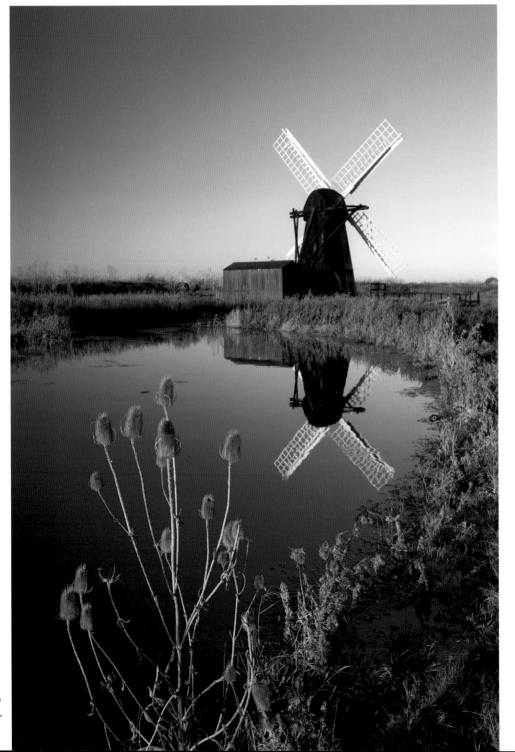

≪ Herringfleet wind pump, Suffolk, England. I used the curve of the bank to lead into the mill, placing the teasle in the lower right to balance the mill slightly off-centre.
Canon EOS 5D, 24–105mm lens, 1/6 sec at f/18, ISO 100

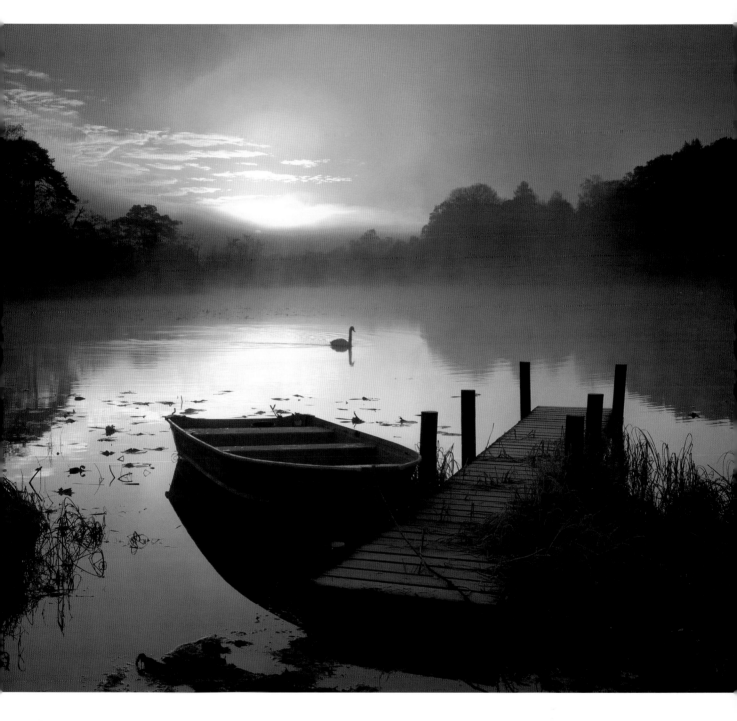

LAKES

Whether you are photographing a large lake or a small pond, avoid filling the frame with water and little else or your composition will appear very empty with no central point of focus. By introducing something into the foreground, such as rocks or grasses, or possibly a boat, you can use this to anchor the image within the frame or to draw the viewer into the scene. When including prominent foreground elements such as large boulders in the water, try not to have them merge into one another or break the edge of the frame.

REFLECTIONS

Reflections are a favourite subject of mine. The best time to capture them is in the early morning or evening when the air is likely to be still and the light is at its best. Always keep a plastic bin bag handy, especially when there is morning dew, so you can spread it out and lie on the ground to give you a different angle.

Depth of field and metering need special attention with reflections. If the reflection is close to the lens, a part of it might be out of focus; a wide-angle lens and small aperture will be necessary to counteract this. Very often, the subject is two to four stops brighter than the reflection. In order to record both the brightest highlight of the subject and the darkest shadow, I spot meter off an area between a midtone and the darkest area of the reflection, then meter off a midtone in the main subject (blue sky is average), then compare the two. I don't want the subject to be more than one stop brighter than the reflection. If it is greater, I will use a neutral density graduated filter over the main subject in order to even out the contrast.

MOUNTAINS

Mountains are extremely challenging for photography – not least because they involve climbing something vertical while carrying all your gear. At least, shooting digitally, I can transport all my equipment, apart from the tripod, in my belt pack, whereas my large- or medium-format outfit was a very hefty weight to carry on my back! What entices me to keep repeating the feat is the wonderful atmosphere that can be captured, which will never be repeated in exactly the same way. The different air mass, temperature and elevations at altitude all help create dramatic images.

Ironically, it is partly because a mountain range can be such an awe-inspiring place to be that photographs taken there are often disappointing. Because the scenery looks so fantastic to the eye, the temptation is to snap away with a wide-angle lens only to find that the resulting images don't come near to capturing the sense of being there.

The secret is to refuse to let yourself be lured by the general, overall view but to examine every aspect of the landscape carefully to see how you can best portray it through the medium of the camera. What are the elements that will produce a strong, graphic image in the frame? How can you convey the grandeur of mountains without watering down the effect with too much information? Viewpoint is obviously crucial, as is your choice of lens. Experiment with different focal lengths to see how the perspective changes. A long telephoto, for example, can be very effective in compressing the perspective of a mountain range, making the peaks appear much close together than they are in reality.

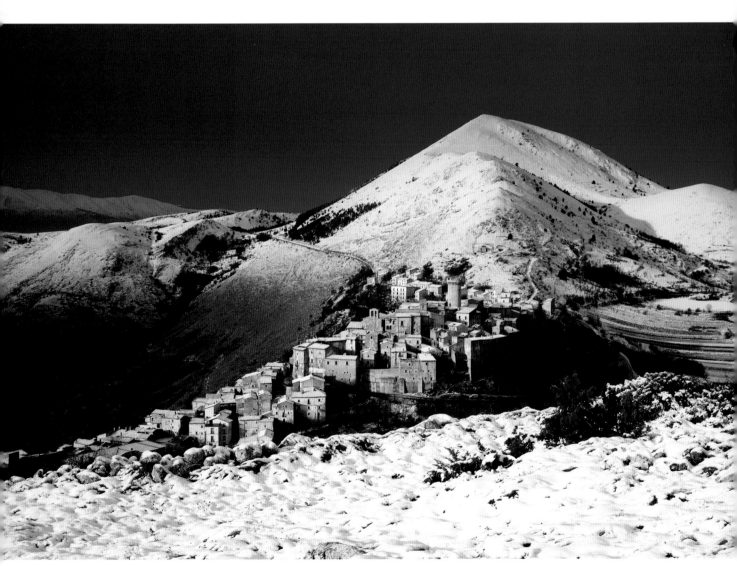

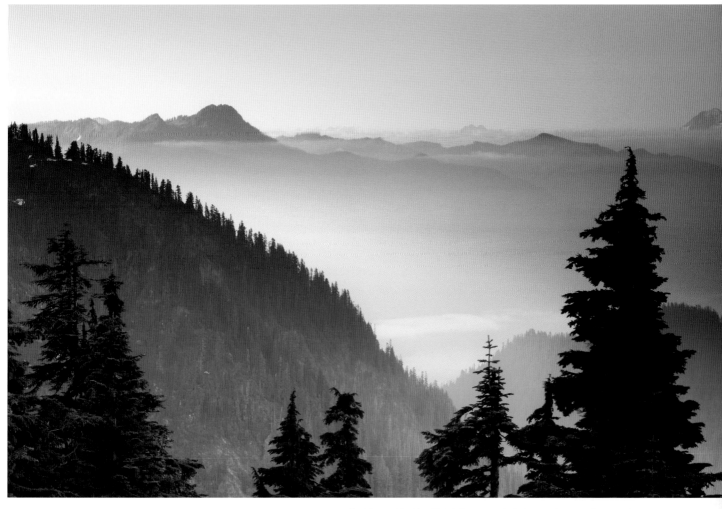

^ Photographing from high in the mountains in the morning can often result in an inversion when the temperature difference between the valley and the top of the mountain creates a low cloud layer. I used a Lee soft .09 ND grad to balance the sky with the valley in the foreground.
Canon EOS 5D, 24–105mm lens, 1/15 sec at f/16, ISO 100

EMPHASIZING SCALE

It's easy for you, the photographer, to realize the grand scale of a mountain range as you are standing in front of it, but for the viewer looking at a two-dimensional image, more consideration has to be given in order to emphasize the scale. The most obvious way to do this is to include an element that has a known size, such as a person or building, within the frame to show the difference. Choosing a suitable vantage point can also be effective in emphasizing scale. Photographing a mountain scene from the top of an adjacent mountain is sometimes better than from a valley below.

In my image of Santo Stefano (left), the mountains of Abruzzo are given more scale by including the village nestled below, as seen from a high vantage point. Using a DSLR to accomplish the hike is not only much easier on the back, but the system allowed me to carry out a variety of different images in a short period of time as the weather was changing very quickly. I was even able to shoot a complete 360-degree panoramic, showing the mist in the adjacent valley, before the clouds enveloped the sun completely.

« I climbed high above the ancient Italian village of Santo Stefano in fresh snow so the village was below the horizon line of the mountains to give it more of a sense of place. The lighting and weather conditions were changing rapidly when the sky behind the mountain suddenly went dark and the sun hit the scene. I used a Lee .06 soft ND grad filter to darken the sky even more to enhance the drama of the light.
Canon EOS 5D, 24–105mm lens, 1/15 sec at f/16, ISO 100

TIP

" It might be tempting to ditch the tripod for a hike in the mountains, but it really is advisable to use one as you'll need long shutter speeds to give the small apertures you'll require. If you really can't face the weight, use your camera bag or a beanbag to support the camera and consider using a higher ISO to increase the shutter speed and therefore the risk of camera shake. "

Tom Mackie

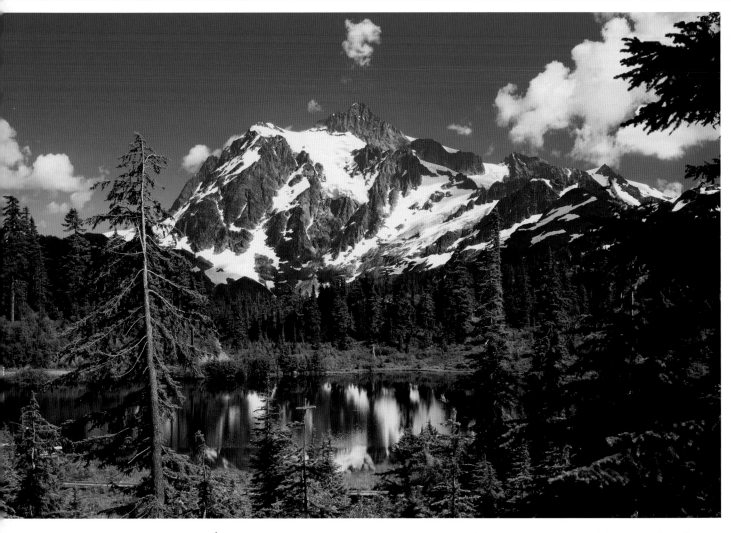

⌄ Mount Shuksan, Mount Baker National Wilderness, Washington. Polarizing filters can give your mountain images more impact by deepening the blue sky and adding saturation, which intensifies the green pine trees. Not all mountain images require a strenuous hike. This was shot next to the road, but I had to wait two hours for the clouds to clear over the mountain.
Canon EOS 5D, 24–105mm lens, 1/4 sec at f/18, ISO 100

CHOOSING FOREGROUNDS

It's easy to photograph an impressive mountain range on its own, but including an interesting foreground will add more depth to the image. Waterfalls, lakes, rivers and trees are a few of the elements that can balance an image and create a more three-dimensional look. Detailed maps of the area are invaluable for location-searching some of these and will also reveal the contours of the mountains – so you know what kind of climb you will be in for!

LIGHTING

It's important with any landscape to emphasize the contours of the scene, but especially so with mountains. Sidelighting is undoubtedly the best light to bring out the rocky crags and shapes of the mountain. Frontlighting is best avoided for this subject, as it produces a very flat and featureless effect. The only exception to this rule is at first or last light, when the warm tones are more of a feature, especially when set against the dark, cooler tones of a foreground in shadow. In this case, I try to include something in the foreground to reflect the mountain, such as a still river or lake.

TIP

❝ It's advisable to hike with someone else, especially during long, remote hikes. If you do hike on your own, take some sensible precautions. Let someone know where you are hiking, and take along basic food and water supplies as well as a compass, mirror and whistle for attracting attention should you get lost. Depending on the mountain environment, take suitable waterproof clothes to change into should the weather conditions change suddenly. And don't forget a good map. ❞

USING FILTERS

Polarizing and neutral density graduated filters are essential for mountain photography. The polarizer has the usual effect of deepening blue skies and making clouds stand out when used at a 90-degree angle to the subject for maximum effect. But when the sky is void of clouds and you use a wide-angle lens, the sky can take on an uneven tone, with a dark blob in one area of the sky. A good method to correct this is to use the Gradient tool in Photoshop. By selecting the colour of the existing sky, then adjusting the gradient of it according to the position of the sun, you can achieve a more even tone.

Often at very high altitudes, when using the polarizer at maximum polarization, the sky can turn black. To overcome this problem, dial the polarizer back from its maximum. Also, at altitude there is more ultraviolet light, which causes a blue colour cast. This can be countered either by using a warm polarizing filter, which is like adding an 81A filter to a polarizer, or by setting your white balance to Cloudy and using a standard polarizing filter.

Neutral density graduated filters control the exposure latitude of a scene. For example, with a mountain scene, the lower section of the frame is likely to be darker than the sky or snow-covered mountain. With the ND grad over the sky, it brings the exposure in line with that of the lower half of the scene. They come in varying densities and transitions, being either hard or soft relating to the transition. I would recommend the 0.6 and 0.9 (2 stops and 3 stops respectively).

Whether you use a hard- or soft-edge transition depends on the irregularity of the mountain range. If it were a fairly level range then I would use a hard-edge grad. If there are jagged peaks, then a soft-edge grad will be more effective because it will not darken down the peaks too much – especially important if they are covered in snow.

⩔ **Mount Baker at Sunrise, Washington. Because there was such a great exposure difference between the light hitting the mountain and the area in shadow, I used two ND grads, Lee .06 and .09, together in order to compress the exposure range. Checking the display as I shot allowed fine-tuning of the filter placement.**
Canon EOS 5D, 24–105mm lens, 1/8 sec at f/14, ISO 100

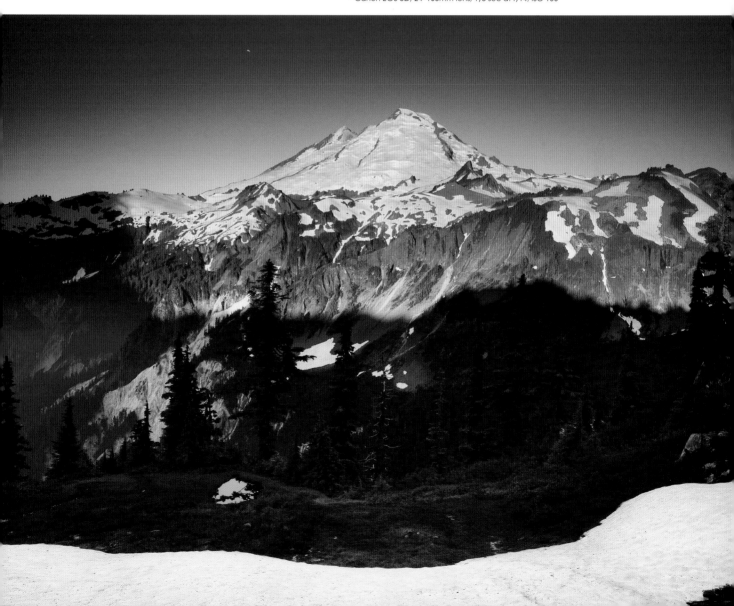

DESERTS AND WILDERNESS

If you are planning a visit to a desert or other area of wilderness, it will pay to do some careful research and plan out a wish list of the kind of photographs you are hoping to take. Each place has its own unique character or, in the case of Death Valley, for example, many different characters. In Namibia, the most striking feature is the colour and size of the sand dunes, which can reach 365m (1,200ft) high. There are wonderful opportunities to create abstract shots of the patterns in the dunes, criss-crossed with light and shadow. Californian deserts, on the other hand, have more vegetation, and in Joshua Tree, the huge granite blocks and unusual rock formations inspire graphic compositions.

One thing that all desert locations have in common is the lighting required to capture them at their best. You need to be out there, camera ready, before dawn, waiting for the first light. When the sun rises, you'll have another hour or so to shoot until the hour before sunset. Between those times, the light is just too flat to reveal the form and texture of the landscape. Added to that, by 10am the tourists will be out and about. One or two people in the composition can be useful to give an idea of scale, but tour parties are another matter, as it's the sense of isolation and separation from civilization that you'll want to portray.

My two favourite lenses for deserts are a wide-angle and a telephoto. The former is great when you want to include a foreground detail, the middle ground and background all in sharp focus. Telephotos are ideal for isolating rock formations and shapes – going in close for more graphic shots. If I were to opt for only one lens, I would choose the versatile 24–105mm.

More often than not I will use a polarizer, as it increases saturation, darkens skies and makes any clouds stand out. This would also reduce the reflected glare from the sand.

I used a wide-angle lens to concentrate ≫ on these unusual rock formations in the Bisti Wilderness area, New Mexico, catching the last rays of light. The strong sidelighting brings out the shape and texture of the rocks while throwing the desert floor into shadow.
Canon EOS 5D, 17–40mm lens, 1/2 sec at f/20, ISO 100

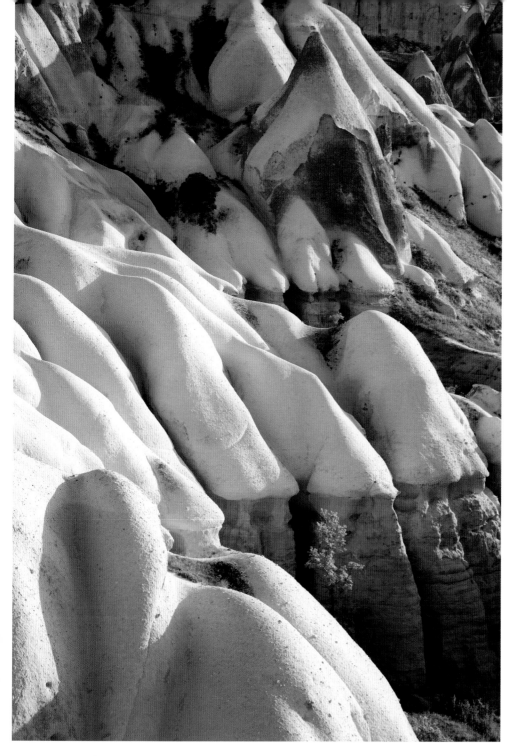

≪ I zoomed in to use a focal length of 105mm to isolate the sensuous shapes of these tufa formations in Cappadocia, Turkey. The soft, diffused sidelighting brings out their shape and form.
Canon EOS 5D, 24–105mm lens, 1/13 sec at f/14, ISO 100

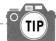

TIP

❝ Dust and sand are a camera's worst enemies, but especially to the sensor of a DSLR. A charged sensor will attract dust like bees to honey. Change your lenses as little as possible. If you do need to change a lens, always turn the camera off, keep it facing down so no dust can settle on the sensor, and shield the camera if it's windy. Enclose each lens and body in a resealable plastic bag. This is especially important when photographing sand dunes, as it's not a matter of *if* any sand gets into your camera bag, but when. ❞

COPING WITH CONTRAST

Desert shots often have an extreme exposure range between the bright sand, dark shadows and the sky. You need to record all the highlights and shadows to begin with, which is much more easily done with a sensitive digital sensor than with film. You can check you have done so on the histogram.

There is a useful technique in Photoshop to retain the highlights while bringing up the shadows so they are not blocking in. Go to Image > Adjustment > Shadow/Highlight. Here there are sliders to adjust the shadows and highlights. However, this default setting can look unrealistic, so click on the Show More Options box and it will allow you control over midtone contrast as well as the tonal width and radius of shadows and highlights. Experiment with the sliders until you have achieved the effect that you desire.

Tom Mackie

FORESTS AND WOODLAND

As a landscape photographer, there are not many occasions when you will greet a dull, overcast and even rainy day with enthusiasm, but for photographing forests and woodland, those kinds of conditions are ideal. These subjects may look appealing to the eye on a bright, sunny day, but the contrast will be far too high to produce acceptable results. You can get away with soft, subtle lighting with a bit of sun coming through an open canopy and hitting the main subject, but generally the colours will appear most saturated when the sky is overcast.

Because of this, spring and autumn are a great time to use woodland locations. In spring, look for the patterns and shapes created by newly emerging ferns on the forest floor. Patterns of trees can make interesting images. You can use a telephoto lens to foreshorten the perspective, so that the trees in the middle ground and background appear much closer to those in the foreground. Alternatively, choose a wide-angle lens and look for foreground interest, such as a fallen log or patch of flowers, using a small aperture to keep the background sharp. When photographing really oversized species of trees, show the scale by including a figure or something else of recognizable size.

In autumn, of course, you can use the colour of the foliage, but timing is crucial to ensure you hit the peak of the display, and this can vary hugely from year to year. Consider visiting an arboretum where the large collection of trees will offer a great deal of scope within a confined area. Most arboretums have their own website with information on what to see from season to season and a photo gallery to steer you towards potential viewpoints.

In dense forests and rainforests, use a polarizer on the lens, especially if the light is overcast or it is raining. Foliage covered in water is highly reflective and the filter will cut out reflections and enhance the colours. You may need to increase saturation further in Photoshop, but take care not to go over the top with this; you have to judge what looks acceptably natural.

Dewdrop and bluebells, Norfolk, England. To help convey the impression of a ⋁ densely carpeted colour of bluebells, I used a focal length of a mid to long telephoto to compress the flowers against the backdrop of trees. This large open meadow allowed the sun to evenly light the scene without too many distracting shadows from the trees.
Canon EOS 5D, 24–105mm lens, 1/13 sec at f/14, ISO 100

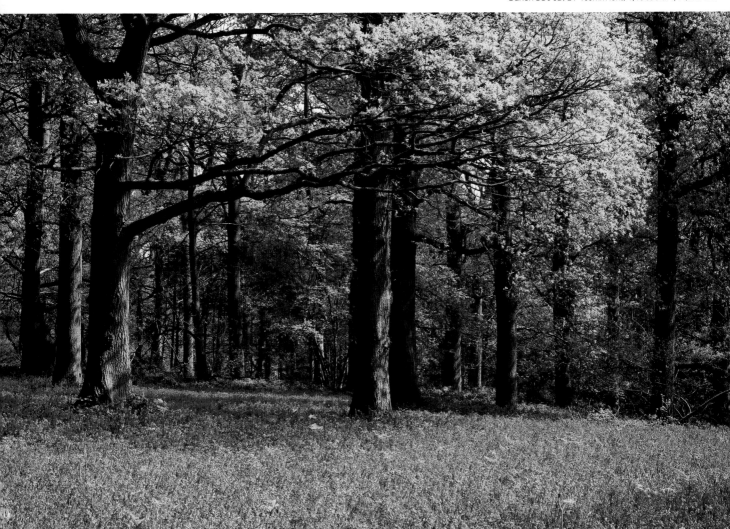

WOODLAND FLOWERS

Many deciduous woods will have a carpet of flowers in the spring, and bluebells are a perennial favourite subject to photograph. They generally come into flower in late April or early May but, again, timing is crucial to catch them when all the buds are open and there is a nice arc to the stems, with no rough edges to the petals.

When we were all shooting with film, there was always a debate about which film captured the true colour of bluebells. Digital has made this much easier to do, although I still find that overcast light produces a more lavender look while stronger sun gives a truer blue.

You can either capture a scenic carpet of flowers in the woodland or go for close-ups of one or two bending stalks, perhaps using differential focus so one flower is sharp and another is slightly out of focus behind it. When shooting close-ups, make sure the plane of focus is parallel with the flower, or not all of it will be sharp. That means lying on the ground with the tripod as low as it can get. For my image, I used a 100mm macro lens with a white diffuser between the sun and the flower to soften the light. An assistant held a silver reflector in place to bounce light into the 'dewdrop'.

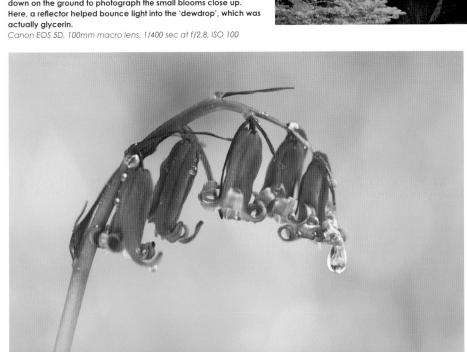

Glen Bruar, Tayside Region. Scotland is notorious for ≫ rainy conditions, but they were ideal for this image of a stone bridge and waterfall beautifully framed by autumn larches. A few minutes later the sun appeared for a brief moment, but the contrast was too great, obscuring the fine details of the scene.
Canon EOS 5D, 24–105mm lens, 2 sec at f/18, ISO 100

≫ For close-ups of flowers, choose specimens that have no imperfections, as any flaws will be magnified. You need to get right down on the ground to photograph the small blooms close up. Here, a reflector helped bounce light into the 'dewdrop', which was actually glycerin.
Canon EOS 5D, 100mm macro lens, 1/400 sec at f/2.8, ISO 100

 TIP

❝ To fake a dewdrop, I like to use a trick I learnt as a commercial photographer – glycerin. Because of its syrupy nature, you can place it where you want it and you have more time to react when the drop is about to fall. You can use water in an atomizer, but you will need to be very quick to catch a droplet. ❞

Tom Mackie

105

URBAN LANDSCAPES

Because of the close proximity of structures in an urban landscape, shadows cast across the subject from an adjacent building can potentially ruin the shot, so a careful study of shadows and light is important. It's very rare to stumble across the perfect light for a particular building by luck. I generally do a recce of the location, walking right around the subject and returning several times during the day to see how the light is working.

Treat every building as unique and see how the light can interact with it to bring out its strengths and distinguishing features. For modern architecture, this could be the lines, curves and contours. Highly reflective materials, like shiny metal, will alter in appearance according to the changing colour of light during the day.

Ancient buildings may have carvings and detailed stonework that you want to reveal and this is best done when the angle of light is three-quarters to the camera, so the front is lit but part of the side is in shade. Generally, frontal lighting flattens details.

ANGLE OF VIEW
It isn't just the light to look out for when exploring a subject. The angle of view is also vital, especially to make your images stand out from the usual tourist shots taken from the front. Look out for nearby buildings that may have a window or rooftop that will give you a special view. Gaining permission may take a lot of perseverance, but it can often be done if you explain what you are trying to do and offer pictures in return. If this is impractical, there is still much you can achieve from the ground by experimenting with camera angles and different lenses.

There was a time when I wouldn't consider getting the camera out of the bag because of the various obstacles that could ruin the integrity of an urban landscape, such as cranes, scaffolding, satellite dishes, obtrusively parked vehicles and jet contrails. Now these can be obliterated into the digital cyberspace using Photoshop or other image-editing programs.

There is no need to panic if there are people in your shot. In fact, they can be crucial to an urban landscape to show a sense of scale or to provide a context for the architecture. How people are placed in the frame is important, though; if they are too prominent you may produce what looks like a holiday snap.

STRAIGHTENING VERTICALS
When photographing buildings, it is always best to keep the verticals straight – unless, of course, you are photographing the Leaning Tower of Pisa or you are using the converging angles for an effect.

Converging verticals happen when you use a wide-angle lens and point it upwards to include all of the building. There are a couple of things you can do to overcome this effect. The more expensive route is to buy a PC (perspective control) lens or shift lens. Once you have levelled your camera on your tripod using a spirit level attached to the camera's hotshoe, you will see that you have only part of your building showing in the viewfinder. Now all you have to do is adjust the lens so that the lens elements shift upwards to include the entire building.

> **TIP**
>
> 66 When taking a picture that has converging verticals, make sure you include enough space around the building to correct the converging lines in Photoshop. Otherwise, you will straighten the building right out of the frame. 99

The City of Arts and Sciences in Valencia, Spain, was designed with a shallow ≫ pool of water around the buildings to complement the modern architecture, which adds additional symmetry. I wanted to keep the composition confined to simple shapes by zooming in to exclude the other structures. In early morning, there was no wind, giving mirror-image reflections of the building in the pool. I used a polarizing filter to deepen the blue sky, adding greater contrast between the building and sky.
Canon EOS 5D, 24–105mm lens, 1/30 sec at f/16, ISO 100

If you don't have the spare cash to spend on one of these lenses, then a quick and easy alternative is to follow this procedure in Photoshop:

- Open your image in Photoshop.
- Put your curser on the lower right-hand corner and increase your workspace by holding down the mouse button and dragging the frame out.
- In the top menu, choose Select > All. Now the 'marching ants' will surround your photo.
- At this stage, you can either add grid lines as a guide for straightening the verticals (Apple or Windows key + ') or pull in a guide line from the edge of the frame.
- In the top menu, choose Edit > Transform > Perspective.
- Put your curser on either the right or left anchor point at the top of the image frame, hold and drag out until the building is completely vertical. Then press the return key.
- Select from menu > Deselect.

I generally know what I'm going to ≫ photograph in cities, but it's refreshing when I come across a structure that isn't one of the over-photographed iconic images. This incredible structure of metallic arches was built over a major intersection in Madrid, Spain, and, unusually, I found it by chance. I walked around it, checking all angles for the best viewpoint. I chose a backlit position by placing the sun behind one of the arches. This made the shadows an integral part of the composition. I removed some distracting elements in Photoshop such as a poster on the closest arch and a pole in the background.
Canon EOS 5D, 17–40mm lens, 1/10 sec at f/22, ISO 100

⌃ **St Helen's Church, Ranworth, Norfolk, England. Unless you are using a shift lens, it's difficult to avoid converging verticals when photographing buildings. The tilting church steeple in the original picture (left) was easily corrected in Photoshop (right).**
Canon EOS 5D, 24–105mm lens, 1/13 sec at f/16, ISO 100

Tom Mackie

⌃ The dynamic view from underneath the bridge at the City of Arts and Sciences complex in Valencia, Spain, complemented the modern architectural design of the building and created an angular aspect to the image. The reflections in the water add an interesting element and balance the light values. To the eye, the scene appeared quite dark and lacking detail, especially under the bridge, but the sensitivity of the sensor extracted the necessary detail. The building is lit only by the lights on the bridge.
Canon EOS 5D, 17–40mm lens at 17mm, 10 sec at f/16, ISO 100

THE CITY AT NIGHT

For me it is at night, or more specifically twilight, when a city really seems to come alive. This is the best time to photograph buildings, monuments and street scenes, lit up against the darkening sky. All the irritating details like satellite dishes, cranes and telegraph wires seem to melt away and, with fewer people around, less time is wasted waiting for them to pass before you can take the shot. Even if people are moving around, it isn't a problem as the exposures you need to use are too long to record them.

Essential preparation

Timing is everything with night shots. There is a short time – maybe 15 minutes – when the sky has the perfect gradation of blue that contrasts so well with the illuminations. Of course, this depends on the direction the building is facing; if it is west you will have a little longer, but if it is facing east, the tone in the sky will be different and will darken more quickly.

Because of the shortage of time when shooting at night, do some research beforehand to establish your viewpoint, think about composition and lens choice – and make sure that your chosen subject isn't covered with scaffolding! I generally go to a location with specific shots already in mind. I will plan out the most promising shot and do this first. If there is enough time after this, I will then go on to set up a second composition.

If I am shooting film as well as digital, I always take the film shot first. Digital is much more sensitive to light than film and so extends the available shooting time until well after film is able to record the night light levels satisfactorily – ideally, this is when the sky is one stop brighter than the building illuminations. This is where shooting with digital really comes into its own: it can pull out detail even in the subtlest of lighting conditions.

Exposure for night shots

Metering for night shots is potentially problematic because of the differences in contrast in various parts of the scene. I read the histogram as a way of judging exposure; if it is too blocked in to the left it will be underexposed. I want it to the right so that the most amount of information is preserved.

I find, using my Canon 5D, that I need to underexpose by as much as one to two stops as the sensor is so sensitive to light that the image will not look enough like night time otherwise. You need to be careful, as if the shot is too underexposed it will build up noise (the digital equivalent of grain). At night, it is a huge advantage to see your results immediately and make exposure adjustments accordingly.

Although you can often get away with handholding a DSLR to achieve acceptably sharp results, this is not the case with night photography: a decent tripod is invaluable. A cable release is also a good idea to avoid camera shake while pressing the shutter, although it is possible to use the camera's self-timer.

Traffic trails outside the Colosseum in Rome make a dramatic image. The camera is ⌃ facing east, so it is quite dark, but the sky has retained some tone. You need an exposure of 15 or 20 seconds to allow enough traffic to pass through to provide the light trails. You could use a self-timer, but I prefer to keep the shutter open and fire with a camera release at the optimum time. Try to avoid buses as they are too big and their lights are too high up.
Canon EOS 5D, 24–105mm lens, 20 sec at f/16, ISO 100

⌃Castel Sant' Angelo in Rome, reflected in the River Tiber. The camera's chip is so sensitive that there is detail even under the arches of the bridge and on the statues, which are lit only by street lights. I often set the white balance to Cloudy because it slightly warms the scene. The ISO is generally 100 to avoid digital noise.
Canon EOS 5D, 24-105mm lens at 24mm, 30 sec at f/14, ISO 100

> **TIP**
>
> " You may not be able to use a tripod in parts of some European cities, including London, Paris, Rome and Florence, as the authorities object to their use for health and safety reasons or fear of terrorism. You will also need permission to photograph some buildings or monuments (the glass pyramid in front of the Louvre, for example). In such cases, take another camera support with you, such as a beanbag or a camera bag that can be placed securely on a wall or a bench. "

EXPLORING YOUR LOCAL LANDSCAPE

It's tempting to think that your library of landscapes would improve dramatically if only you could afford the time and expense to visit exotic locations – especially when you are gazing out of an office block window on a dull winter's day.

It's true that new sights can be inspirational and renew your enthusiasm for picture-taking but, where photography is concerned, familiarity should not breed contempt. There really is no need to travel to far-flung places searching out much-photographed subjects only to return empty-handed because it rained for the entire trip. In fact, nothing beats local knowledge. If you are guilty of taking your own surroundings for granted, it's time to look again with fresh eyes.

Even if you live in the most built-up area, it's almost always possible to find some rural landscapes (or even a city park) within a day's reach. If you live in the countryside, like I do, you have even less excuse. I am continually looking at my surroundings through the confines of a viewfinder. Possible pictures appear everywhere: the shape of a lone tree sitting on the brow of a hill, contrasting colours and patterns in different fields throughout the seasons, a road or path winding through a scene and so on. Look hard enough and you will always see something that has changed, or that you never noticed before. Analyse the pictures you create and see how you can improve on them next time.

RECORDING LOCATIONS

It's very rare to stumble on the perfect conditions at the precise moment you happen to be somewhere, so it's a good idea to create a digital diary of locations and features in the landscape, perhaps just using a simple compact camera. Make notes about the best time to return to create the final image, recording the direction the subject faces and how it might look at different times of day or throughout the seasons.

This approach is especially useful for winter locations. I know exactly where I can go to take advantage of snow and frost, for example. I can be sure to get there while the snow is fresh instead of driving around aimlessly while it melts.

Photographing the same place time after time will give you a better understanding of it and open up many creative interpretations. In rural areas, you can also get to know the people who live and work there. People who have an insight into a location, such as park rangers, guides and farmers, can provide very useful information.

TIP

66 A local scene or simple landscape feature such as a tree in field could be photographed in every season from exactly the same position. 99

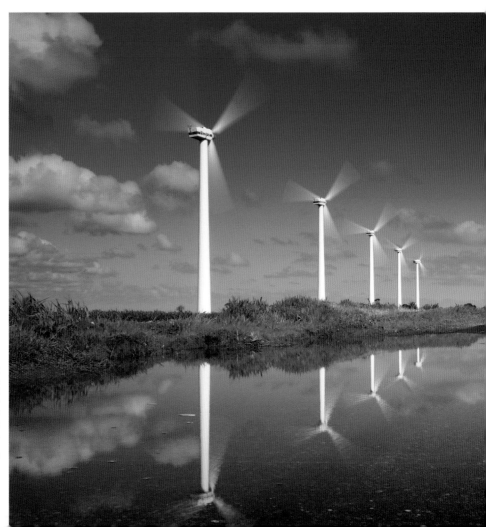

I was conducting a workshop where we ≫ were trying to get a different take on these wind turbines in Norfolk, England. There was a puddle in the road, so I set the camera on the ground to take in the reflection of the turbines. A shutter speed of 1/6 sec gave enough of a blur to the blades to suggest movement, while the small f-stop made sure the reflection was sharp.
Canon EOS 5D, 24–105mm lens,
1/6 sec at f/22, ISO 100

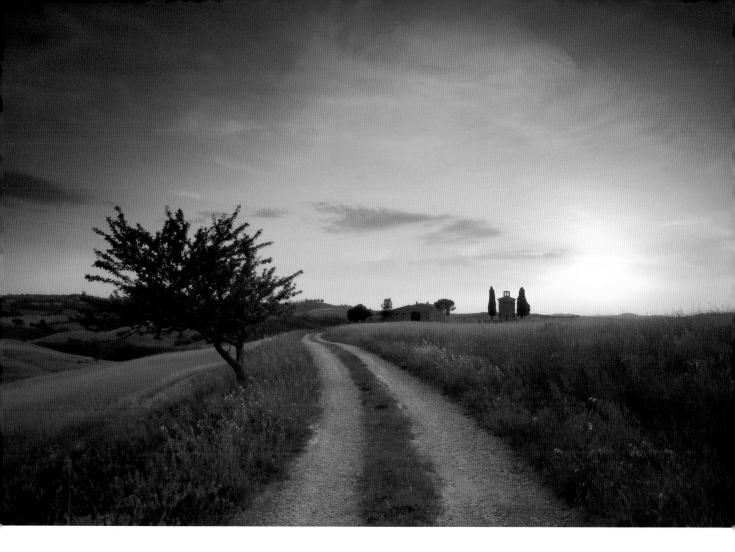

⌃ Images with basic compositional elements are often the most effective. The simple curve of this track and a tree at sunset in Val d'Orcia, Tuscany, Italy, served to bring this image together.
Canon EOS 5D, 24–105mm lens, 3 sec at f/16, ISO 100

≪ When I was scouring the countryside of Bavaria, Germany, for interesting subjects, this single tree sheltering a little house stood out on the horizon. I spent the afternoon making various compositions as the skies changed. The appealing aspect is that the image could be anywhere and conveys concepts such as security, property, mortgages or insurance – very useful for stock libraries.
Canon EOS 5D, 24–105mm lens, 1/60 sec at f/9, ISO 100

Tom Mackie

CHANGING THE SKY

 I don't make a habit of changing skies, but for commercial reasons it is often necessary to improve an image by putting another sky in digitally. This is especially the case after travelling to a far-flung location and spending a week or so waiting for good weather conditions that never arrive.

In order to change the sky, you obviously need to have a selection of replacements available. It is always worth capturing a great sky with interesting or dramatic cloud patterns, even if the landscape below fails to impress. That way you can build up a 'bank' of sky images to use in the future.

There are a few considerations to bear in mind when carrying out this procedure. Most importantly, you need to choose a sky that matches the direction of light that falls on the landscape. Also, avoid putting in a completely contrasting tone of sky if, for example, you can see parts of a lighter-toned sky through the branches of a tree. Otherwise you will create a lot of work for yourself to try to prevent it looking obvious. One way round this is to select a sky that has a clouded area and place it around the selected area of the tree, so the light areas will appear as a part of the cloud.

⌃ Open the landscape image and the sky image. Make the landscape Layer 1.

⌃ Using the Magic Wand or Lasso tool, make a selection along the join where the land meets the sky.

BEFORE

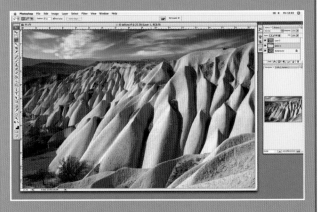

⌃ Once you have copied and pasted the new sky, check the join between them and adjust the sky layer using Opacity to suit the image.

⌃ The original picture of Cappadocia, Turkey, has a bland sky that does nothing to complement the desert rock formations.
Canon EOS 5D, 24–105mm lens, 1/13 sec at f/16, ISO 100

It is possible to purchase sophisticated programs such as KnockOut by Corel that will do a brilliant job of omitting backgrounds or skies and retaining the fine details of your subject. It is fairly straightforward to change the sky with Photoshop, however. The following is one of several different techniques to do this.

- Begin by opening both the original images in Photoshop; the one with a sky that needs replacing, and the one with the sky that will be used instead.
- Select the image that has the good sky you want to copy. Ensure the size of the files are equal, then, using the Crop tool, crop the section of the sky that you want to use. Go to Select > All, then Edit > Copy.
- Select the original landscape file and Edit > Paste the sky onto the file, which becomes Layer 1, and move accordingly. The new sky will now be placed on top of the landscape image (Background Layer).
- The image used for the sky selection can now be closed.
- In the Layers palette, go to the new sky (Layer 1 unless otherwise named) and adjust the opacity to 0%.
- Select the Background Layer and, using the Magic Wand or Lasso tool, make a selection of the sky, as generally it makes an easier selection.
- Inverse (Select > Inverse) the selection so the foreground is now selected. Feather the selection (Select > Modify > Feather) with

a Feather Radius of 2–3 pixels, or adjust accordingly to suit the image, to soften the selection edge.
- Copy this selection (Edit > Copy).
- In your Layers palette, select the new sky (Layer 1) and Edit > Paste. The selection will be on a new layer (Layer 2 unless otherwise named) above Layer 1.
- Select Layer 1 and bring the Opacity back to 100%. Adjust the sky using Levels, Saturation or Curves to suit the overall image.
- Magnify Layer 2 to 100% to check the edge of the selection where the images will join. Use the Erase or Clone tool to make adjustments if necessary.
- Once you are happy with the join, Layer > Flatten Image.

⌄⌄ The new sky has a richer colour and more drama in the clouds, which strengthens the overall image.

AFTER

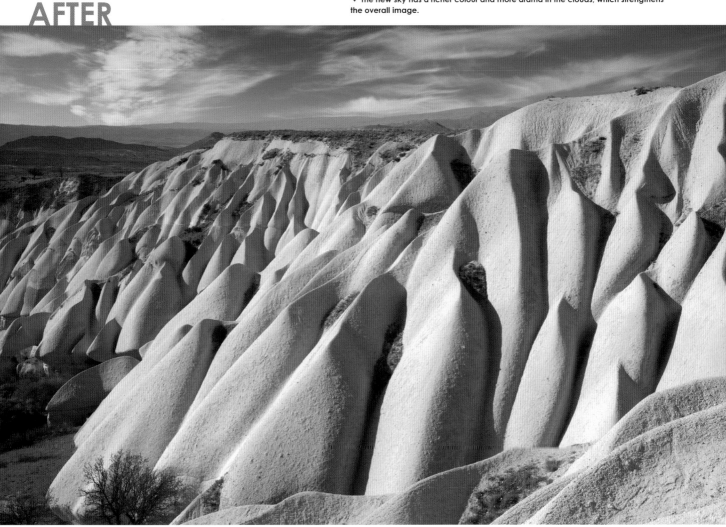

CHAPTER 5: LANDSCAPES IN BLACK AND WHITE
Tony Worobiec

There is no doubt that digital SLR cameras and post-production techniques have radically transformed black and white photography. There are many more options open now as, instead of deciding whether to capture a landscape in colour or mono, the decision can be left until later, depending on which medium suits the individual image. This chapter looks at how you can best make that choice; the methods of converting colour to monochrome; and some of the Photoshop techniques that replicate traditional darkroom processes.

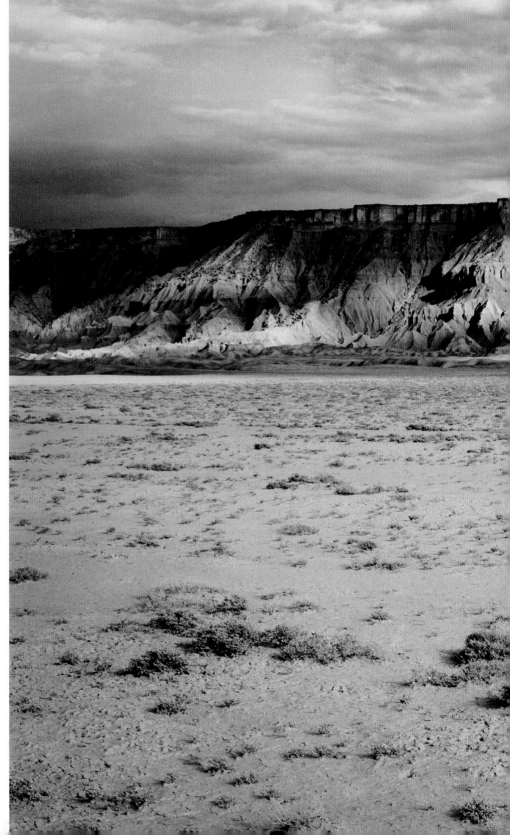

There are occasions when one knows ≫ instinctively that something is likely to work well as a monochrome. Broken cloud with elements of light breaking through often succeeds. After making a conversion from RAW, the foreground appeared much darker than it appears here, but with a careful bit of selection and a judicious application of Curves, a pleasing tonal balance was achieved.
Canon EOS 5D, 17–40mm lens, 1/125 sec at f/16, ISO 200

THE BLACK AND WHITE MINDSET

The world is in colour, we see in colour, and unless you are using your camera's mono mode, you capture in colour. So how do we identify a subject that will work in mono? The key is to think in terms of tone and learn to translate what you see through the lens into areas of dark and light. For example, you may wish to photograph a landscape that contains a red building as one of its key elements. While this building might stand out in a colour image, it might easily lose its impact once it has been converted to monochrome.

When everything is reduced to tones of grey, the way to create impact is to establish maximum tonal contrast at the point of interest. Ideally this is done at the taking stage, but, as with all photography, a little post-production work in Photoshop can also prove useful.

When I used film to shoot mono, I would invariably use an appropriate filter, often either orange or green. These filters helped me to separate out the colours I didn't need and were also a superb way of helping me to translate a colour landscape into tones; I found a light orange filter particularly useful in this respect. Shooting digitally, you need to remove the filter from the lens before taking the shot, as it will have a detrimental effect on the tones. If you prefer not to use a filter, try squinting at the landscape. By drastically reducing the amount of light getting to your eyes, any sense of detail is lost, which allows you to see the broader tonal masses.

AFTER

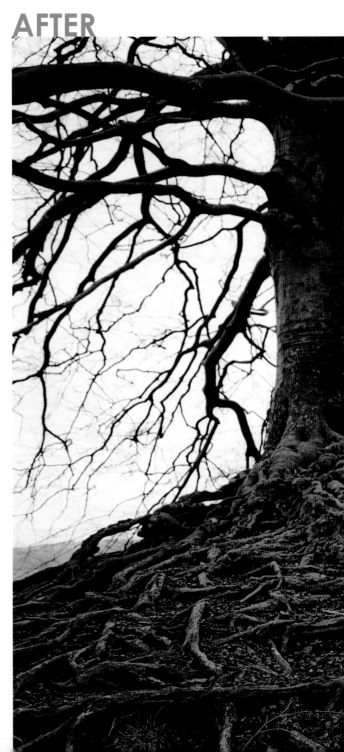

BEFORE

 I have photographed this old tree on various occasions over the last 15 years, but rarely in colour. Although the lighting was particularly flat, I was still attracted to that element of counterchange, where contrast of the dark branches set against the bright sky is countered by the light roots and the dark ground.
Canon EOS 5D, 17–40mm lens, 2 sec at f/16, 100 ISO

TIP

❝ If you are aiming to achieve the maximum quality, shooting colour (ideally RAW), then converting your image in Photoshop or other image-editing software is a far better option than shooting in the camera's mono mode. However, shooting a frame using the mono mode might help you to assess the potential. If you are convinced, then revert back to colour. ❞

LIGHTING AND CONTRAST

It is often suggested that a landscape with bold, graphic qualities makes an ideal subject matter for monochrome. The textural qualities of land, as revealed by strong, directional lighting, are also much favoured. But that is only half the story. Generally, most good monochrome landscapes are taken in overcast or subdued lighting conditions, which offer a much smoother tonal range. As contrast is contained, the file is far easier to manipulate.

One should never set rules, but as a simple guide, retain the image in colour when there is a great deal of blue in the sky, but consider converting your image to monochrome as the sky begins to fill in. Contrast, either too little or too much, is undoubtedly the biggest problem when working with black and white. From a technical standpoint, I would much prefer to start with an image that shows too little contrast, as expanding tones in Photoshop is considerably easier than compressing them.

A truly great black and white picture conveys emotion. By using the full tonal range, a skilled monochrome worker can communicate a variety of moods. For example, a low-key landscape can appear eerie, sinister or even threatening, whereas a high-key image can exude a sense of confidence and optimism. A good monochromatic landscape is capable of engendering a powerful emotional response; by removing that element of colour, we are presenting an image that is one step removed from reality.

⋁ In this example, I chose to create a digital lith effect, which has not only introduced an attractive sepia brown, but has also emphasized the strong graphic qualities of the image. Often images with these characteristics will translate extremely well to monochrome.

Tony Worobiec

IN-CAMERA SETTINGS FOR BLACK AND WHITE

The first question that DSLR users ask themselves is, should they shoot JPEG or RAW? If you use your camera on the largest JPEG setting, the results are virtually indistinguishable from images shot using RAW, but you can get many more images on to your memory card. RAW also has the downside that you must post-process it with a PC or with editing software such as Photoshop. So many might question why anyone should wish to shoot RAW.

Shooting RAW offers far greater flexibility for monochrome images. Compared to colour, there is often a lot more work to do in Photoshop to get the image looking right – by making considerable tonal changes, for example. Critically, when shooting RAW you are retaining all the image data and therefore starting with the best possible file.

Apart from retaining all the image data, one of the biggest advantages of shooting RAW is that you will always have two bites of the cherry. You can opt to retain your image in colour, or, if you suspect that your image has some potential as a monochrome, use one of several methods for converting your file. If you are inexperienced with black and white, it is worth experimenting with a range of RAW files and discovering for yourself the ones that work best.

> **TIP**
>
> 66 The hallmark of a great black and white print is one that shows excellent gradation in the midtones. RAW offers the highest bit resolution, and if you truly want to achieve quality, this is the option to use. 99

⩗ **Many DSLR cameras now offer a mono mode. If you really want to get the best possible black and white image, perhaps ironically, you will be far better served by shooting colour in RAW mode and then using one of several methods for desaturating the image. This way you will also have two bites of the cherry, either retaining your final image in colour, or converting it to mono.**
Canon EOS 40D, 17–85mm lens, 20 sec at f/16, ISO 100

EXPOSURE MODES

Most, if not all, DSLRs will offer an auto exposure; 'P'. With this, the camera will make a quick assessment of the lighting conditions and, providing these are not too demanding, usually delivers an accurate exposure. The big drawback with this mode is that the camera, not you, is determining the shutter speed and depth of field; these are important decisions that should be taken by the photographer.

You may wish to use a semi-automatic option such as 'Tv' (time value). Select the shutter speed and the camera will automatically work out the correct aperture. This mode should be used when movement is an issue. You may wish to capture a figure running across the landscape, to freeze moving water, or perhaps to create a blurred effect. Being able to select the shutter speed clearly is important.

In my experience, most landscape photographers prefer to use 'Av' (aperture value), as this gives you complete control over the depth of field. There is a tradition with many landscape photographers for ensuring that both the foreground and background are pin-sharp. This requires setting a very small aperture and compensating for the possible camera shake by using a tripod.

While these last two semi-automatic options work well for most lighting conditions, there are times when the camera's metering system can be fooled, and using 'M' (manual) is the best solution.

SELECTING ISO

One of the great advantages of shooting digitally is being able to change the ISO setting frame by frame. But is there a setting that specifically suits a monochrome image? Some enthusiasts wax lyrical about the graininess of traditional black and white films and therefore assume that this can be achieved by selecting a high ISO setting on a

DSLR. Personally, I was less impressed by the graininess of some black and white films, preferring instead to use a much slower emulsion. Shooting digitally, too, my own instincts are always to select the slowest ISO setting you can get away with; if you do wish to add grain (or 'noise', in digital terms), introduce it via your image-editing software.

METERING PATTERNS

Modern DSLR cameras offer a variety of metering modes, designed to ensure that your exposure is accurate every time. In most lighting conditions, the evaluative metering mode works extremely well. But it is important to appreciate that your metering system is always trying to achieve an 18 per cent grey and can easily be fooled by very bright or very dark situations. The classic error is photographing snow; as the meter is trying to achieve 18 per cent grey, this often leads to underexposure. This is where the camera's bracketing option really helps.

Backlighting can also present certain difficulties. The centre-weighted mode works particularly well in these circumstances. However, if the subject is backlit and the surrounding light is strong, using the partial metering mode might be a better option. Unlike with film, burnt-out highlights are the biggest problem shooting digitally; shadow detail is far easier to reveal. If you are using a handheld meter off-camera, take your light readings from the highlights, or bracket exposures.

⋁ **The key to all successful monochrome images lies in tone.** Once you have converted the image from colour to black and white, it should be possible to apply numerous small changes using image-editing software to create a dramatic yet moody seascape.

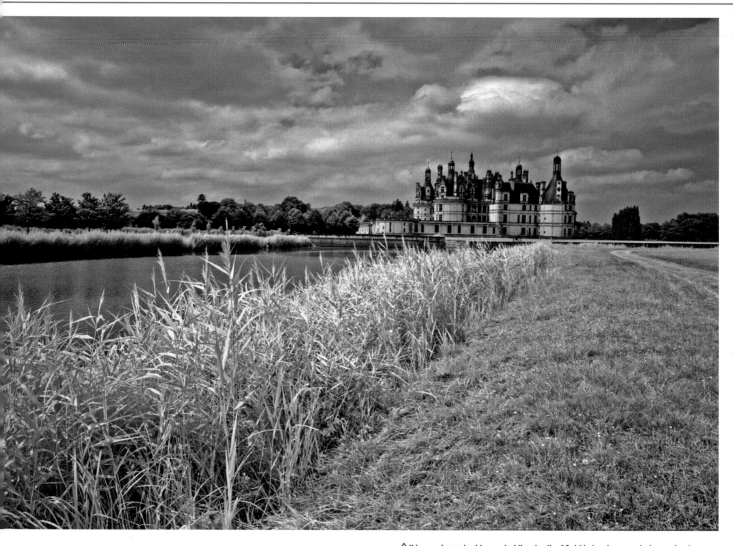

⌃ It is very important to control the depth of field in landscape photography. I wanted to ensure that the grasses in the foreground and the chateau in the distance were all in focus, so I used the Av exposure mode to give me the smallest aperture available. The infrared effect was created by using the Infrared option in Photoshop's Black and White Command.
Canon EOS 5D, 24–105mm lens, 1/30 sec at f/16, ISO 100

WHITE BALANCE SETTINGS

This may appear to have little relevance to monochrome, but it still pays to get the white balance right, as it can affect the tonality of the image. For most landscape situations, using AWB (auto white balance) works well, although it is not fail-safe. Using Daylight Preset (balanced for midday light) or Cloudy Preset (balanced for overcast light) should also be considered. If you do pick the wrong setting, it is not the end of the world as it can be changed at the RAW conversion stage.

FILTERS FOR MONO

If you are a traditional black and white photographer, it is difficult to get out of the mindset of using specialist monochrome filters, particularly as you are best advised to shoot colour and then convert. Although you may get away with some of the traditional monochrome filters like yellow and orange, they may have a detrimental effect on the tonal range and so are best used only to help you assess what a scene may look like in black and white (see page 116). There are, however, other filters that might prove helpful.

- Polarizing filter: this is great for clearly defining clouds by boosting the blue in skies. In many ways it can act in the same way as an orange or red filter. It can also remove irritating reflections in water.
- Neutral density filter: there are occasions when we want to slow down the exposure, typically to create a blurred effect when shooting the sea or waterfalls. This will help by cutting the amount of light reaching the lens.
- Graduated grey filter: more often than not, the sky will be lighter than the land; by using a graduated grey filter, you are able to more successfully balance the exposure. It can also help to make stormy skies appear more dramatic.

I use the lowest ISO setting I can to prevent digital noise. If you like the grainy feel ≫ of some traditional black and white prints, this can always be added with Photoshop. The lith effect was added in Photoshop, see page 134.
Canon EOS 5D, 24–105mm lens, 1/320 sec at f/16, ISO 100

CONVERTING COLOUR TO MONOCHROME

It is always better to shoot in colour rather than use the in-camera mono option. Having done so, there are a number of ways you can convert the image to black and white on the computer. The following are some of the options in Photoshop.

DESATURATE

By far the easiest method is simply to desaturate. Go to Image > Adjustment > Desaturate. While this method retains the image in RGB (red, green, blue), the resulting conversion is rarely satisfactory, as the tones often look muddy.

CONVERT TO GRAYSCALE

A second, equally simple, method is to change the mode to Grayscale, by going to Image > Mode > Grayscale. This, in effect, gets rid of the three colour channels and replaces them with a single monochrome channel, thereby greatly reducing the file size. Although this is quick and convenient, there are more subtle methods to use. You are able to continue using important facilities such as Curves and Levels while in this mode, but should you then wish to tone your image using either Hue/Saturation or Color Balance, you will need to convert the image back to RGB.

LAB COLOR

This is also a relatively easy way of converting to black and white and is the method of choice for many. A RAW file comprises three channels: red, green and blue. It is useful at this stage to open the Channels palette for reference.

- Convert the image to Lab Color: Image > Mode > Lab Color. This has the effect of separating monochrome from colour, which is clearly visible in the Channels palette. In essence, the monochrome element is contained in the Lightness Channel.
- To discard the colour information, select Lightness from Channels and then convert the image to Grayscale. This action, of course, will reduce the image file size. This method offers advantages over simply converting the colour file directly to Grayscale, as it both retains good shadow detail and delivers exceptionally smooth midtones.

≪ Converting the image to Lab Color separates the monochrome element from colour. This is clearly illustrated in the Channels palette.

≪ **A RAW file of Mont St Michel, France, retained in full colour.**
Canon EOS 40D, 17–85mm lens, 5 min at f/18, ISO 100

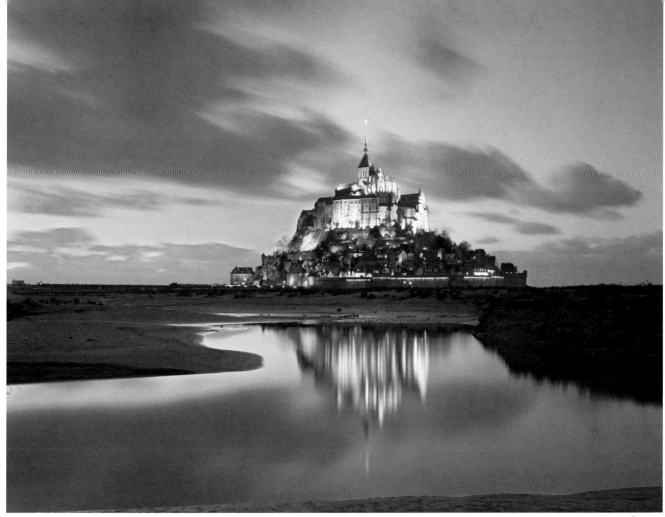

⌃ Isolating the black and white channel using Lab Color prior to converting to Grayscale has several advantages, not least good shadow detail and smooth midtones.

BLACK AND WHITE COMMAND IN PHOTOSHOP CS3

Unquestionably the best facility for converting colour to monochrome can be found in Photoshop CS3. The Black and White command has been designed specifically with this task in mind and does it particularly well. To access it, go to Image > Adjustments > Black and White. The Black and White dialog offers you six sliders: Reds, Yellows, Greens, Cyans, Blues and Magentas. These sliders allow you to make very precise tonal adjustments.

The principle is not dissimilar to Channel Mixer, except that the Black and White command adjusts the actual colours within the image. Put simply, when using the Red slider in Channel Mixer, all the colours are adjusted to a greater or lesser degree. However, when using the Red slider under the Black and White command, Photoshop is able to identify only those parts that are red and respond accordingly.

Like Channel Mixer, the slider is dragged to the right to lighten tones and dragged to the left to darken them. However, unlike Channel Mixer, there is no need to total the adjustments to 100 because the values used are not components.

The second big advantage of the Black and White command is that it is offered as an adjustment layer option, so it is possible to make a black and white conversion non-destructively. You can also dispense with the sliders completely by simply selecting the tones in the image that you wish to change, then drag to lighten or darken it.

⌃ Using the Black and White command in Photoshop CS3, you can adjust all the channel sliders to make very specific tonal changes.

Tony Worobiec

123

CHANNEL MIXER

Apart from the Black and White Command available in Photoshop CS3 (see page 123), the best method is to use Channel Mixer. This retains the image in RGB and offers enormous flexibility.

- Go to Image > Adjustment > Channel Mixer (or, if your version of Photoshop allows, make an adjustment layer and select Channel Mixer). The Red channel will automatically default to 100% red.
- Click the Monochrome box and the image will appear as black and white.
- By moving the three sliders, you are able to adjust the tonal values of each of the colour channels, which offers an extremely flexible method for making changes. Doing this randomly rarely helps, however. Try to think of each channel as one of the colour filters you would use when shooting with black and white film. A red filter would darken blue skies, while an orange or yellow filter could be used to lighten features such as sand dunes.
- It is important that the total percentage values for all three channels should not add up to more than 100%. Less than that and shadow detail can be lost, but more than that and you risk clipping your highlights.

BEFORE

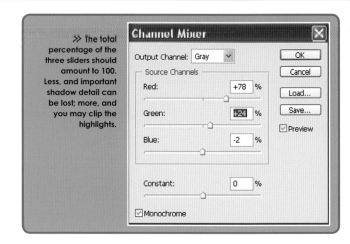

≫ The total percentage of the three sliders should amount to 100. Less, and important shadow detail can be lost; more, and you may clip the highlights.

Should you wish to fine-tune your image further, with your background layer active, make a second adjustment layer by selecting Hue/Saturation, so that the Hue/Saturation layer is below the Channel Mixer layer. By scrolling Master, each of the six colour channels (Red, Green and Blue, plus their complementaries) will appear. Select each of the channels and use the Hue slider to tweak the tonal values. Do not expect to see huge changes; this is about fine-tuning.

Occasionally it also helps to use the Saturation slider. Note that excessive use of either of these sliders will cause parts of the image to posterize, so exercise caution.

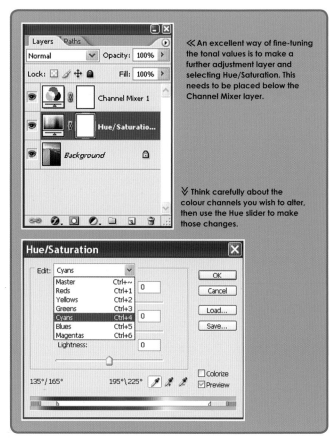

≪An excellent way of fine-tuning the tonal values is to make a further adjustment layer and selecting Hue/Saturation. This needs to be placed below the Channel Mixer layer.

⩔ Think carefully about the colour channels you wish to alter, then use the Hue slider to make those changes.

≪Taken in Death Valley, Arizona, this the kind of graphic image that lends itself very well to conversion to black and white.
Canon EOS 5D, 17–40mm lens, 1/125 sec at f/18, ISO 100

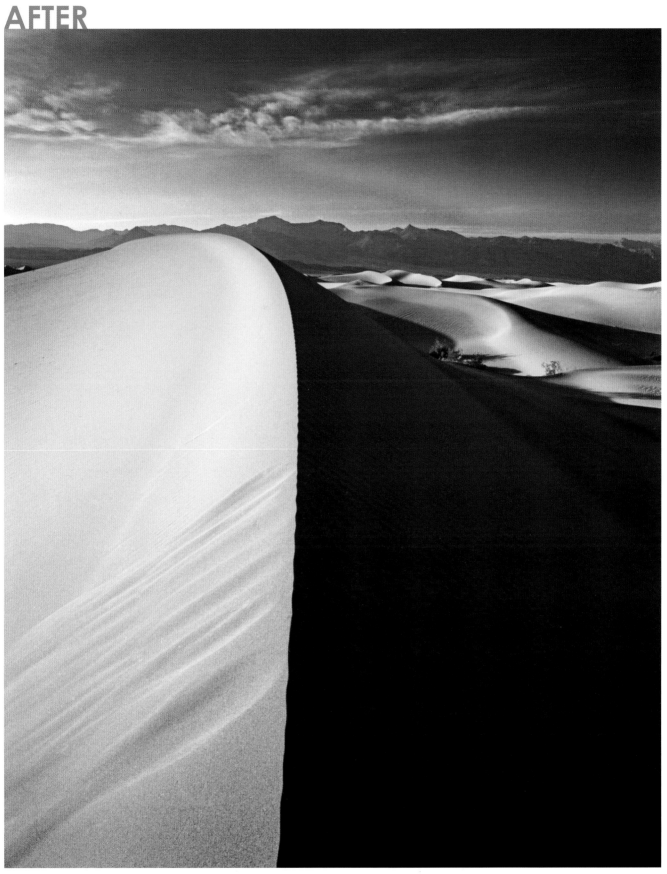

⌃ Having made a conversion from colour to mono using Channel Mixer and Hue/Saturation, I made further small, localized changes, particularly in the sky, to give this image added impact.

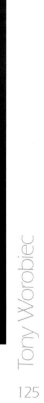

Tony Worobiec

NON-DESTRUCTIVE DODGING AND BURNING

Traditional darkroom workers will no doubt be familiar with the concept of dodging and burning as a means of making localized tonal adjustments to an image. Traditionally, a small piece of card was attached to thin wire and used to lighten parts of the picture during exposure; this was known as dodging. In order to darken parts of the image, a small hole was cut into a sheet of card, which was used to selectively increase exposure; this was known as burning-in. As tonal values are the key to any successful black and white photograph, being able to replicate this practice in the lightroom is of enormous benefit.

The Dodge and Burn tools in Photoshop have been designed with exactly this principle in mind. However, many users are wary of them because the process is viewed as 'destructive'. One way of overcoming this is to make a new layer and apply Gray Fill. By doing this, all the adjustments can safely be made on the new layer. By making two new layers, one dedicated to burning and the other to dodging, even more flexibility is introduced, as it is then possible to undo any detrimental changes as you go along.

USING A GRAY FILL LAYER

- First, call up the file you wish to use and then create a new layer.
- Go to Edit > Fill and select 50% Gray. This will cover the background layer, but by applying Overlay or Soft Light from the blending mode, the background layer re-emerges. Label this layer 'Dodge'.
- Create another new layer, repeat the process, but this time call it 'Burn'. Ensure that the background colours are set to Black and White.
- Select the Brush tool and opt for one of the softest settings.

To dodge an area (make it lighter), while white is selected as the background colour, use the Brush tool to lighten the image. It is very easy to overdo this, so set the Opacity to no more than 15–20%. Apply the brush in single strokes to give your computer time to make the changes, particularly if you are working on a large file. The great advantage of working in this way is that if you find that you have overdone the dodging, select black as the background and simply paint the lost detail back in again.

To burn-in areas (make them darker), activate the Burn layer, ensure that the background colour is black, select a suitable brush size and then apply as single strokes. Once you have achieved the required tonal balance, flatten the layers and save.

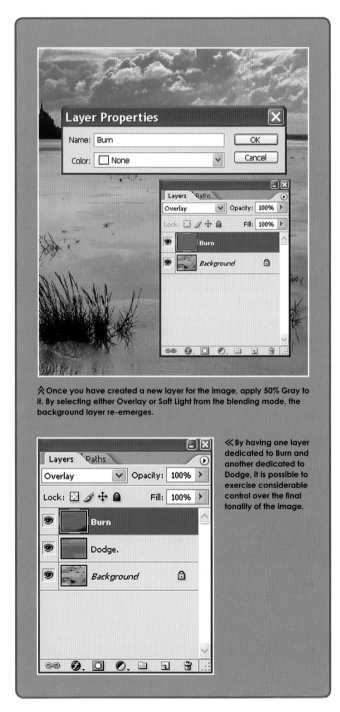

⌃ Once you have created a new layer for the image, apply 50% Gray to it. By selecting either Overlay or Soft Light from the blending mode, the background layer re-emerges.

≪ By having one layer dedicated to Burn and another dedicated to Dodge, it is possible to exercise considerable control over the final tonality of the image.

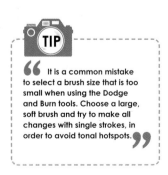

TIP

❝ It is a common mistake to select a brush size that is too small when using the Dodge and Burn tools. Choose a large, soft brush and try to make all changes with single strokes, in order to avoid tonal hotspots. ❞

BEFORE

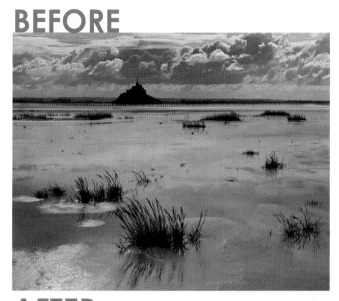

≪ A desaturated image in RGB mode. A successful black and white image depends on tone, and often making small localized changes can greatly improve the photograph. This is where using Dodge and Burn can prove so useful.

⋁ Curves and Levels are a very useful means of making general tonal changes, but are difficult to apply when more localized alterations are required. In this example, I wanted to lighten the highlights in the clouds without lightening the entire sky. It was also important to gently darken the bottom right corner, but the central area needed lightening slightly in order to counterbalance this. Normally this would require making tricky selections. By using Dodge and Burn, changes can easily be made and, by using the 50% Gray Fill layer, the process is non-destructive.

AFTER

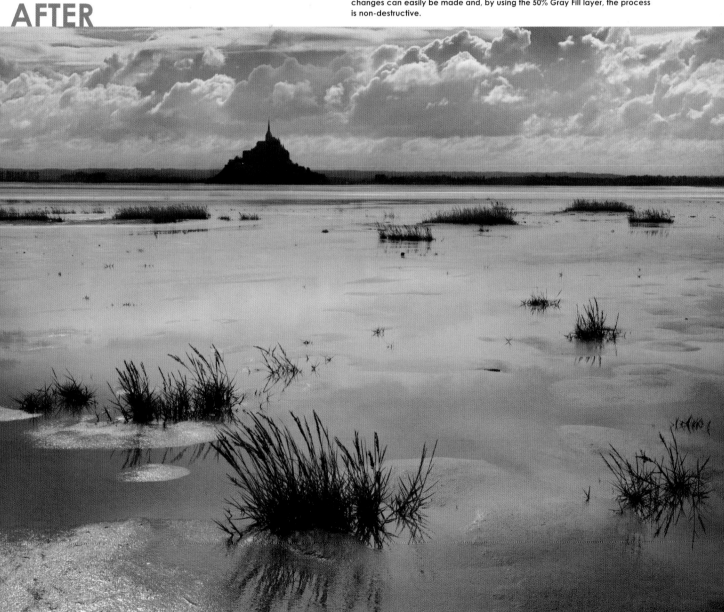

SEPIA TONING

When considering toning a black and white image, one automatically thinks of sepia. It conjures up a warmth and nostalgia that is associated with a bygone era. However, increasing numbers of contemporary photographers have come to recognize its unique visual qualities and have applied the technique in interesting and unusual ways. Its earthy, light brown hues can be successfully applied to a range of subject matter including portraiture and figure work, but particularly to landscape.

Although most DSLR cameras offer a toning effect allied to the monochrome adjustment facility (mono mode), this is not a method I would recommend. First, as I have suggested earlier, the mono mode does not use the camera's full potential. You are far better served by shooting RAW, then converting your image accurately to give the best possible monochrome result to work from.

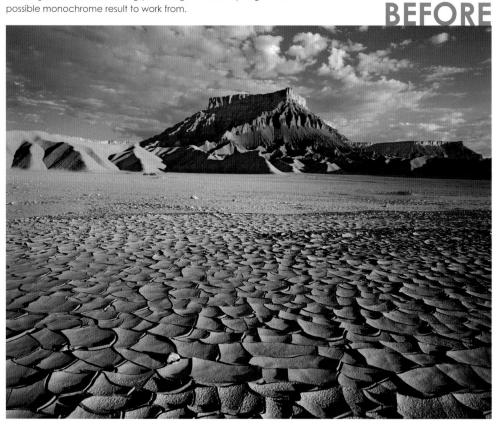

BEFORE

TIP

❝ When using Color Fill, it is possible to lessen the strength of the toning by reducing the Opacity, as an alternative to moving the Fill slider. This decreases the tones incrementally across the full tonal range. ❞

« A desaturated image in RGB mode. This classic American landscape makes an ideal subject for sepia toning. The land appears arid and dry, bleached by the hot sun. I anticipated that a light sepia tone would enhance the desert atmosphere here.
Canon EOS 5D, 17–40mm lens, 1/125 sec at f/13, ISO 100

Second, sepia is a generic description to cover a range of hues from a very pale straw colour to a rich chestnut brown. Why let this be governed by the camera manufacturer, rather than by you? Traditional darkroom workers would often go to great lengths to ensure that the quality of the hue best matched the image they wished to tone. Sepia toning your image post-production offers you the same flexibility.

There are a variety of methods of sepia toning using Photoshop, but the following two are quick and effective.

By selecting each of the channels in »
Curves, subtle adjustments can be made to
create a very plausible sepia hue.

AFTER

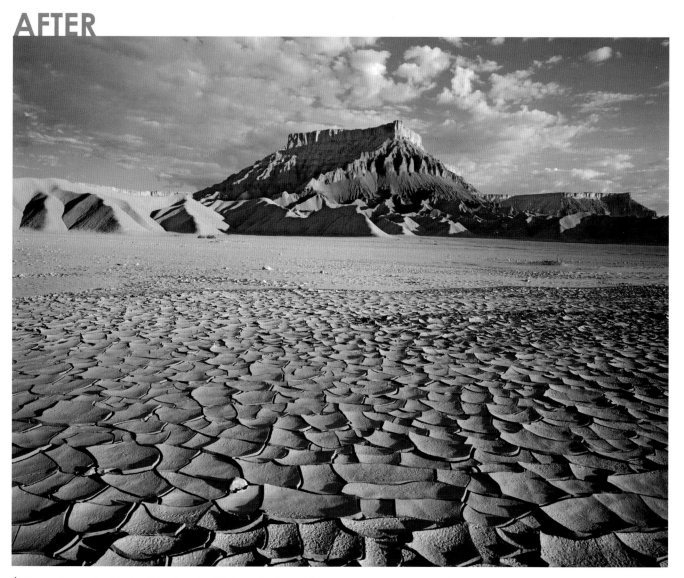

⌃ With a gentle warm hue introduced, the character of the image has been subtly changed. The big advantage of sepia 'toning' your image post-production rather than in-camera is that you can accurately determine the hue you wish to use.

USING CHANNELS

- Start with the image in RGB mode. Click the New Adjustment Layer button at the bottom of the Layer palette, and select Curves. Scroll the Channels box and select the Blue channel and then gently pull the curve downwards so that the image appears slightly yellow. This needs to be done with care, otherwise you risk overwhelming the image with colour.
- Now select the Red channel and pull the curve upwards, once again exercising caution. If the result proves too orange, select the Green channel and make a very gentle pull towards green. This should produce a subtle, overall sepia colour. If your first attempts do not quite work, discard the adjustment layer and start again; remember, no change of pixels has occurred at this stage.
- Introducing colour to a monochrome image often appears to lighten it. Making another adjustment layer and selecting either Levels or Curves, which can be used to darken the image, can counter this. Once you are happy with the final result, flatten and save.

Making an Adjustment Layer and applying Solid Color is my preferred method for ≫ toning an image because the highlights are unlikely to bleach out. The intensity of the colour and the tonal range it affects can be adjusted by using the Opacity and Fill sliders.

USING COLOR FILL

- This is another quick way of achieving a sepia effect. Start with an image in RGB mode. Make an Adjustment Layer and select Solid Color.
- Using the Color Picker, aim to select a hue that most closely parallels sepia; try Red 210, Green 165 and Blue 90 as a starting point. A solid colour will appear over the image, but by selecting Overlay from the Blending Mode the image will reappear through the Colour Fill Layer.
- To some, the effect can appear a little overwhelming, but moving the Fill slider to 50% can reduce this. It restricts the toning just to the darkest tones.

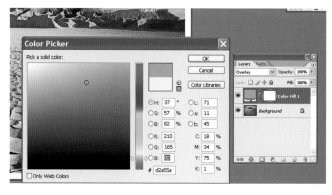

Tony Worobiec

BLUE TONING USING DUOTONE

If you are accustomed to working in colour, Duotone might prove a mystery to you, but it is a wonderful facility. The word 'duotone' originates from the printing industry and describes a process of separating tones in order to give a monochrome image greater depth. This was achieved by using different coloured inks.

To achieve this in Photoshop, change your image to Grayscale. Once converted, the Duotone facility becomes available. There are two advantages to this. First, it allows you to use up to three 'inks' in addition to the first one, which is normally black. Second, each of the inks can be applied using Curves, allowing you to restrict the toning effect to a selected part of the tonal spectrum. Finally, you can also create an interesting dual-toning effect, although there are others ways of achieving this too.

- Once you have converted your image to Grayscale, go to Image > Mode > Duotone. Note that the image size has been reduced. When selecting Duotone, it will default to Monotone, offering ink 1 as black.
- Duotone offers four options: Monotone (one ink), Duotone (two inks), Tritone (three inks) and Quadtone (four inks.) These options can be found by scrolling the Type dropdown menu. When toning a single colour, use either Duotone or Tritone; there is little to be achieved by using Quadtone.
- In order to achieve a blue tone, it is important to choose a second ink. Click inside the white box next to that ink and the Custom dialog box will appear. This offers a multitude of colour options. It also offers a variety of 'books'. For general purposes, I find that Pantone Solid Coated contains every imaginable hue required for toning.
- Scroll the general area of colour you require; in this example, blue. By clicking this area, a more specific range of hues will appear presented as bars. You still have the option of scrolling the bars if the precise hue you are after does not appear. Select the colour that you want, click OK, and this becomes your second ink.
- It is important to check the strip at the bottom of the dialog box, which gives you a useful overview of how the ink will appear across the full tonal range.
- By clicking in the box with the diagonal line, you are able to access the Duotone Curve. Normally the Curve will default to a straight line, but if you make some careful adjustments, it is possible to restrict the colour, either to the highlights, or just to the shadows. This is known as split toning. It can be applied when using just a single ink plus black (Duotone) or when using two different inks plus black (Tritone).

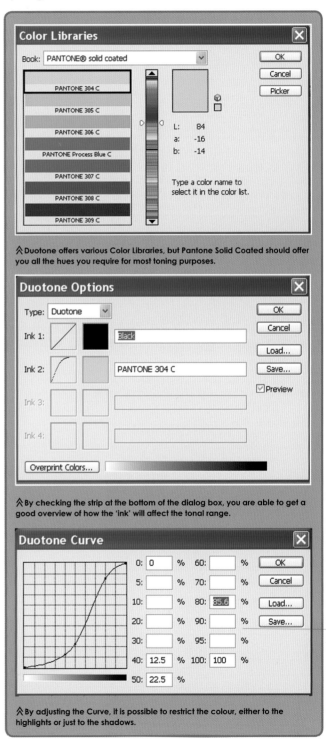

⌃ Duotone offers various Color Libraries, but Pantone Solid Coated should offer you all the hues you require for most toning purposes.

⌃ By checking the strip at the bottom of the dialog box, you are able to get a good overview of how the 'ink' will affect the tonal range.

⌃ By adjusting the Curve, it is possible to restrict the colour, either to the highlights or just to the shadows.

BEFORE

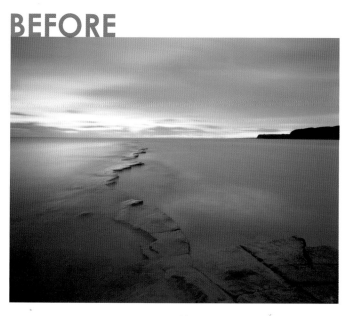

≪ Photographed about 30 minutes after sundown, this image already appears quite monochromatic. However, I was not happy with the mix of green and magenta bias of the blues in the foreground and felt a more uniform hue was required. Before I could access Duotone, I needed to convert my file to Grayscale.
Canon EOS 40D, 17–85mm lens, 4 mins at f/18, ISO 100

AFTER

⋁ Duotone works best when the hue is applied with subtlety. Moreover, by using Curves, the hue has been restricted to just the darker tones, creating an interesting split tone. The hue achieved is not dissimilar to gold toning a traditional black and white print in the darkroom.

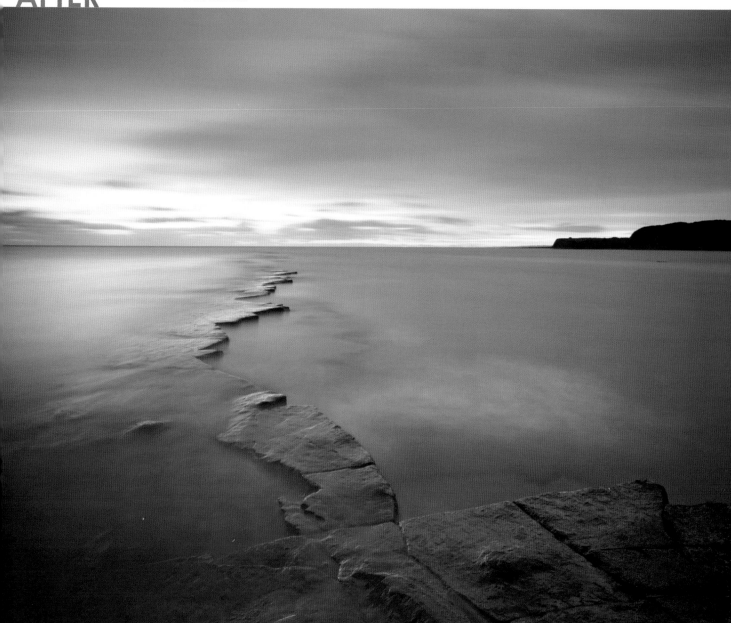

DUAL TONING USING SELECTIVE COLOR

Dual toning is another much cherished darkroom technique that is currently experiencing a revival. There is quite a fashion, particularly with the greeting card industry, to produce images with just a very limited range of hues. Traditionally, photographers would use a broad range of toners such as copper, selenium, thiocarbamide or gold toners to produce wonderfully subtle colour images. As certain toners worked on the darker tones first, while other toners worked on the lighter tones first, it was possible to allow the individual toners only to partially convert the print, leaving sufficient silver for another toner to colour the image.

There were disadvantages with this process. First, it was very difficult to judge in the darkroom the extent of the first toner, so balancing the two toners took a lot of skill – a huge number of prints ended up in the waste bin. Second, many of the toners used were expensive and potentially damaging both to the user and the environment. Third, combinations of toners that started from the same end of the tonal spectrum could not be used together, so the permutations were limited.

BEFORE

TIP

❝ The secret of all dual toning is that it should appear subtle; therefore, ensure that 'Relative' is clicked in the Method box. ❞

≪ A desaturated image in RGB mode. This technique usually works best with an image displaying a broad tonal range.
Canon EOS 5D, 17–40mm lens, 1/80 sec at f/16, ISO 100

There was an initial reluctance to try to mimic these effects digitally; largely, I suspect, because it was difficult to achieve the same quality. However, with a new generation of printers offering high-quality pigmented inks, together with inkjet papers that have been designed specifically for the discerning monochrome specialist, increasing numbers are now experimenting on the computer.

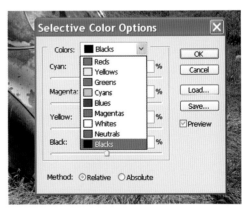

By opening the Colors dropdown menu, ≫ you are able to select either the 'Whites', 'Neutrals' or 'Blacks'.

There are various ways of dual toning by using Duotone or by making an Adjustment Layer and selecting either Color Balance or Gradient Map. However, my preferred method is to use Selective Color.

- Starting with an image in RGB mode, make an Adjustment Layer and choose Selective Color. While this is a facility designed for changing main colours, it can also be used to change black, white and grey, referred to as 'neutrals'.
- Select the tones you wish to change from the Colors dropdown menu found in the top left of the dialog box.
- Having selected black (for the darkest tones), I have dialled in a small amount of red from the Cyan slider and yellow from the Yellow slider. This can have the effect of degrading the darkest parts of the image, so dial in a small amount of black to counter this.
- By selecting 'White' from the Colors dropdown menu, you are able to affect just the lightest tones. In this example, I dialled in cyan and blue in order to achieve an effect similar to a gold toner/ selenium split that I often struggled to achieve in the darkroom.

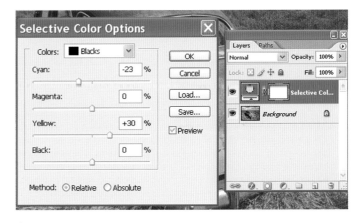

⌃ Using red from the Cyan slider and yellow from the Yellow slider, a hue very similar to selenium is introduced to the darkest tones.

AFTER

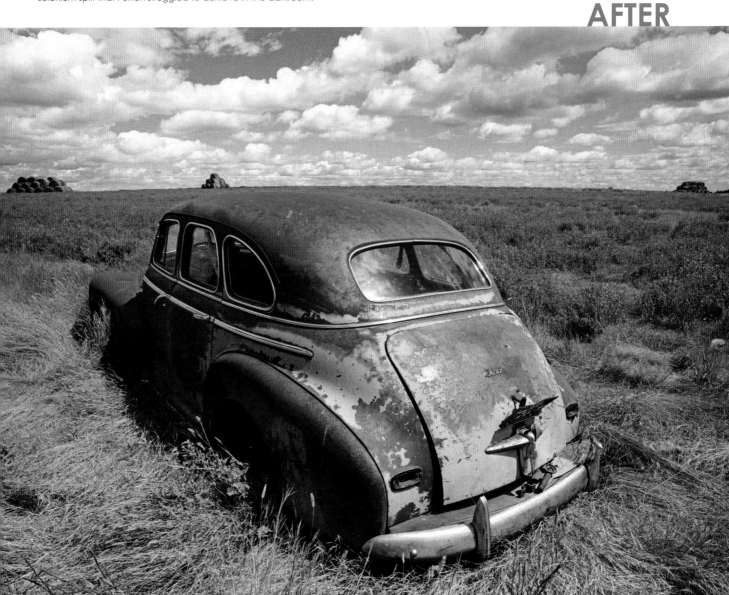

⌃ Using Selective Color, I am able to accurately mimic one of my favourite darkroom processes – dual toning using selenium and gold.
The great advantage of doing it this way is that I do not need to use potentially hazardous chemicals.

CREATING A LITH EFFECT

The lith printing technique is often used in advertising, or on fashionable book and CD covers. Frequently mistaken for sepia toning, lith is a highly specialized darkroom technique that requires grossly overexposing the paper and then processing it in a weak solution of lith developer (hence its name). The result is a very warm-toned image that shows extremely delicate highlights countered by gritty, harsh shadow detail.

It is this wonderful combination that is part of the appeal of this fascinating technique. Not surprisingly, it was once the preserve of seasoned darkroom experts, but, with just a little knowledge, identical results can be achieved digitally.

- Start with a desaturated image retained in RGB mode. Most kinds of images work well with this process, although something with strong shadow detail can prove to be particularly effective.

- Make a Duplicate layer, then make an Adjustment Layer and select Hue/Saturation, making sure that both Colorize and Preview are ticked. The precise colour of a lith print depends on the paper or developer used. To achieve this digitally, select any Hue between 10 to 25. Don't adjust the Saturation at this point.
- A defining characteristic of lith is the grittiness in the shadows; this is achieved by making a new layer and filling it with grey (Edit > Fill > 50% Gray). The Background layer will disappear.

⌃ First make an Adjustment Layer and select Hue/Saturation. Make sure both Colorize and Preview are ticked.

⌃ Having used the Color Sampler to select one of the darker parts of the image, use the Fuzziness Slider to determine the extent of the tonal range selected.

⌃ Make a new layer and fill it with grey (Edit > Fill > 50% Gray), then select Noise from the Filters option. Make sure that the Monochromatic box is ticked.

⌃ After applying the grain, it is possible to revisit the Hue/Saturation to make further adjustments by double-clicking the Hue/Saturation icon.

- While this new layer is still active, select Noise from the Filter option and start with 140. It is important to ensure that the Monochrome box is ticked. This will prove too gritty in the final print, and should be subdued by applying a small amount of Gaussian Blur; try 0.4.
- In order to bring up the Background layer, select Overlay and the image will appear through the grain screen. The image will display an overall graininess and, to create a proper lith effect, it is important to restrict this just to the shadows. To achieve this, while Layer 1 is still active, go to Color Range and use the Color Sampler to select the shadows. Using the Fuzziness Slider will determine how much is finally selected.

- Once you are satisfied with the selection, click OK. I frequently find that this is too precise, and it helps to feather it by 5 pixels. Now make a Layer Mask, which will restrict the grain to the selected darker areas only.
- You may now wish to alter either the hue or the saturation. In the Layers box, double-click the Hue/Saturation icon and the Hue/Saturation Command will appear. Make any further adjustments you require, hit OK, flatten and save.

BEFORE

⌃ **A desaturated image in RGB mode. Photographed in flat, overcast light, this image works well in black and white, but it lacks the desired punch.**
Canon EOS 40D, 17–85mm lens, 1 sec at f/8, ISO 100

 TIP

❝ Having gone to the trouble of producing a lith print, try printing your creation on one of the various high-quality papers, such as Fotospeed Platinum or PermaJet FB Gloss, which are designed to look and feel like traditional darkroom fibre papers. ❞

AFTER

Dark, gritty shadows and warm ⟫ caramel midtones are the defining characteristics of a typical lith print.

SIMULATING HAND-COLOURING DIGITALLY

Without doubt, the most beautiful, yet technically demanding, hand-colouring technique was to colour black and white prints using Marshall Oils. These were translucent materials that looked very similar to traditional oil paints and were specifically designed to apply directly on to photographs. Using wads of cotton wool, the pigment was carefully buffed on to the surface of the image to achieve just a suggestion of colour, rather than the full intensity you would find in a colour print. It is the subdued delicacy that is the charm of this technique.

Such traditional skills are still practised by some specialists today, as many appreciate the hand-crafted quality they bring to an image. For the rest of us, it is possible to achieve results that are virtually identical to the real thing using Photoshop and a little imagination.

- Call up the image retained in full colour. This becomes the background layer. Make two duplicate layers, naming the first 'Black and White' and the second 'Blur'.
- With the Black and White layer active, make an Adjustment Layer and select Channel Mixer. By ticking the Monochrome box, this layer will default to black and white. Do not be too concerned about high-fidelity quality with this layer; if anything, it needs to be rather contrasty. Don't worry if you lose some highlight detail, as this will be retained in either of the other two layers.
- Activate Layer 2, which is still retained in full colour, then go to Filter > Blur > Gaussian Blur and apply a radius of 30 pixels. The image will appear unacceptably fuzzy. Now, using the Opacity Slider, reduce the strength of the Blur layer by 50% so that the Black and White layer comes into sharper focus.
- Further subtle changes can be made until the result you are after is finally achieved. The resulting image should be an attractive blend combining a high-contrast monochrome layer with softly coloured, translucent hues.

TIP

❝ This technique is best used on romantic, pastoral landscapes, just as Marshall Oils were. If you want to colour a hard-edged urban scene, for example, then there are other more suitable methods. ❞

BEFORE

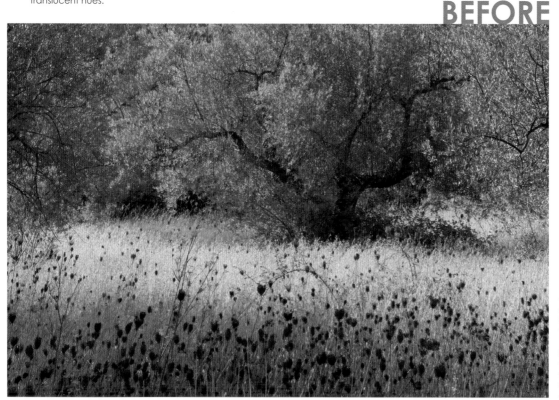

« Although this image has some interesting qualities, it does not work sufficiently well as a colour image, but it does make an ideal subject for digital 'hand-colouring'.
Canon EOS 40D, 17–85mm lens, 1/60 sec at f/13, ISO 100

≪ By ticking the Monochrome box in Channel Mixer, this layer will default to black and white. You are not necessarily trying to achieve a high-fidelity monochrome layer at this stage. If anything, it should appear slightly more contrasty than normal.

≪ The 'Blur' and the 'Black and White' layers merge using the Opacity slider. While I have dragged the slider to 50% here, a more aesthetically pleasing outcome might be achieved using a slightly different blend. You need to experiment to see what works best.

AFTER

⋁ By adding just a suggestion of colour, very much in the manner of a traditional hand-coloured image, a more evocative image is created. I have also opted to crop a little from the left of the image in order to place the olive tree more centrally.

AUTHOR BIOGRAPHIES

TOM MACKIE

Tom Mackie is an accomplished landscape, travel and architecture photographer, having established a reputation for himself in both the US and the UK. Tom's work is featured in *The World's Top Photographers: Landscape*. His two books, published by David & Charles, *Photos with Impact*, and his more recent publication, *Landscape Photography Secrets*, feature a collection of images with strength, boldness and simplicity that create a visual impact that many other technique-style books lack. Tom regularly supplies a variety of photographic magazines and holds photographic workshops around the world.

For more information, view his website at www.tommackie.com.

WILLIAM NEILL

William Neill, a resident of the Yosemite National Park area since 1977, is a landscape photographer concerned with conveying the deep spiritual beauty he sees and feels in nature. His award-winning photography has been widely published in books, magazines, calendars and posters. His limited-edition prints have been collected and exhibited in museums and galleries throughout the US, including the Museum of Fine Art, Boston, the Santa Barbara Museum of Art, The Vernon Collection and The Polaroid Collection. In 1995, Neill received the Sierra Club's Ansel Adams Award for conservation photography. He is a member of Canon USA's elite Explorers Of Light and Print Masters.

Neill's assignment and published credits include *National Geographic*, *Smithsonian*, *Natural History*, *National Wildlife*, *Condé Nast Traveler*, *Gentlemen's Quarterly*, *Travel and Leisure*, *Wilderness*, *Sunset*, *Sierra* and *Outside* magazines. He also writes a monthly column, 'On Landscape', for *Outdoor Photographer* magazine. A portfolio of his Yosemite photographs has been published entitled *Yosemite: The Promise of Wildness* (Yosemite Association, 1994), for which he received The Director's Award from the National Park Service.

Visit his website at www.williamneill.com
For information on William Neill's BetterPhoto.com courses, see www.betterphoto.com/courseOverview.asp?cspID=168

DAVID NOTON

Born in England, David spent much of his childhood in Canada, where his parents emigrated when he was eight. Back in the UK, on leaving school, he joined the Merchant Navy and then undertook a variety of jobs before deciding to become a photographer. In 1981 he returned to college to study photography in Gloucester and went freelance in 1985. Since then, David has concentrated primarily on landscape, nature and travel-related work for stock, commissions and publishing. He won awards in the British Gas/BBC Wildlife Photographer of the Year Awards in 1985, 1989 and 1990. He now runs his photography business, together with his wife, Wendy, near Sherborne, Dorset. David

writes a monthly column, 'Despatches', for *Practical Photography* magazine. His book *Waiting for the Light* was published by David & Charles in 2008 and was accompanied by an exhibition of the same name at The OXO Tower Gallery, London. He has also recently produced a DVD, *Chasing the Light*, and regularly travels to all four corners of the globe photographing in environments ranging from rain forests to deserts.

For more information, visit www.davidnoton.com.

DARWIN WIGGETT

Photo by Samantha Chrysanthou

Darwin Wiggett specializes in landscape, animal and child photography and lives in Cochrane, Alberta, Canada. Darwin is a former contributing editor and co-editor of Canada's *Photo Life* magazine and currently is a regular columnist for *Outdoor Photography Canada* magazine. Darwin is author and photographer of ten photography books on landscapes and dogs, including his two Canadian best-sellers *How to Photograph the Canadian Rockies* and *Dances with Light*.

Darwin regularly teaches photography through workshops, seminars and photo tours and through the online photo school at www.ppsop.com. He is well known for his writing about photography and for sharing techniques with other photographers.

You can see more of Darwin's work at www.darwinwiggett.com.

TONY WOROBIEC

Tony Worobiec studied Fine Art and spent 18 years as head of a large design faculty. He has won awards for photography in the UK and internationally and has had work exhibited in London's Barbican Gallery and Bradford's National Museum of Photography. He is a founder member and current chairman of The Arena Group of Photographers.

Tony's work has appeared in many photographic magazines both in the UK and the US. More recently he has developed an expertise in digital imaging, exploring both monochrome and colour techniques. He has been invited to write extended articles for many of the specialist digital photographic magazines. A passionate traveller, Tony (together with his wife, Eva) has made frequent visits to the US, documenting the depopulating areas of western Nebraska, North and South Dakota and southeastern Montana. The culmination of this work was *Ghosts in the Wilderness; Abandoned America*, which shows numerous haunting images of deserted communities and homesteads, a graphic illustration of the American dream backfiring in a hostile land.

His most recent book is *Black & White Photography in the Digital Age*, published by David & Charles and his forthcoming book, *The Complete Digital Guide to Night & Low-Light Photography*, will be published by David & Charles in April 2009.

Tony is a Fellow of the Royal Photographic Society and was a member of that society's Distinctions Panel for Visual Arts. He is a fine-art photographer with work in the permanent collection of The Royal Photographic Society.

See more of Tony's work at www.arenaphotographers.com

INDEX

ACKNOWLEDGMENTS

TOM MACKIE

Thanks to Neil Baber for including me in this project along with four highly skilled photographers.

I would also like to thank my assistant, Lisa Hood, who has kept me up to speed with the digital processing and totally organizes my business while I am away on location. Her Photoshop skills astound me as she works her magic on my images with speed and ease.

A huge thanks to my friends Gerry and Sue Yardy; their infinite help and advice has made recent events easier to cope with.

WILLIAM NEILL

I would like to thank my family for their constant support. I would also like to thank Nature for the endless wonder of its beauty and the inspiration for my art.

DAVID NOTON

I'd like to acknowledge all those people all over the world running guest houses, bed and breakfasts, campsites, hotels, restaurants, bars and cafés where I've sought shelter or sustenance whilst waiting for the light.

Cathy Joseph, for her help in pulling my part in this book together at the last moment. Mike Mould and Matt Hunt, who keep my business ticking over with their Internet and IT support. Sharyn Meeks, who is our rock of reliability in the office.

And of course my Mrs, Wendy, without whom I'd be cleaning windows.

DARWIN WIGGETT

Thanks to Samantha Chrysanthou for love and inspiration. Thanks to Bob Singh and Weir McBride of Singh-Ray filters for great products and wonderful support. Also thanks to Peter Jeune of The Camera Store in Calgary, Alberta for long-term service and support. And special thanks to all the great photographers out there on the web who continually share information and techniques and produce amazing photos. What a great community!

TONY WOROBIEC

I would like to thank my wife, Eva, who continues to correct my punctuation.